OUTDOOR
PHOTOGRAPHY
MASTERCLASS

with best wishes from

Niall Benvie

OUTDOOR
PHOTOGRAPHY
MASTERCLASS

Niall Benvie

photographers'
pip
institute press

First published 2010 by
Photographers' Institute Press
An imprint of
Guild of Master Craftsman Publications Ltd
Castle Place, 166 High Street,
Lewes, East Sussex BN7 1XU

Text and photographs © Niall Benvie, 2010
© in the Work Photographers' institute Press, 2010

ISBN 978-1-86108-679-2

Associate Publisher Jonathan Bailey
Production Manager Jim Bulley
Managing Editor Gerrie Purcell
Project Editor Beth Wicks
Managing Art Editor Gilda Pacitti
Designer Simon Goggin

Set in Din and Spectrum

Colour origination by GMC Reprographics
Printed and bound in China by Hing Yip Printing Co. Ltd

TO IONA

With the hope that nature will continue to enrich
your life as much as it has mine.

outdoor

CONTENTS

INTRODUCTION

It is just over ten years since I began to write the first of a pair of how-to books, *The Art of Nature Photography* and *Creative Landscape Photography.* Two years and 110,000 words later, I was hugely relieved that it was all over and certain that I had nothing else to say on the subject. I retired from writing photography books. Well, that didn't last...

Not only did I have a continuing flow of new ideas, but I also reviewed my old ways of thinking about things and often found them wanting. And while I harboured many reservations about switching from film to digital capture, I eventually made the break and realized pretty quickly that I could bring more ideas to life than I had been able to using film. The camera began to feel like a partner rather than an adversary.

For workshop tutors, digital photography is a boon, not least in respect of instant review. We can be disappointed straight away and set about correcting the problem without delay – rather than having to wait for the film to be developed. The downside, from the student's point of view, is that there is a lot more technical stuff to learn with digital photography. Yet it's worth persevering and pushing through the jargon in the certain knowledge that once you're comfortable with the technical side of things there is the scope to fly creatively like never before. This is a golden age for photography in respect of what the equipment lets us do, the freedom many of us have to travel to locations, and the means that exist to share and distribute our pictures electronically.

For this book I have adopted the structure of a three-day course, with each day broken down further into day-time sections out in the field (pale yellow), night-time sessions at the computer desk or making use of the dark (mauve), and, finally, bed-time reading to take you into the subject of photography in greater depth (blue).

I *will* teach you what you need to know to be a technically competent photographer, but more importantly, I aim to help you become a creatively confident one. Just as the advent of word processors didn't increase the numbers of great writers, neither has digital imaging spawned great photographers. Nevertheless, the barriers are lower now than ever before, so let's go and give them the final shove!

day 1

CAMERA PREPARATION

Time was when you could pick up a new camera and start to use it straight away with only the briefest reference to the instruction manual; no more, I'm afraid. Sit yourself down in a comfortable chair and prepare yourself for a long afternoon of menu scrolling and button pushing as you thumb through the half-inch thick manual to configure your camera.

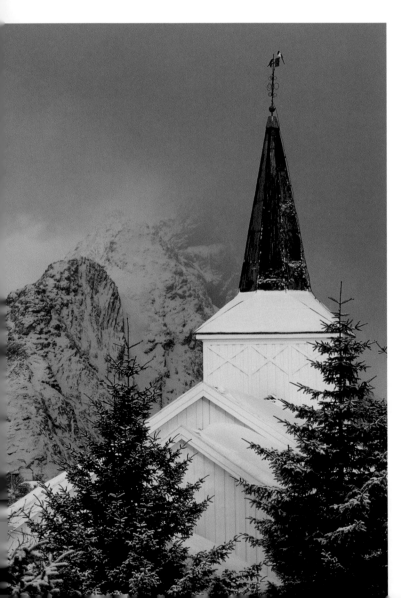

You could, of course, leave your camera on the factory settings, but those fellows know no more about the sort of pictures you want to take than you know what they like for breakfast. The first lesson in our quest to be creative photographers is to take control whenever possible and never to assume that the manufacturer knows best: how dull film photography would have been if we had all followed Kodak's advice to keep the sun over the left shoulder. Just don't do anything that will void the warranty. Alternatively, you can follow the guidelines below.

RAW AND JPEG

Before I give an overview of the key menu settings, it's important to draw a distinction between shooting RAW files and JPEGs. The difference between them is as fundamental as the difference between negative film and transparencies. With the latter, you had to get everything right in-camera and the processed film was the end product. With a negative, there was always some scope during printing to make corrections and alterations. I will talk more about RAW on page 16. For now it's enough to know that JPEG shooting requires many more things to be right at the time of exposure than if you shoot a RAW file; a *lot* more. Of course, you can also tweak a JPEG file afterwards, but if you end up doing that you might as well have shot a vastly more versatile RAW file in the first place.

Church at Reine, The Lofoten Islands, Norway.
Familiarity with your camera's settings is vital so that you can capture the transient light that comes your way.
Nikon F5, 80–200mm, Velvia 50, 1/8 sec at f/11

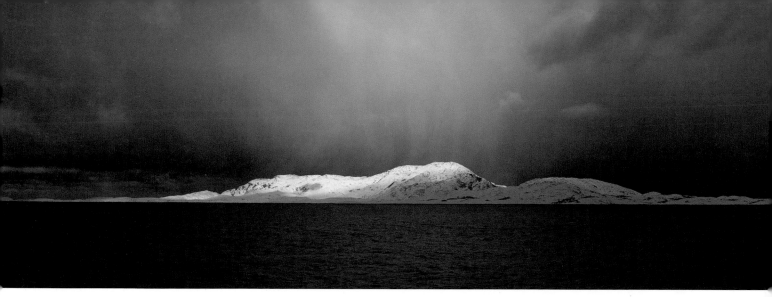

KEY SETTINGS

Here are some of the most important settings you should get right in your camera straight away, and why:

• **Folders:** The image files are stored in-camera in folders. Later on, as part of the image workflow, I will show you how to manage folders of images, but the default folder name in this menu is fine for now. However, the most important thing is to ensure that the folder and file names are not duplicated when your computer imports them, so it does no harm to switch on Sequential Number in the camera's file-naming menu to provide another line of defence against duplicate names.

• **Image Quality:** This allows you to specify the format, or combination of formats (RAW, TIFF and JPEG at different levels of resolution) in which the images are captured and stored on the memory card in the camera. The RAW format records simple binary data that you have full creative control over at the processing stage. A JPEG, meanwhile, is a heavily compressed file. Using the RAW format ensures that you get the best out of your files at this stage. By all means, set it to capture a JPEG simultaneously, but be aware that the best exposure for a JPEG is often different from that for a RAW file.

• **Bit Depth:** This is the number of bits per pixel and describes the number of colours possible in an image, so an 8-bit image has 256 colours, and a 16-bit image 65,536 colours. In theory, capturing at 14-bit rather than the standard 12-bit provides smoother tonal transitions but it's also generally better to have too much information from the outset, some of which can be discarded later. So, if you have the option, select 14-bit capture.

(Above) **Squall in the Norwegian Sea.**
A scene like this is open to various interpretations. Using a RAW file would have certainly given me greater control.
Hasselblad XPan, 45mm with centre-spot filter, Velvia 50, 1/60 sec at f/4

(Below) **Wild gladioli in the field studio, Spain (composite of two images).**
The speed and flexibility of digital capture allows me to handle the specific exposure requirements of my field-studio work.
Each element Nikon D3, 200mm, ISO 400, flash at f/22

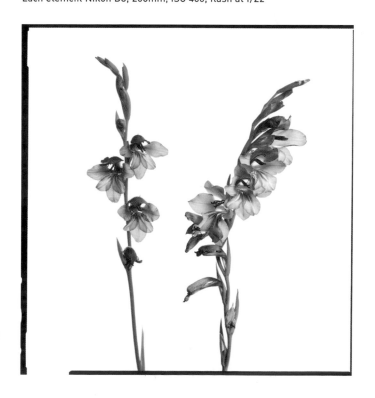

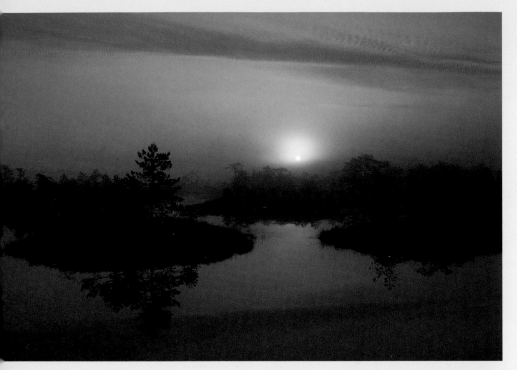

Männikjärve bog, Estonia.
The latest generation of sensors using 14-bit capture can produce smooth tonal gradation around highlights as well as film did.
Nikon F5, 17–35mm, Velvia 50, 1/4 sec at f/11

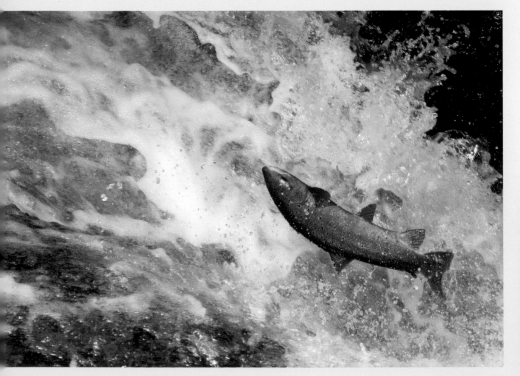

Leaping Atlantic salmon, Scotland.
Manual daylight metering is the order of the day when you are working with high-powered manual flash outdoors.
Nikon D2x, 55mm, ISO 400, flash at f/6.7

COMFORT ZONE

Until you feel comfortable using manual exposure, select either AV (where you choose the aperture) or TV (you choose the shutter speed), then adjust the EV compensation if the exposure is too light or too dark.

• **White Balance:** Ensuring that this setting is correct – so that the whites you see appear white in the final image – is particularly important to get right when shooting JPEGs. You cannot amend the white balance later, so you'll need to choose camera settings that reflect the prevailing light conditions on each shoot. By contrast, with a RAW file you can assign whatever white balance you prefer during processing without 'eroding' the captured data.

• **Colour (editing) Space:** The Colour Space describes the range of colours that are available on output devices, including screens and printers, and can be set in the camera, so that the image file is recorded with these limits taken into account. So, Adobe RGB or sRGB? This is a contentious one, but let me make it simple for you: shoot RAW and it becomes irrelevant which editing space you choose in the camera. When exporting the finished file you can select the space according to the picture's final use. The majority of uses will demand an sRGB file, although most imaging professionals expect files in Adobe RGB, then make the conversions themselves. Adobe RGB (also known as Adobe 1998) encompasses a wider colour gamut, but requires colour-managed applications and devices to display the colours correctly. Very few monitors can actually display all the colours of that gamut, and also very, very few people colour manage. The net result is that your print or web post looks dull and flat because someone along the way didn't convert it into the right space for that device. If I can't persuade you to shoot RAW, at least select the sRGB Colour Space option.

• **Long Exposure Noise Reduction (LENR):** This may seem a little obscure to mention at this early stage, but you'll want to know about it as soon as you make exposures longer than a few seconds. Heat in a camera sensor generates 'noise', which is similar to grain in film, and the longer the shutter is open (and therefore the sensor is on) the worse it becomes. Setting in-camera LENR removes most of the noise, but at the cost of extending the time before the next picture can be taken by as long as the shutter remained open. So for night-time shooting, it will save time if you to turn it off while you determine the best exposure, then switch it back on when you are ready to take the shot. Alternatively, some people leave it off altogether and simply remove the noise during RAW processing.

• **Preview:** If you have a custom function on your camera that brings up a 100% image preview at the touch of a button, then set it. It saves lots of time being spent zooming in manually when you should be paying attention to what's going on.

There are many additional controls that allow you to refine the colour, dynamic range (in a few cameras), sharpness and contrast, although these are mostly of concern for JPEG shooters. If you shoot RAW, you'll have all that control and more in post-production.

OTHER OPTIONS

Moving away from the menus, there are plenty of other buttons to ponder over. Perhaps the most important is the one that allows you to select the manual exposure mode. If this seems a backward step given the sophistication of modern metering systems, consider this: if the lighting is 'interesting' you will rarely use an automatic meter reading without dialling in some plus or minus exposure value (EV) compensation – something you will determine only after checking the histogram. Why not go with a manual reading from the outset? Then you won't find yourself endlessly dialling in compensation as the subject moves across the scene. In the days of film I used manual exposure, but spent ages metering the scene and thinking about the best exposure. Now there's no need: the histogram will tell you straight away if your first exposure isn't quite optimal, then you can simply adjust the ISO, shutter speed or aperture accordingly.

BALANCING ACT
For a given amount of light, there is an optimal balance of ISO, shutter speed and aperture. Give priority to either shutter speed or aperture, then use the ISO to achieve the result you require.

REASONS FOR **RAW**

In the first chapter, I made the case for selecting RAW ahead of JPEG for the majority of the time. The one proviso is that you *will* have to spend time converting and processing the pictures afterwards with software, so they can be displayed and printed but that's the price for saying 'no' to compromise.

Adobe Lightroom is the popular application that we will be using throughout this book. It employs the same conversion engine found in Photoshop's RAW converter, ACR. We'll see how to coax the best out of your files tomorrow evening, see page 96. For now, it's enough to understand that a RAW file is simply a string of binary data that the camera captures and which needs to go through a converter to become a recognizable photograph. The image on the back of the camera is actually a JPEG interpretation of the RAW file, rather than the data itself. This can cause problems if there is a disparity between the two in respect of tonality and if what appears to be a correctly exposed file (according to the histogram display on the camera, see page 18) is actually slightly underexposed.

THE DNG FORMAT

There are many RAW formats: each camera model has its own profile, so it is essential that the RAW converter you use supports that camera. When a new model is released it is sometimes a few months before a profile becomes available. If you have difficulty opening files from your new camera, check with the software company first. There is a strong possibility that in the future profiles for older models of digital camera will no longer be supported, leaving you high and dry if you want to reprocess the files with the latest software.

Yet there is an easy solution to assure forward compatibility: Adobe's DNG format. A DNG (digital negative) file preserves all the information of the original RAW file (you can even preserve the RAW file by embedding it in the DNG file) and writes it in an open, documented format, which is more accessible to third-party software developers than the manufacturer's own RAW formats. The converter is a free download and you can edit DNGs in Lightroom in exactly the same way as you would a RAW file. Alternatively, convert the files while importing to Lightroom, when they are added automatically to the catalogue. Just don't bank on the camera manufacturer's own RAW-processing software-supporting DNGs.

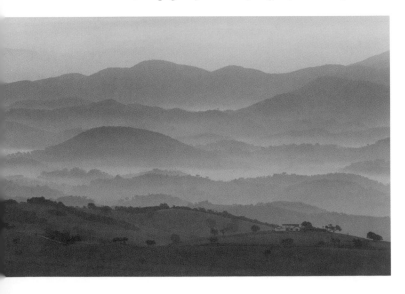

Near Montellano, Spain.
A RAW file offers much more scope for interpretation during the editing process than a JPEG.
Nikon D3, 80–200mm, ISO 200, 1/30 sec at f/11

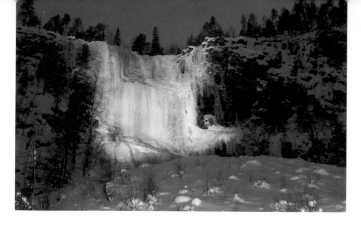

(Above) **Frozen waterfall in the Korouoma Gorge, near Posio, Finland.**
The colours produced by mixed light sources often need refinement
at the processing stage to render them acceptable.
Nikon D3, 24–70mm, ISO 800, tungsten light, 10 secs at f/14

(Below) **Magpie at dawn, Alicante, Spain.**
Memory cards fill up much quicker when you shoot RAW.
So, buy bigger cards!
Nikon D3, 400mm, ISO 800, 1/500 secs at f/3.5

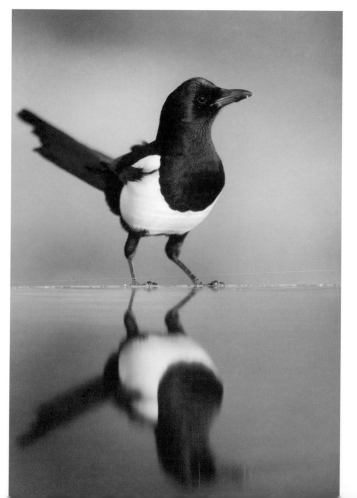

We'll see in the next chapter that 'precise' exposure is almost as important in digital capture as it was with transparency film. However, it is worth being aware that a 12- or 14-bit RAW file can be very forgiving should you under- or, to a lesser extent, overexpose the shot. Exposure salvage is possible in a JPEG, but not without considerable image degradation.

MEMORY CARDS

If you have been shooting JPEGs up to now and are coming round to thinking that RAW might be worth a try, I have to point out that you will get far fewer RAW files onto a memory card than JPEGs, simply because they are not so compressed. An 8Gb card will typically allow you to store about 320 14-bit RAW files from a 12Mp camera, instead of more than 1,000 fine JPEGs or 2,100 normal ones. Nevertheless, large-capacity memory cards are relatively inexpensive now, so don't let their appetite for space put you off shooting RAW files.

I prefer to spread the risk by using only 2 or 4Gb cards most of the time, keeping them sealed in watertight Gepe boxes until they are needed. When a used card is returned to its box, I turn it face down to avoid confusion with empty cards. While I have never experienced memory-card failure – the equivalent of opening the camera before the film is rewound – many photographers have done. Before giving up on the card, experiment with some of the image-recovery software applications. Even if you reformat a card by mistake before you have downloaded the pictures, it is still possible to recover them as long as you haven't started to shoot again on that card. Once the pictures are downloaded and the files backed up, always reformat the card (rather than simply delete the files) to reduce the chances of file corruption in future. This should be done with the card in the camera, rather than when it is still attached to the computer.

CONVERSION
If you want to shoot RAW, you'll need the right software so you can convert your pictures to a JPEG or TIFF.

HISTOGRAMS: ACHIEVING THE PERFECT EXPOSURE

It used to be a matter of professional pride that I could bang off roll after roll of film and lose hardly a frame to ill-judged exposure. Unfortunately, my knack for consistently good exposure is a redundant expertise in the age of the histogram. With it you can instantly see whether you've made an optimal exposure and if not, you can sort it out there and then. Now everyone can master exposure in a day.

READING THE HISTOGRAM

Let's look at some background first. The histogram is a graphical representation of the colours or shades captured by a camera exposure. The left end of the histogram represents pure black, the right pure white. In a shot of a tree in a grassy field against a blue sky with cirrus clouds, a good exposure would occupy the whole width of the histogram, with a peak of luminance values in the centre, corresponding to the blue sky and green grass. A mole in its hole will have most of the values on the left side of the histogram, a seal pup in a snow storm, most on the right. If there are lots of values pressing against the right or left side, the picture is probably over- or underexposed. The trick is to get an *optimal exposure* — one that gives you as much editable data about a scene as possible. In order to do this it helps to understand more about how a camera sensor deals with light.

In essence, sensors are much better at differentiating between light tones than dark ones. Unlike our eyes or film, their response to light is linear. In practice, this means that of all the different levels they can record, half are concentrated in the last (brightest) stop before a picture is overexposed. Good exposure matters.

Ice, Scotland.
Subjects like this typically display a U-shaped histogram with most values bunched at either end.
Nikon D3, 200mm, ISO 250, flash at f/22

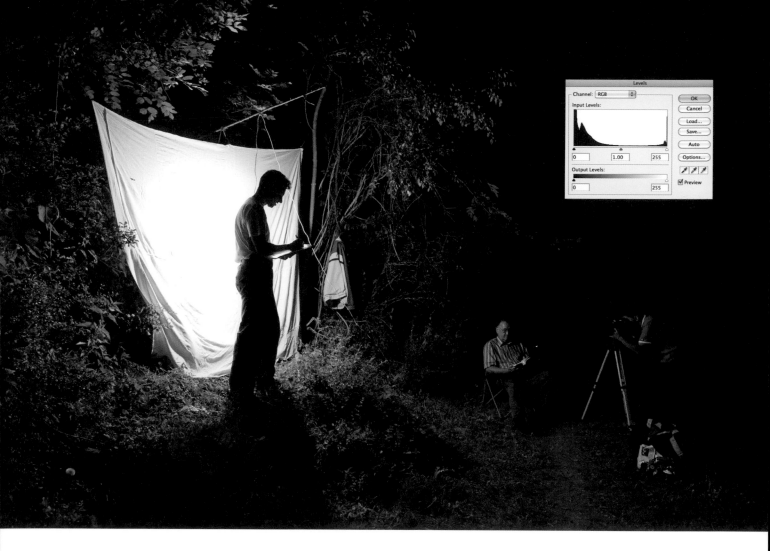

If you underexpose the image, you will be asking the RAW converter to construct the entire tonal range from dark shadows to bright highlights with far fewer levels than if you exposed the picture 'to the right' to give it as many different levels as possible to re-map. This means that there will be smoother tonal transitions in your image and less risk of banding and other nasty artefacts. Underexpose and you may well be able to recover detail but at the cost of a lot of digital noise and a loss of diffentiation between colours – you are not working with nearly so much data after all.

WATCH THOSE HIGHLIGHTS

What is most important, though, is avoiding loss of detail in *important* highlights: I'm not talking about sparkling water or shiny surfaces where we wouldn't expect to see detail anyway

Entomologists at work, Fliess, Austria.
This scene has huge contrast with a high risk of 'clipping' – the loss of shades of colour towards the pure black or white end of the spectrum. 'Clipped' dark values (undifferentiated blacks) are not a problem here. The clipped white values are not ideal, but they reflect the brilliance of the light source.
Nikon D3, 26mm, ISO 1600, 1/15 sec at f/5.6

HIGHLIGHTS
The histogram is a better indicator of good exposure than the image in the camera's viewfinder. Enable blinking highlights to let you see quickly if something is overexposed.

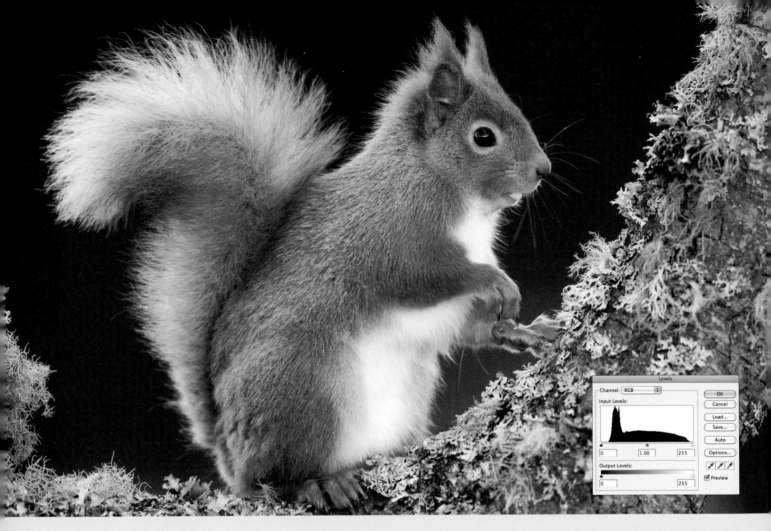

Red squirrel, Brechin, Scotland.
A shot like this, with values from pure white
to pure black, occupies the entire width of
the histogram.
Nikon D2x, 300mm, ISO 250, 1/80 sec at f/3.2

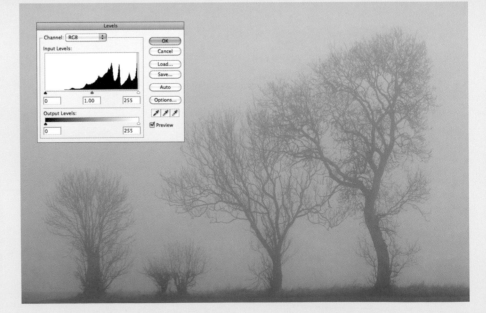

Ash trees in fog, Scotland.
Don't overexpose in fog, generating a histogram
with values too far to the right – everything in
the scene is midtone after all.
Nikon D2x, 80–200mm, ISO 100, 1/8 sec at f/9

but things that are pale and should show detail. If your camera has the facility, set it to display the separate histograms for the Red, Green and Blue colour channels, as well as the composite one. While one channel may be pressing hard against the right side of the histogram, if the other two are not, there will still be detail to print. The composite histogram will lead you to believe that all is lost when it is not, and suggest giving the shot less exposure than you require.

The received wisdom that you should always expose as far to the right of the histogram — by decreasing shutter speed, aperture or increasing ISO — without burning out vital details can be misleading. It's great advice if the scene has a wide dynamic range (the difference in f-stops between light and dark) in the first place, but what if it's, say, a midtoned foggy scene? Expose too far to the right and you may have problems getting the right tonality when you process it — simply dragging the black slider to the right (to darken dark values) will create contrast that didn't exist in the first place. Similarly, try exposing a very dark subject to the right and you'll have a job getting the blacks back. The application of common sense is strongly recommended.

DON'T TRUST THAT LCD IMAGE

Avoid falling into the trap of thinking, 'It looks great on the LCD: therefore the exposure *must* be good'. The histogram is the only trustworthy guide on the back of the camera by which to determine good exposure, and even then it is only a histogram of the JPEG preview rather than the RAW file itself. It's worth checking the camera histograms of pictures you have taken against their RAW converter's equivalents — to see if there are regular disparities between them, so that you know if you could be capturing more data at the outset.

Often, the LCD image appears too light despite the fact that you have optimized the exposure. Darker values can be restored during processing so long as the darkest one shown on the histogram is no further than about a third of the way to the right and, crucially, that you have captured as many lighter levels as possible without overexposing the shot. More and more cameras are now offering a live histogram, which means that you don't even have to make a test exposure first.

CHOOSING THE BEST EXPOSURE

The best exposure is the one that provides the maximum amount of useful data to process the image and allows you to achieve, aesthetically, what you want to. This means not only exposing to the right where appropriate, but also choosing the balance of shutter speed, aperture and ISO that creates the look you are after.

As a general principle, higher ISOs make for noisier pictures. Noise (a speckling of random colours in the image) is caused by artefacts generated by the camera circuits. The sensor signal is amplified, more so at high ISO settings, and this increases any noise present. Having said that, the newest generation of cameras produce often extraordinarily quiet images, even at settings in excess of ISO 1600. If you underexpose a picture by a couple of stops at ISO 100, the noise can often be just as bad as a correctly exposed shot at ISO 1600. So don't be afraid of upping the ISO, even under bright light, to get a faster shutter speed and to freeze action.

The improvement in depth of field by closing down the aperture by just one stop, say f/5.6 to f/8, is fairly marginal compared to the benefits of shortening exposure from 1/60 to 1/125 sec. To select the best daylight exposure, I suggest that you start by figuring out how fast the shutter speed needs to be to keep the camera still and the subject sharp (if that's what you want), select an appropriate aperture (small number, e.g. f/4 = small depth of field), then set the ISO that corresponds to the available light. Don't get too hung up on noise. Not only is there good software available to reduce it, but much of it disappears during printing anyway. If you are worried about it, take a look at a drum-scanned 35mm Velvia 50 transparency: you will soon wonder why on earth you are stressing about a little bit of digital noise at ISO 1600 once you've seen the previous gold standard at 100%.

NO WORRIES
Don't worry about losing sparkling highlights in water: you don't see detail in them so why should the camera do so?

CREATIVITY EXERCISE

I'm as guilty as the next person for kidding myself that if only I had the right lens, or was in a better location or with better light, *then* I could make a picture worthy of my ability. This is self-delusion. The *real* creative looks at the visual scraps left in the fridge and throws them together for a delicious feast. They see not only what is before them, but imagine what those elements could become.

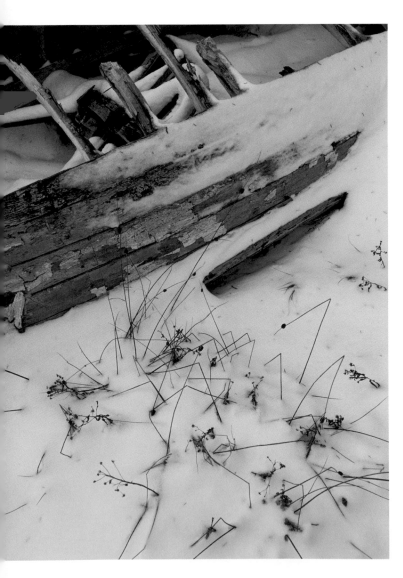

This exercise is all about getting you to look really closely at what's around you and understand that, far from being constraining, limits often stimulate creativity. True, having lots of expensive gadgets opens many new possibilities, but sometimes the limits imposed by equipment also make you work harder and smarter. Those of us who shot transparency film know this only too well and can both appreciate and exploit the comparative ease of digital shooting.

APPLY LIMITS

Limit yourself to a 160ft (50m) radius from where you are standing, and go and find your best shot within half an hour. I guarantee that no two creative people will come up with the same image.

STARTING POINT

If you're not sure where to start, simply try standing still. Obvious images present themselves to anyone running around looking for them, but more subtle and unique ones may well be just in front of you, quietly waiting to be discovered. I suggest that you take the camera off the tripod until you have found your shot; the fewer hindrances at this stage the better. And since this workshop is all about creativity, I won't discourage you from using any filter you want to try or any particular technique you wish to employ – just so long as you can explain why it would have been a poorer picture without it. The one thing that we can't be asked to imagine is post-processing work you might want to do, so try to get the final look in-camera for this exercise.

(Opposite page) **Abandoned boat, Bellevue, Newfoundland.**
Sometimes it's more productive to look at something until it reveals its potential rather than scuttling around looking for the obvious.
Nikon F5, 17–35mm, Velvia 50, 1/2 sec at f/16

(Below) **Iris leaves and abandoned fridge, Scotland.**
When you really look at your immediate surroundings, you may start to notice things, such as this iris-shaped exposure of insulation.
Nikon D2x, 55mm, ISO 100, 1/15 sec at f/11

EYE CATCHING
Ask yourself what it is that catches your eye then choose the techniques you need so that the viewer sees the same thing.

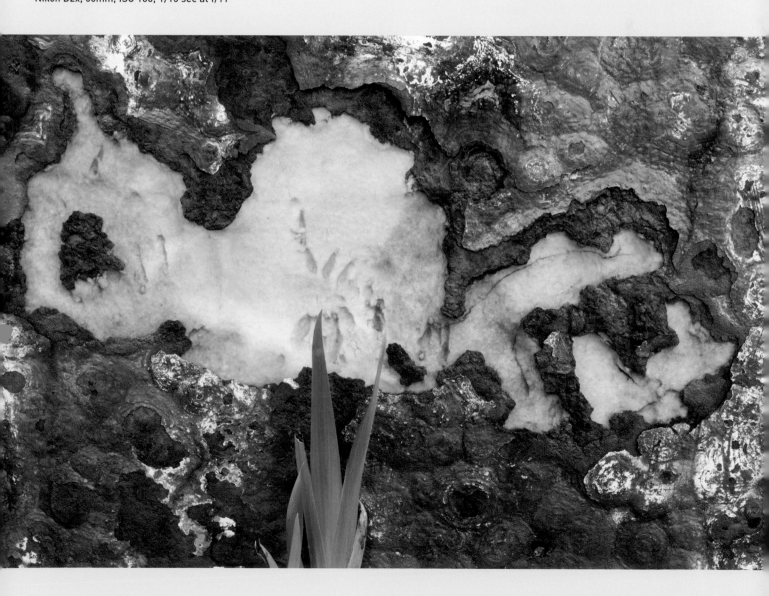

THE **FUNDAMENTAL** DIFFERENCE

As well as seeing how self-imposed limits concentrate the mind, there is an altogether more fundamental notion you need to understand, the difference between narrative and expressive images.

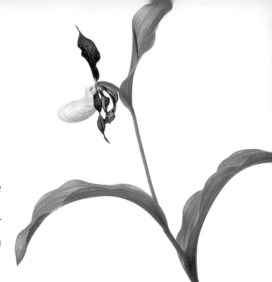

Every photograph arises from one of two distinctive intentions: to tell a story, or, alternatively, to make something that looks great. Sometimes a narrative picture can look good as well, but that is not the key point of it. The expressive image, on the other hand, is all about the photographer's aesthetic response to a scene; any narrative content is entirely coincidental and therefore poorly articulated. Why would it be otherwise? That is not what the picture is about.

These are two very different types of photograph. Neither is better or worse than the other, they just do different things. Have you ever wondered why the type of wildlife shots that are featured in the *National Geographic* magazine are so different from those that adorn popular calendars and photography magazines? It's because magazines like *National Geographic* are looking first and foremost for pictures with a strong narrative content. For example, a shot of a polar bear on an ice flow surrounded by the open ocean stimulates questioning and story-building in a way that a very beautiful head shot of the same animal cannot. Yet if you want to sell warm clothing, the portrait is a better bet: the advertiser will want to create their own story.

A few people will have found a story to tell, but the large majority of photographers will have enjoyed creating an image that simply looks good. You may have demonstrated a strong sense of how colours interplay, or shown a keen eye for how line, form and texture work together. This is all good, yet the reason I want to draw this clear distinction between narrative and expressive images is because the way in which you will go about making each is fundamentally different. If the picture is to be a success, you need to be true to your intention at every decision-making stage as you put the picture together.

IN PRACTICE

Let me give you an example. It's early June and we are in south-eastern France in a mixed forest on lime (you can tell by the flora). Before us is a large clump of Europe's most spectacular flower, the lady's slipper orchid (*Le Sabot de Venus*, according to the French guide) in all its gaudy magnificence.

What is it to be then: narrative or expressive? Let's face it: there are tons of lady's slipper pictures about already. Do you really just want to copy what has been done before? If not, this picture is going to have to be, in part, about you – about what gladdens or frustrates you, or how you perceive the world. You are going to have to be subjective, something nature photographers have been traditionally wary of. In the context of both narrative and expressive pictures, that's good since the picture will have a soul.

STARTING ORDERS

Before you frame your shot, decide if the priority is to tell a story with it or just to make a beautiful image. Choose what to include on this basis.

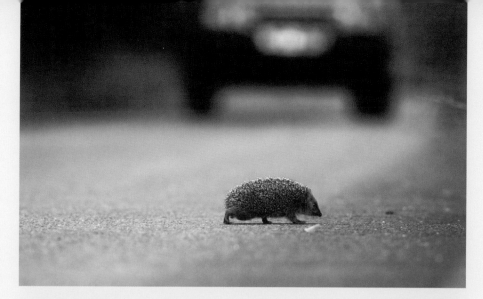

Hedgehog and 4x4, Czech Republic.
Sometimes the narrative is best served when the picture is staged, so long as we are open about the circumstances under which it was made. (The hedgehog lived.)
Nikon F5, 300mm, ISO 100, fill flash 1/60 sec at f/4

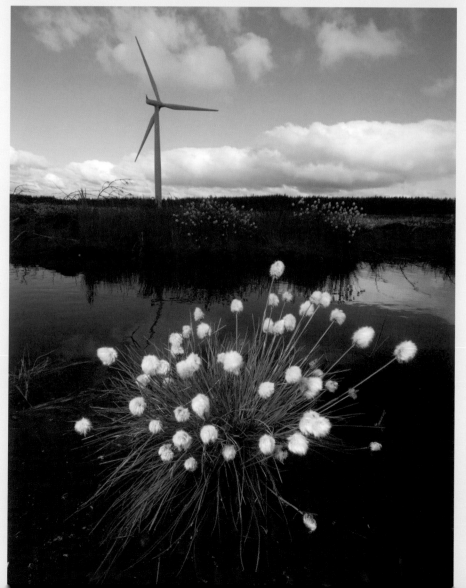

Cotton grass and wind turbine, Scotland.
The balance between the carbon released when peat is disturbed during the construction of wind farms and the carbon emissions their operation prevents is a hot topic in some places.
Nikon D2x, 12–24mm, ISO 100, fill flash, 1/250 sec at f/10

FOCUS
The more distant the background, the easier it is to focus attention on the subject.

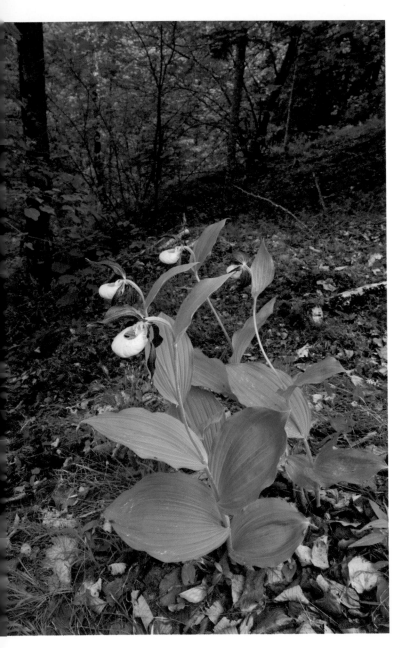

Lady's slipper orchid, Queyras, France.
Here is a straightforward narrative picture showing what the plant looks like and where it grows.
Nikon D3, 17–35mm, ISO 400, fill flash, 1/20 sec at f/20

THE EXPRESSIVE IMAGE

Let's look at the expressive approach first. As always, it starts with questions. What attracted you to this subject? What do the surroundings contribute? Can you describe in words what you are seeing? Is the lighting sympathetic? This questioning helps you to establish just what you feel about the subject in that particular setting so that you can choose the appropriate techniques to express those feelings.

Here, I'm thinking about the odd combination of yellow and maroon, the elegantly curved stems, spirals and top-heaviness. What I'm not drawn to are the oversized leaves and the scrubby woodland round the clump. In this case I opted to make a portrait of the flowers by themselves in my field studio with all the context removed by the backlit, pure white background, see page 24. The flowers' own form creates the composition. I could equally have gone in really close and used a very shallow depth of field to create an impression of the colours and forms. Either way, the decisions I make and techniques I use all serve the creation of one particular type of picture.

THE NARRATIVE IMAGE

In making a narrative picture, it helps if you know something about the subject's background before you start. The old adage about becoming a better naturalist if you want to be a better nature photographer is as true as ever; it will help you to represent the subject properly as well as construct a narrative image with more authority – you can tell a true story.

We can take a couple of different approaches with the lady's slipper. I just happen to have brought a trowel with me – ideal for staging a picture that appears to show the orchids being dug up. Don't worry, it's not for real, but it does let me tell the story of why the plant almost totally disappeared from the UK and remains under threat in parts of its range today. I want the reader to feel troubled when they see the shot and eager to know more. This may be a staged representation rather than actuality, but the narrative is served nonetheless.

Another potential story concerns the plant's natural history: its morphology, habitat, and the community it belongs to. Abstract close-ups of flowers may express what excites me about the plant, but are of little use for someone wanting

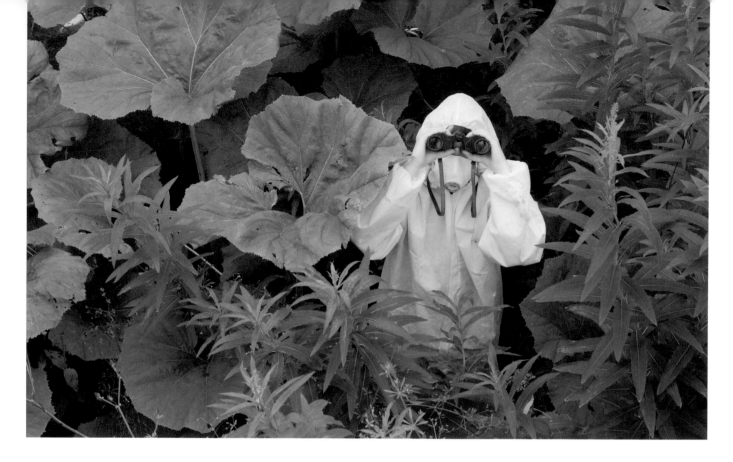

to know what a lady's slipper is (ultimately defined by its environment) and what it looks like. So it is important that I show the whole plant, using a wide angle to include its habitat, and to allow natural light to provide most of the illumination. This is an altogether more objective representation, largely free of cultural references and personal interpretation.

CLEAR INTENTIONS FROM THE OUTSET

It is rarely possible — and always disingenuous — to ascribe a narrative to an image that was conceived as an expressive one, simply because it is the answer to a different set of questions. However, there's no reason why we shouldn't try to create narrative images that are both thoughtfully composed and beautifully lit. I suspect that many art photographers steer clear of the 'merely beautiful' image for fear that their pictures would be judged only on that level and therefore no account will be taken of the 'serious' intention of their work. Be that as it may, in a world flooded with gaudy, superficial imagery, the visually banal narrative image will only ever have a very small readership.

(Above) **Boy in a protective suit, Scotland.**
This narrative image reflects evolving attitudes towards children's experience of wild nature.
Nikon D3, 24–70mm, ISO 1250, 1/125 sec at f/11

(Below) **Trowel**
Here the introduction of a menacing trowel into the picture leads to an entirely different story.
Nikon F5, 80–200mm, Velvia 50, 1/30 sec, fill flash at f/5.6

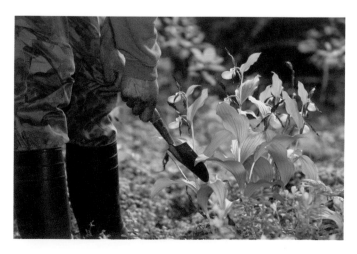

CREATIVITY, STYLE AND VISION

Each time I pass through an airport, I'm reminded that people fall broadly into two distinct categories: escalator riders and escalator runners. The rider is a person who, when given an advantage, uses it to have an easier life. In contrast, the runner never slackens his pace and uses that advantage to make progress that was previously impossible. There are clearly parallels in photography.

I've witnessed young Estonian photographers sprinting up the creative escalator as they combine digital technology, in-the-blood field sense and a powerful creative drive to produce fresh and daring work. Yet many other folks continue to shoot just as they did on film only with the facility now of digital capture.

BE YOURSELF

With the technical playing field levelled there is now a tsunami of competent imagery washing into every corner of our lives. The only survivors of the flood – the ones whose work will be noticed – will be the runners, headed up by the likes of those creatively uninhibited Estonian teenagers getting themselves out of bed after three hours' sleep to shoot great dawn locations most of us have never heard of.

Today, creative daring is no longer an act of courage but a basic requirement if you want your work to be noticed and your stories heard. Even then, I for one would much rather people looked at my pictures and thought, 'Hey, that's a new take! I don't like it, but it's fresh,' than scoff, 'I've see this a thousand times before.'

STYLE AND LABELS

Many photographers, professional and recreational, spend years trying to develop a recognizable style, when in reality 'style' is something latent and the real work is in overcoming the external influences that inhibit its expression. The trouble with style is that it is inclined to be the master, rather than the servant of creativity. Style should be dictated by concept

Why biodiversity matters, indoor studio.
After conventional methods to illustrate this principle failed, I turned to the toy cupboard and added the words in Photoshop afterwards.
Nikon D3, 80–200mm, ISO 200, flash at f/14

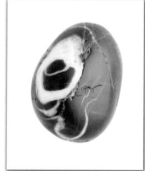

Beach pebbles composite, Scotland.
Making a piece like this would have been quite an undertaking in the days of film. Yet, with its options for shooting and editing, digital capture doesn't hold us back.
Nikon D2x, 55mm, ISO 100, flash at f/11

APPLICATION
Look at what photographers in other fields are doing and see if it is applicable to your own.

WEBSITES
People tend to value fresh content on a website ahead of fancy design. Free blog templates – such as Wordpress – make it very easy to add content yourself.

and content rather than something superimposed on the work. If it is not easily remoulded to the occasion, style can often stifle.

It's not just style that can be inhibiting; labels also hinder. For a few years now, I've struggled with the title of 'nature photographer' because it describes only a small part of what I do and what interests me. Leaf through this book and you'll see a lot of material that doesn't fit with the usual notion

of nature photography. Yet it all reflects my feelings about the natural world. If you are passionate about making pictures (and taking them too) you aren't too picky about what you shoot, you just want to get the observation, idea or feeling across to the viewer. It's old advice but still true: if you want to stimulate your creativity, shoot something new, but bring the experience you've accumulated photographing familiar subjects to the shoot and put something of yourself into it.

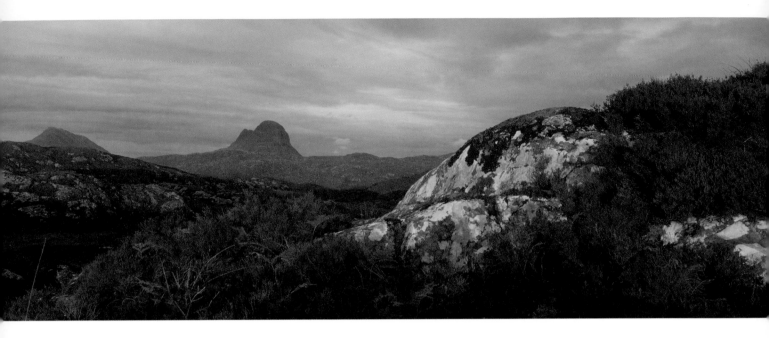

Suilven at dusk, Scotland.
This picture could be interpreted either as a representation of the beauty of Scotland or a nicely lit deforested landscape high on spectacle but low on biodiversity. Your world view will decide which.
Hasselblad XPan, 45mm with centre-spot filter, Velvia 50, 1/4 sec at f/11

VISION

That something is your 'vision'. This word crops up all the time in discussions among photographers, but it's not always clear what is meant. To explain what I mean, let me use a parallel in language. The following phrase is composed of some of the most beautiful words in the English language, but without verbs, pronouns or conjunctions. It is therefore meaningless. 'Inscrutable languid serendipity crepuscular ephemera voluptuous lugubrious pallid senescence mellifluous ineluctable sombre'. The words themselves represent stunning images, but it is only with the addition of other simpler words that they acquire coherence and meaning. It's those additional words that equate to a photographer's vision.

Photography without vision, without those binding, informing words, is a pretty vapid affair. I suspect it is why, over the years, a number of photographers I have known have

given up. The creation of further and better work is sustained, not merely through diligent application and trend-following, but because we have a world view we feel compelled to share. Without that drive and the means to transform those ideas and feelings into photographs, it's hard to keep going.

EXPANDING ON CREATIVITY

Creativity today is increasingly about what you do with your pictures rather than just what you shoot and how you shoot it. The digital age continues to spawn new media and novel ways of doing things – many that we probably haven't yet imagined. Just take a look at the sudden emergence and subsequent cultural impact of social 'blogging' sites Facebook, Twitter and Flickr, especially on youngsters in the 'developed' world.

As well as finding new subjects to shoot, the aspiring creative would benefit significantly by spending a couple of days on the web exploring what people are now doing with digital images, then reforming those ideas for him or herself.

For me, one of the most exciting options is the possibility to share our work with a large audience through blogging. I'm not talking about what-I-had-for-breakfast blogs, but ones that make informed comment and share good ideas generously – without making a hard sell to the reader.

(Left) **Poppies and cornflowers, Scotland.**
Yesterday's mistakes are today's 'creative expressions'. The difference is that we can now afford to make them and sometimes learn something new.
Nikon D2x, 200mm, ISO 100, 1/3 sec at f/9

(Below) **Holly and barbed wire, Brechin, Scotland.**
Photograph what's on your mind, not just what's in front of your eyes.
Nikon D2x, 55mm, ISO 100, flash at f/16

NEW MEDIA

It's difficult to get away from the traditional notion that the only respectable form of publishing is between two hard covers. Yet let's look at this logically and think in terms of 'impressions' rather than copies. When we publish a book our aim is to put our ideas and pictures into the minds of the readers and, if we are professionals, make some money in the process. But, in essence, we are aiming to make enduring impressions.

My own books tend to be pretty specialist. If the reader likes the book, there is a chance that they will take two, or perhaps three, impressions from it — ideas that change the way they think and practise their photography for years to come. In contrast, a popular blog may generate thousands of visits every day — that amounts to many more impressions. It doesn't take long to accumulate a much greater number of impressions than could be made with a book, even if the reader just smiles when they read your blog.

Clearly, the professional photographer has to figure out a way of using that traffic and community of interest around their work to generate income, but the recreational photographer needn't let these concerns get in the way of becoming an 'impressive' blogger.

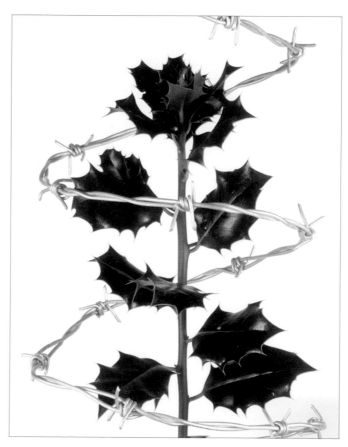

CREATING **SHARP** IMAGES

If the picture is meant to be sharp, let's make sure it is. When I used to write image critiques for magazines, I was always interested to see the diversity of what constituted 'a sharp picture'. All the pictures were shot on film and their sharpness depended to some extent on the quality of the loupe, as well as the brightness and direction of the viewing light and what the photographer tried to get away with.

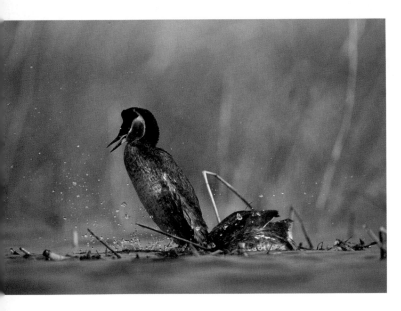

Red-necked grebe, Tartu, Estonia.
In the floating hide, the lens is supported on a beanbag just a short distance above water level. Since the hide itself still moves, a vibration-reduced (VR) or image-stabilized (IS) lens lets you work in lower light levels by allowing you to increase your aperture and shutter speed, letting in more light, with less risk of blurring.
Nikon F5, 500mm, Sensia 200, 1/1250 sec at f/5.6

ASSESSING SHARPNESS

Today, viewing an image at 100% on my camera's high resolution 3in LCD, I can tell straight away in the majority of cases if the shot is as sharp as it should be. But you certainly shouldn't trust smaller or lower-resolution screens. Wait until the files are imported, then check them on your computer monitor at 100% magnification. Many things affect how sharp the picture appears including contrast (caused by the prevailing weather conditions), the quality and type of the lens (wide angle shots rarely look as sharp at high magnification as telephoto ones), in-camera sharpening (which doesn't affect the RAW, but does influence the JPEG preview) and, frankly, our own eyesight. While sharpening for output can make the image crisper, you can't make an unsharp capture sharp. So, let's see what we need to do to get our pictures sharp in the first place. Since many workshop participants are better equipped today than I am (a common observation amongst professionals), let's assume that any lack of sharpness is not down to the quality of your lenses.

WALK AWAY FROM THE TRIPOD

I'm going to start with a heresy; sometimes it is better to shoot without a tripod. I couldn't possibly have said that in my earlier books because then we were still struggling with ISO 50 film, a desire for depth of field and scarcely ever enough light away from the tropics to get a fast enough shutter speed to hand hold. If you wanted a sharp, grain-free picture, particularly with a long lens, there was no alternative, apart from resting

Black-throated diver, Sør Trondelag, Norway.
Low light levels, a low viewpoint, a long lens and long exposure all meant that a beanbag was much the best support. I laid it on a couple of flat stones inside the hide at the edge of this Norwegian lake.
Nikon D2x, 500mm, ISO 200, 1/30 sec at f/4

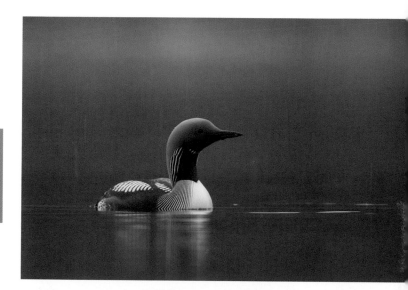

> **FULL OF BEANS**
> An old bank bag, filled three-quarters full with rice, instead of coins, makes a great rest, but keep it dry.

the lens on a beanbag. Today we have low-noise, high-ISO cameras and image-stabilized/vibration-reduced lenses. Set the camera to ISO 800, switch on the IS or VR and you can have an action-stopping shutter speed *and* enough depth of field, even if the light isn't brilliant. If you are shooting active subjects with nothing longer than 300mm, give it a go without the tripod: you will be able to react more quickly and work more fluidly.

KNOWING WHEN YOU NEED IT

For relatively static subjects, it is a different story. For close-up work especially, composition is a critical and often time-consuming process. Apart from the obvious benefits of being able to use slower shutter speeds, lower ISO and smaller apertures (big numbers such as 11 and 16 = large depth of field) it is more convenient to use a tripod. I still prefer to take a good look round and to work out my composition before mounting the camera on a tripod.

CARBON FIBRE VERSUS ALLOY

Carbon-fibre tripods are significantly lighter than the older alloy models, yet what a tripod needs is lots of mass. It's not much fun to carry, but that's what keeps the camera still. To get a really steady carbon-fibre tripod you will either need to hang your camera bag from it or buy one with really chunky legs – which will probably be the same weight as your original alloy model. A super-size carbon-fibre tripod is as expensive as it is stable, money that could have been spent on the equally important tripod heads.

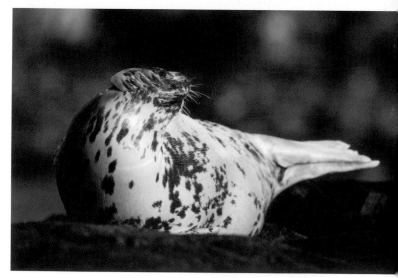

Grey seal, Scotland.
When you stalk shy mammals, a tripod is rarely an option. Amongst the seaweed-covered rocks I rested my lens on a beanbag filled with polypropylene granules.
Nikon D2x, 500mm, ISO 320, 1/400 sec at f/5.6

> **STRENGTH IN DEPTH**
> The depth of field (DOF) is the range of subjects in an image that appears in focus, and is determined by the subject's distance from the lens, the lens's focal length, and the chosen aperture, or f number.

HEADS 'N' TAILS

I can confidently report, after years of trying, that no one head does it all. A low-profile, ball-and-socket head is wonderful for close-up and landscape work for lenses of up to about 300mm. However, try controlling a 500 or 600mm lens on it and you'll have your work cut out.

Many wildlife photographers favour gimball-type heads to suspend their long telephoto lenses from. These are especially suited to following moving subjects. Their main drawback (apart from being unusable with any lens lacking a tripod collar) is the need to level the head before shooting or else experience sloping horizons. Some photographers get round this by slackening the tripod collar ring on their lens; this works, but it also introduces a weak link in the mass coupling chain that compromises sharpness at lower speeds.

I favour a more compact video head (which also needs to be levelled) with which I can make exquisitely smooth pans using a handle, rather than exerting torque on the camera's lens mount. This is a 'hands-off' method as I trigger the camera with an electric release further to reduce movement during the exposure.

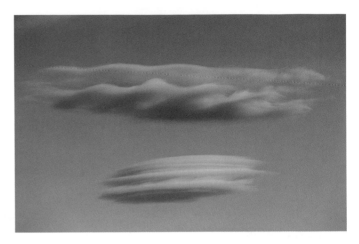

Lenticular clouds, Scotland.
Cloud patterns change very quickly – often faster than you can set up a tripod. So live dangerously, crank up the ISO and hand hold.
Nikon F5, 80–200mm, Velvia 50, 1/250 sec at f/4

AN EDIBLE PHOTO ACCESSORY

All other things being equal, you will get sharper pictures with your long telephoto lens if you place it on a beanbag rather than on a tripod head, especially at slower shutter speeds. This is because you are supporting it along most of its length, rather than just at one point. Indeed, if you are going to stalk a shy animal, a tripod will just get in the way. In very open places without convenient rocks, I take an empty beer crate and a beanbag as a lightweight, extremely stable support combination. Polypropylene granules, rice and split peas are all excellent, mouldable fillers.

ONE YOU SHOULDN'T BE WITHOUT

If you have saved yourself some money and bought an alloy rather than a carbon-fibre tripod, something *very* useful you can spend some of the balance on is a right-angle bracket tailored to your camera. If you use a ball-and-socket head,

or even a Precambrian pan-and-tilt one, you will know how awkward it is when the head is tilted on its side to make a vertical composition. It is especially tricky to change format during close-up work as the camera moves off to one side and the tripod needs to be repositioned. With the right-angle bracket, the ball remains upright and it is the camera that is remounted vertically. It is a simple idea, but it often works brilliantly.

NO SUBSTITUTE FOR GOOD TECHNIQUE

Even with a great set of legs and a beautiful head, there is no getting away from good technique if you want to get sharp pictures with long lenses in low light. If your camera has a mirror lock-up, use it, even if the subject is active. Once you are past about 1/60 sec it won't help, but at slower speeds it can make a huge difference. Don't let the high ISO capabilities of cameras and VR/IS lenses make you sloppy.

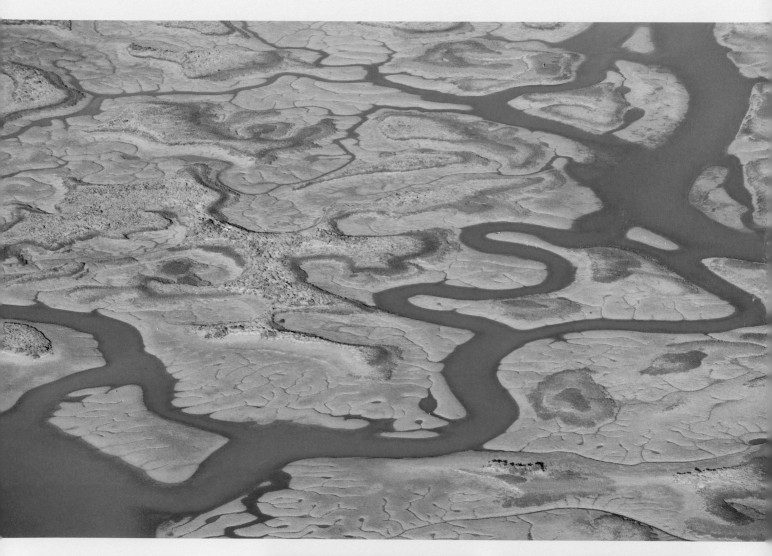

Salt marshes near Cadiz, Spain.
Aerial photography calls for high shutter
speeds to overcome buffeting and vibration.
High-ISO digital cameras have sensors that
are able to produce images with less noise in
low light conditions, and so make it possible
to work until much later in the day.
**Nikon D3, 80–200mm, ISO 800,
1/250 sec at f/5.6**

MIRROR, MIRROR

The mirror is the part of the camera
that diverts the image from the
sensor to the viewfinder. When the
shutter is pressed, the mirror snaps
back, shaking the camera. Mirror
lock-up (MLU) holds the mirror in
position, preventing this vibration.

STANDING FIRM

If your pictures aren't sharp it is
more likely because of camera
shake than poor focus. Even a
miniature tripod, firmly braced,
can make all the difference.

BLUR IS GOOD – SOMETIMES

While I was helping to judge a recent international nature-photo competition, I was astonished by the number of blurry entries. I don't mean shots in which someone had knocked their tripod or sneezed during the exposure, but pictures where blur was a deliberate act of rebellion against photo-realism.

ORIGINS

Motion blur, caused either by the movement of the camera or the subject during a long exposure, is certainly nothing new. The Austrian photographer and former president of famous photography agency Magnum, Ernst Haas, was publishing this sort of picture in the late 1950s and exploring the way colours in motion blend together. His 1971 book, *The Creation*, showcases some of this pioneering work. More mainstream nature photographers remained wary of this highly subjective interpretation of the natural world, resistance that began to crumble after the publication of Art Wolfe's *Rhythms from the Wild*, in 1997 – a portfolio composed entirely of animals on the move.

Digital capture is undoubtedly driving the current interest in this style of photography. It takes many, many exposures to find the best combination of type and speed of camera movement, and shutter speed. It was very expensive to get right on film, but costs nothing today other than a few extra minutes at the computer.

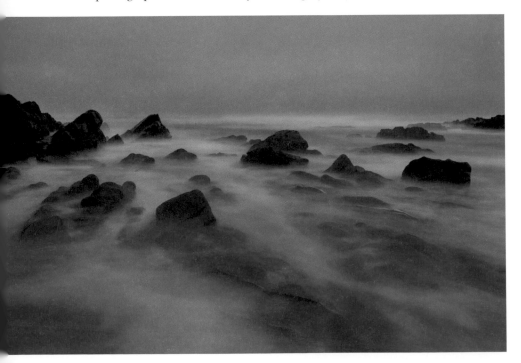

Saligo Bay, Islay, Scotland.
During this long exposure, the trick was to release the shutter on the approach of a big wave so that it closed again just before the wave reached my tripod. Long exposure reveals things we can't see ordinarily.
Nikon D3, 17–35mm, ISO 1250, 13 secs at f/13

ON THE MOVE
To photograph moving water, put your camera on a tripod and try a variety of exposure times between two seconds and 1/30 second depending on how fast and how close the water is. Salt water is corrosive, so both your camera and tripod should be cleaned after being used at the seaside.

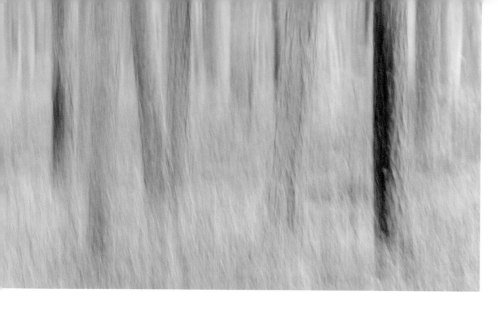

Pinewood in Alam Pedja, Estonia.
I wanted to summarize the colours and
shapes of this snow-free winter woodland,
so shook the camera during the exposure
to minimize detail.
Nikon D3, 80–200mm, ISO 400, 1/8 sec at f/9

INITIAL QUESTIONS

Motion-blur pictures are all about essence and impression
rather than literal, detailed description. As such, they work
better with 'mature' subjects – those already familiar to the
viewer. With very few clues, they can answer the instinctive
first question, 'What is it?', before the viewer enjoys the essential
forms and colours rendered when detail is diffused.

Just because everything is ill-defined doesn't mean that
we can entirely forget about composition, line and form.
The words in a sentence may be slurred, but they still need to
make sense if the reader is to be satisfied; this is perhaps why
tree trunks, running deer and cranes are such popular motifs.

THE TECHNIQUE

It is best to take the camera off the tripod altogether and hand
hold it, even if you are shooting with a telephoto lens at 1/8 sec.
That way you can experiment with a wide range of movement
much more easily. Highly linear blurring may be appropriate
for highly linear subjects, but I prefer the challenge of creating
in-camera texture through a combination of 'drag and jerk'
during the exposure. The resulting look is often very hard to
replicate, bringing a rare and welcome whiff of unpredictability
to digital photography. Be prepared to take dozens of exposures
until you get the look you are after. Try twisting the camera, as
well as moving it up and down.

In the 1990s, rear-curtain sync. flash was all the rage among
photojournalists, as well as some nature photographers, thanks
to the invention of smart TTL strobes that made the mixing of
daylight and flash a breeze. Typically, the daylight part of
the exposure would render the subject blurred to a greater
or lesser extent while the flash retained some detail. While it
may have fallen a little out of favour with the advent of low-
noise, high-ISO cameras, it is still great for conveying a sense
of movement, especially in low-light conditions, without
totally sacrificing sharpness.

Set the camera to Rear Curtain Sync. (you'll need to
visit your Custom Menus again). The flash will go off just
before the shutter closes at the end of the exposure rather
than at the start of it; that way the daylight blur will appear
to follow the subject rather than precede it. This is the
one occasion that I still use a small, camera-mounted TTL
strobe, controlled by the camera's metering: in a fast-moving
situation, where the camera-to-subject distance keeps
changing, there is no time to check manual flash exposures.

DRIVE-BY PHOTOGRAPHY

A variant on the motion-blur theme that has emerged
in art circles in recent times is the sinister-sounding 'drive-
by' popularized by, amongst others, Dewitt Jones. This is
a gift for the lazy photographer: simply wind down the car
window and shoot with a slowish speed as the car whizzes
along. (I *strongly* recommend that you only do this as a
passenger in the car.) Like all work of this sort, it still needs
strong graphic elements and something approximating to
a composition to work, but it is a fun way to pass a long
and tedious car journeys.

YOUR **BACKGROUND** MATTERS

Thanks to his two definitive how-to books of the 1980s, John Shaw has been hugely influential in promoting the low-key, unobtrusive background in close-up photography. Portrayed this way, the subject is freed from visual competition and stands out clearly. The photographer's diligence in subjugating the background is still seen as a measure of general photographic prowess. Yet we underestimate the contribution that the background can make to the look and mood of the picture.

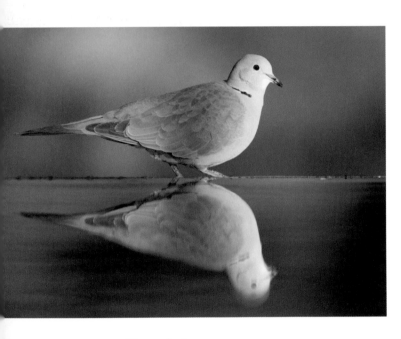

Collared dove, Alicante, Spain.
This drinking pool was positioned so that the background would be illuminated from first light, even though the subject was still in shadow. The resulting contrast helped to add depth to the pictures.
Nikon D3, 400mm, ISO 800, 1/500 sec at f/5

The background can be put to work to create a sense of depth, to set up tension and, under certain conditions, to give sharp edges to out-of-focus subjects. By reversing normal expectations of an illuminated subject and a shaded background, we can get the viewer to look at the subject, literally, in a fresh light.

A sense of depth is created not only by the construction of perspective in the picture, but by juxtaposing warm, advancing colours (red/orange) and cool, receding colours (blue). Things get interesting when the subject in the foreground is shaded and the background remains in sunlight.

LIGHT AND SHADE

I'm no psychologist, so I can't tell you why looking from a dark to a light place appears to make the viewer feel positive, but the device has long been used by painters including Albert Bierstadt' in *Sunset in Yosemite Valley*, 1868, and *Among the Sierra Nevada Mountains, California*, 1868 and also Thomas Cole's *View from Mount Holyoke after a Thunderstorm (The Oxbow)*, 1836. In this last work, the lighting is also used to make a statement reflecting attitudes towards wilderness at the time; the 'civilized' areas bask in bright sunlight while the 'savage' and untamed parts of the composition lurk in shadow.

When I photograph wildlife, I am always on the lookout for these bright backgrounds, although you'll find many more chances to use this technique with close-up photography where you can take on the role of sun and clouds yourself using a number of reflectors to fill in the shadows.

Waxwing, Scotland.
It was early on a frosty morning when the calls of a party of waxwings drew me to this Highland orchard. The background colour created as the sun struck the other side of the valley contrasted with the frosty shadows.
Nikon F5, 500mm, ISO 200, fill flash, 1/60 sec at f/4

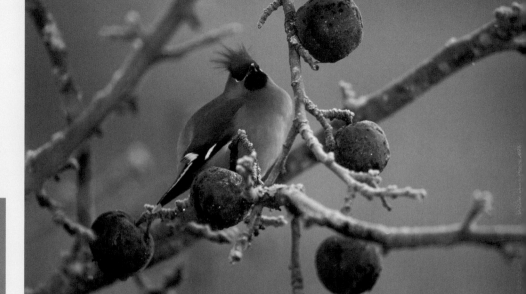

IN ADVANCE

If your camera has a depth-of-field previewer, use it to get an idea how much will be in focus.

Habituated European lynx, the Czech Republic.
The lynx is largely unknown to most Europeans; this was better suggested by photographing the animal in the shadows.
Nikon F5, 300mm, ISO 100, 1/30 sec at f/4

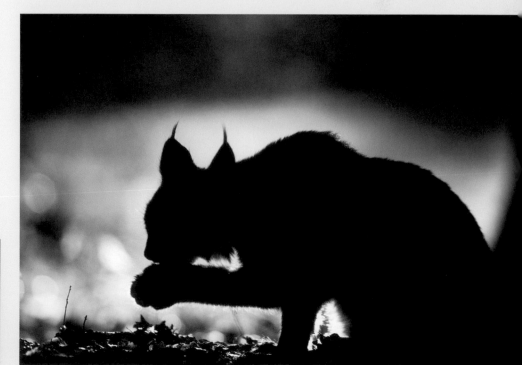

ON THE EDGE

Get into the habit of checking round the edges of the frame for distractions before you release the shutter.

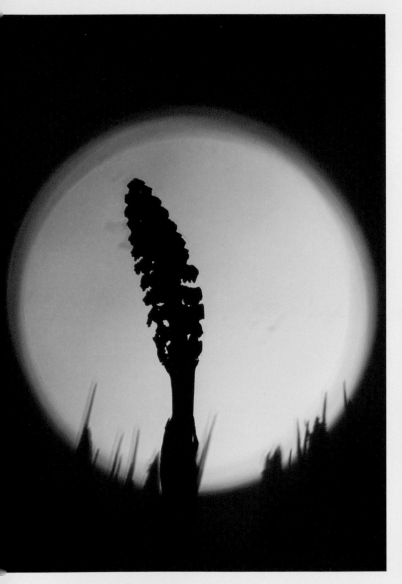

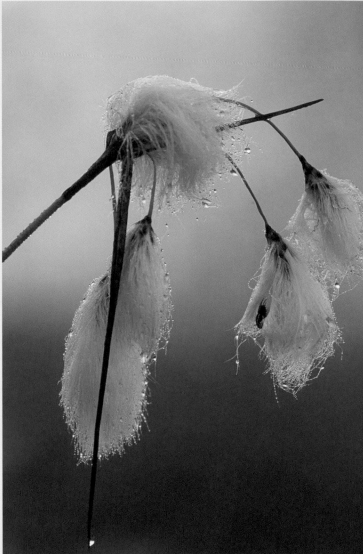

Field horsetail, Tartu, Estonia.
Modern horsetails have an extremely ancient lineage. I wanted to suggest 'the beginning of time' by setting one against the rising sun. At this time of day the sun's position relative to ours moves quickly, so there's no time to dither.
Nikon F5, 200mm, Velvia 50, 1/60 sec at f/5.6

Broad-leaved cotton grass, Alam Pedja, Estonia.
Under a clear dawn sky this cotton grass picked up a blue cast, contrasting with the warm tones where the early sun struck a distant background.
Nikon F5, 200mm, Velvia 50, 1/2 sec at f/11

Be aware that it is extremely dangerous to view the sun directly, so, if you're photographing the sun, use your camera's Live View (if available) rather than the viewfinder.

A telephoto lens – for starters, try the long end of your zoom – provides maximum control of the background. At any given aperture and magnification, the depth of field is the same, whether you use a 50mm or a 500mm lens. However, the background looks radically different as the 500mm greatly magnifies out-of-focus, distant elements which makes them appear closer to the subject. The longer the lens, the more diffused the background. Practically, a 180mm or 200mm macro lens or a 300mm on an extension tube are the most versatile and the easiest-to-handle tools for the job.

Once you've found your subject – ideally one shaded under an open sky with a clear view through to an illuminated background – decide how much background colour to include and adjust the composition accordingly. In these lighting conditions you can expect a strong blue cast on the subject itself, but that can easily be corrected in processing.

CHOOSE YOUR MOMENT, BALANCE THE LIGHT

This work is best done around dawn or dusk so that the contrast between the subject and the background comes within the range of shades from light to dark (the dynamic range) that your camera's sensor can record. In this instance, it's the background exposure you need to watch out for. It doesn't matter so much if your subject is a little underexposed; it is, after all, in the shade. If contrast remains excessive, use a white reflector (silver or gold can be too harsh) to redirect some light on to the subject, taking care not to over-light it. Whatever you do, don't use flash as that will almost certainly flatten the contrast completely and kill the atmosphere.

Use your camera's depth-of-field preview button (if it has one) to assess how sharp the background is. This feature shuts the aperture down to the one you will be shooting at and although it tends to make things dark, you'll get a better idea of what will be sharp. Generally, I use a much wider aperture than I would if framing a close-up for maximum detail, perhaps f/5.6 rather than f/16. It's sometimes wise to back off and sacrifice some magnification for the sake of greater depth of field. Keep a low angle to reduce interference from unwanted vegetation just behind the subject. If plants are still problematic, you could use a sheet of envelope stiffener to hold them out of the way.

INTO THE LIGHT

There are a few more challenges to face when shooting into the light. Firstly, the contrast is much greater when we look towards the sun. It is also harder to achieve a good contrast between warm and cool tones. What you can certainly exploit, however, is the sun's own brilliance. A rising or setting sun in the background silhouettes the subject (a 200mm macro provides ideal magnification for this), but you'll need to make these precise compositions and exposures quickly as Helios doesn't hang around early or late in the day. An altogether more tricky approach exploits the way that brilliant directional light creates a false sharpness around the edge of a defocused subject viewed against it. Save your eyes by switching on your camera's Liveview, if it has that option, and make your composition on the camera LCD, rather than through the optical viewfinder.

In addition to the sun itself, sparkling water also offers an alternative and safer indirect light source, as does a silver or gold reflector angled to catch the sun. Select a wide aperture so that the highlights remain large, and so the camera's iris does not create a pattern of hexagons in the background.

THE FOREGROUND MATTERS

The way in which out-of-focus areas in front of a subject are rendered can often make them look quite different from those behind it. It is more feasible to get a very soft foreground with a relatively short telephoto than an equally soft background with that sort of lens. It is all to do with distance: the closer the foreground is to the camera, the more diffused it may be.

Shoot at quite a wide aperture too, perhaps f/4 or f/5.6, and you will create background blur; this provides an uninterrupted setting for the subject. You'll have the greatest chance to do this with wild animals by shooting from a very low viewpoint so that the ground closest to you comes into the shot.

Like the background, a soft foreground should not be incidental. If you can find colourful elements to shoot through or over, such as foliage, snow or lichen-encrusted rocks, you can set up colour tension that heightens the subject's presence. If these elements are too close to the subject, there is no hope of softening them sufficiently, so use your depth of field previewer to check their distinctiveness at different apertures.

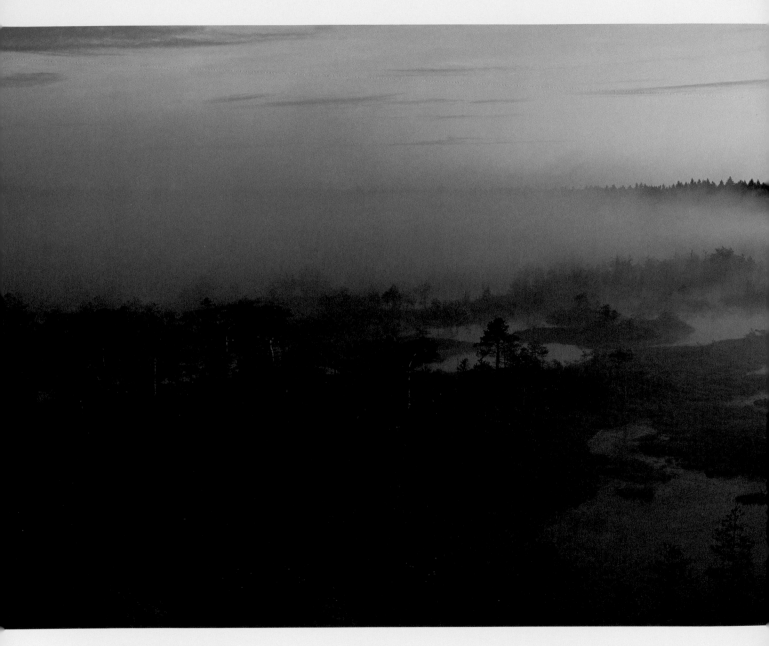

Dawn over Mannik Jarre Raba, Estonia.
Even within Europe, there are many biologically
rich, internationally important areas that are
almost unknown outside the country itself.
Devising a project with local Non-Governmental
Organizations can be mutually beneficial.
**Hasleblad XPan 45mm with centre-spot ND
filter, Velvia 50, 1/8 sec at f/11**

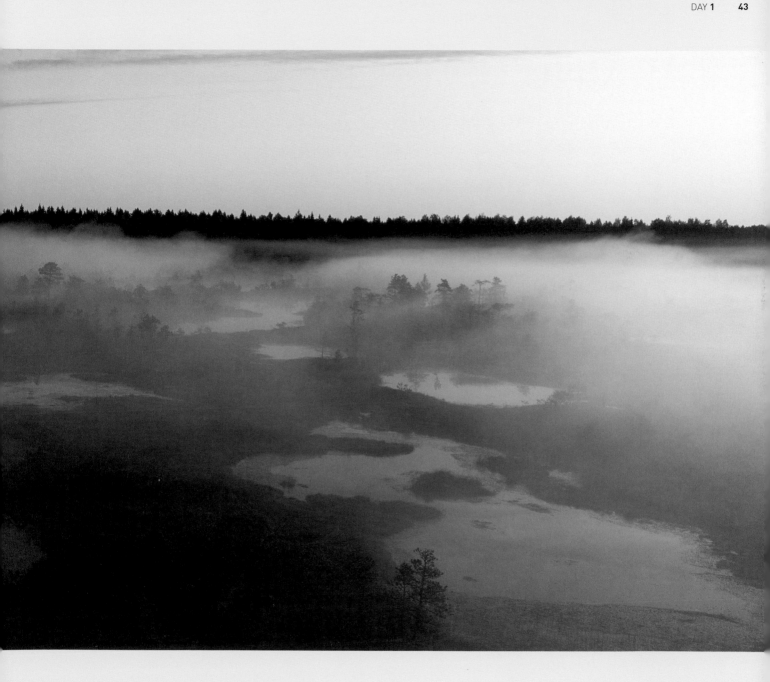

BACKING UP YOUR DIGITAL IMAGES

Anxiety about data loss was the main reason I delayed switching from film to digital capture. At least with a transparency the image was visible with nothing more than a loupe and a light source. If the hard drive with the scan on it failed, another scan could always be made. Digital pictures, on the other hand, seemed just too intangible.

Bluebell wood, Scotland.
If you are lax about backing up, speak to someone who has lost lots of data. It's always better to learn from other people's mistakes.
Nikon D2x, 80–200mm, ISO 100, 1/4 sec at f/13

ROBUST
Backing up to DVDs takes forever; use a robust portable drive instead.

When I was shooting film, on most occasions there was only one transparency, which was vulnerable to damage, loss and theft. My finished digital files, in contrast, exist today in up to seven different locations and media (plus those that my agents hold). This causes me to wonder whether it is these or my back catalogue of transparencies that is more at risk.

BACK UP, BACK UP AND BACK UP AGAIN

I freely admit to suffering from DIS (Data Insecurity Syndrome), in which symptoms include compulsive backing up, watching for electrical-storm activity and an obsessive interest in newer, more stable storage technologies. It is not entirely without justification; rest assured that your trusted hard drives, sooner or later will fail you and if you haven't got back-ups you may never see your work again. If you think that is melodramatic, just ask other photographers.

Desktop hard drives are best regarded as nothing more than a very convenient, temporary storage medium to relieve the pressure on your computer's own hard disk. You may reduce the risk of catastrophic failure by replacing them every couple of years, running regular integrity checks and having other backup and archive drives, but if they are your only form of security you are taking a huge risk. Let me describe my own routine. You may find it excessive, but you can always tailor it to the extent of bad experiences you have encountered.

IT'S NEVER TOO EARLY TO START

On most expeditions I take a laptop with me, so that each day I can download pictures, copy them to a portable hard drive and a large-capacity Flash memory stick, and also load them directly onto a storage device. With this I can continue to empty my cards even if my laptop dies or is stolen. The portable hard drive and memory stick travel with me during the day in my backpack and jacket. However, for security reasons, the storage device stays near, but not with, the laptop.

I never bring the laptop's portable back-up drive from home simply because if it *and* the laptop were stolen I would be in real trouble. If I have enough card space, I don't reformat the cards after downloading until I need to. On expeditions to more remote locations or those without a power source, I simply keep filling cards, store them in watertight cases in my pack and hope for the best. While cards are an expensive way to acquire storage space, they are also comparatively safe if treated carefully. If your camera has a second card slot, you can also configure it to back up the first card in the custom menus.

COVER ALL THE BASES

While electrical storms are quite uncommon where I live, they do happen and friends have lost drives, fax machines and other electrical devices to them. For relatively little money you can buy a unit that not only protects your computer and drives against power surges and failures, but, using its own battery and software, will also shut the computer down properly to prevent data loss or corruption. This is a must-have.

ON RETURN HOME

As soon as I'm back in the office, all the RAW files are copied from the laptop's disk onto two desktop hard drives. I also run back-up software to update the data set on a dedicated portable drive. It's actually better to use software that not only copies files over onto drives for you, but verifies them in the process, avoiding the possibility of simply backing up unreadable files. The RAW files are deleted from my 'field' portable drive and the Flash sticks, but remain on the storage device until it is full, when the oldest folders are deleted. By that time, the files will have long since been processed and archived. Once I have edited

the material, I replace the RAW folders on the desktop drives with the new slimmer ones and back up the computer again. If I have been hasty and deleted something I shouldn't, I can always go back to the storage device.

THE RAID ALTERNATIVE

You might be wondering why I use all these drives when I could just use a RAID (redundant array of independant disks) system – back-up drives storing the same data to preserve it if one fails. However, the trouble with the sort of RAID that is affordable for most of us is that, when configured to the generally recommended Level 5, if more than one disk in the array fails, you've had it. In that respect, it's no smarter than a simple arrangement of a pair of desktop drives with the same content on each; if one goes, you can use the other to rebuild it. If both

Girl on the beach, Scotland.
For Mac users, Time Machine provides easy, automated back-up.
Nikon D3, 27mm, ISO 500, 1/250 sec at f/14

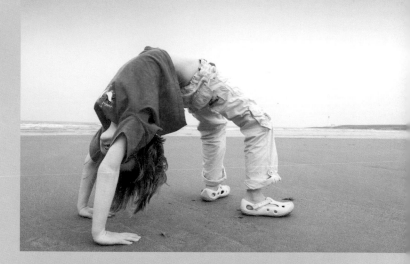

BITS AND PIECES
Most hard drives have lots of moving parts, hence their propensity to fail. Solid states drives don't, they are generally safer, but more expensive.

Birch and pine wood in spring, Estonia.
Spread the risk of data loss by using
different methods, different storage
media and different storage locations.
Nikon D3, 80–200mm, ISO 200, 1/8 sec at f/14

go, then you need another option, some of which we'll look at later. At the time of writing, newer technologies, such as the Drobo, are evolving and continue to have mixed reviews.

USER ERROR

Sometimes what appears to be a catastrophic disk failure might not be. This happens to me quite often. I am accessing an image file on one of the daisy-chained desktop drives when Photoshop crashes. Later in the day I go to shut the computer down, but that drive is still whirring away and just won't let go of the file. A whole lot of chilling scenarios unfolds in my mind and I unwisely pull out cables and disks that no longer appear on the desktop even when reconnected.

In the majority of cases, this can be remedied by shutting the computer down, disconnecting the drives and, after re-booting, reconnecting them one at a time. It's wise to run a disk-repair application after these traumas just to make sure that the data is intact. It's also a good idea to place some red insulating tape around cables to remind you not to disconnect them without checking first. If you pull out a cable responsible for data transfer, such as the ones that connect card readers and external drives to the computer, you will have lots of problems, especially if data is being transferred at the time. If a drive doesn't show on your desktop, don't just assume that it has failed. Plug in a new one and you'll be back up and running in no time.

MANAGING BACK-UP DRIVES

In addition to dumping folders manually onto external drives, (or using copying software to verify them), you should also run back-up software for your computer daily. This builds up a dataset of everything on the hard drive the first time you run it, then on subsequent back-ups it identifies additional or modified files and adds these to the catalogue. Should your computer's own drive fail, it is then possible to restore its entire contents up until the last back-up onto a new drive. It does no harm to try restoring this data every so often onto a spare desktop drive to confirm that it is accessible. Also, when a computer retires, you can have its contents readily accessible from that drive, restored from the last back-up set you made.

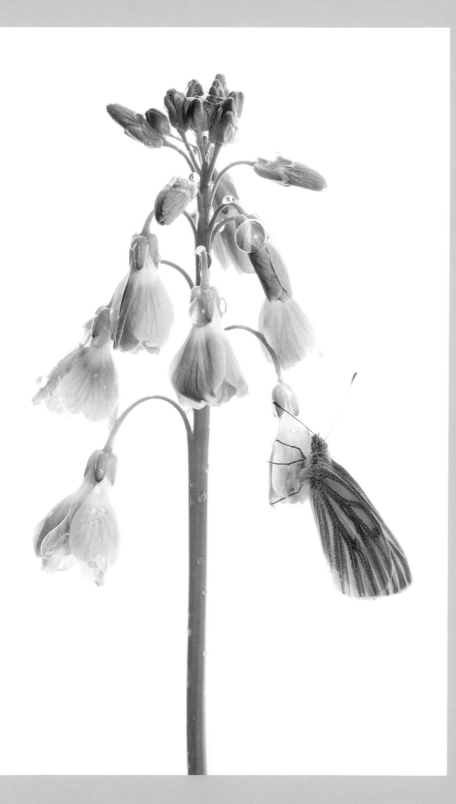

COMPETITION

In time, it's likely that using new technologies will render data loss a thing of the past. Arguably, we need data security more than faster speeds right now. Flash drives, such as memory sticks and cards, lack the moving parts of traditional hard disks so are not liable to mechanical failure. Yet they are far from perfect and a number of succesors to Flash are vying for position. This technology, which was originally developed in 1980, is limited by the fact that it can't store information at very high densities. Its replacement will have to address this shortcoming while also delivering fast performance and, of course, a high degree of stability. One of the front runners at the moment, Racetrack memory from IBM, remains at an early stage of development, but offers the possibility of massive memory capacity in a tiny, stable unit. Just make sure that when a new storage standard becomes available you transfer your data to the new devices while machines to read it are still available.

Cuckoo flower and green-veined white in the field studio, Norway.
Normal computer disks are fragile objects and are best moved as little as possible. Portable, rugged drives are much more robust and are perfect on the road as they need no additional power supply.
Nikon DX2, 200mm, ISO 100, flash at f/18

AVOIDING CHAOS WITH **KEYWORDS**

My office is a bit like a police state. Any picture without a filename or keywords is a 'non-picture'. It can disappear with no-one being any the wiser or languish unnoticed in some long-forgotten folder on a rarely visited drive for years. Keywords and proper filenames are the papers that bestow citizenship and allow participation in the community of images and which allow me to trace and control them.

WHY YOU NEED THEM

On past expeditions, I would spend the evenings talking to friends or reading. Now I write keywords because I know that, by adding these to the file's metadata (the extra information stored in the image file), I will always, with consummate ease and speed, be able to find any picture I need, simply by typing any of these words into my computer's search facility. So long as the file is on the computer or a connected drive, it will be displayed and I can retrieve it. I don't need to maintain separate folders for different shoots or subjects: the finished, sequentially numbered files can all be kept in one big folder, each image traceable by its keywords. This has large benefits when we come to archive pictures. Without doubt, preparing keywords is a drag and requires discipline, yet I never allow myself to export processed RAW files until I've written the keywords. Unless you are selling your work through a picture library, just use as many keywords as you need to find a photo. My own method is unusual, perhaps even a little clunky, but it works rather well. Here is an outline of what I do and why.

Ragged robin and cow parsley, Estonia.
With keywords it's a matter of the more, the better, so long as they are relevant and what you record is consistent.
Hasselblad XPan, 45mm with centre-spot filter, Velvia 50, 1/4 sec at f/11

WHEN AND HOW

Rather than write the keywords in Lightroom, I maintain a separate text-only database containing the keyword sets for many thousands of pictures. Each database record is comprised of 32 fields, which I populate with relevant data. When I devised this database originally, I planned these fields to allow me to describe any picture I might ever take and, so far, I haven't felt the need to add any more. Sometimes I need only 20 fields, sometimes most of them.

The good thing about working with a pre-defined list of topics is that it builds consistency across all your keywording: you don't end up with some sets in which you record the season, month and year, and others where you mention only the year. This makes searching within your own system more effective. Also, if you decide to market your work online, proper use of keywording ensures that your pictures are easier to find.

DATABASE

The advantage of using a text-only database is that it is incredibly quick to search through and to access legacy keyword sets. If, for example, I photograph a red squirrel today, I can search within certain parameters to bring up keyword sets for similar pictures I've shot in the past and re-use these with minor changes — such as the year and file name. If I have shot a whole series of more or less identical pictures, I need only to duplicate the first record, changing the file name each

time. There are currently more than 9,000 different words in my database — a lexicon impossible to manage with drop-down menus in RAW processors. It is possible to copy and paste keyword sets from my database into the appropriate fields in Lightroom, then synchronize this data between different pictures. Yet I find it much more convenient to open the exported image in Photoshop, then copy and paste the dataset straight into the file information. This data is then embedded and present in all future incarnations of the file as it is converted for projection, the web or print. If you go down the parametric image-editing route (the original image and any changes saved in the file) you will have to embed your keywords in the Lightroom catalogue.

DRAWING A LINE

You may feel this level of keywording is excessive, certainly more than you need. Well, figure out which descriptions will let you find a particular shot. If you decide to use the RAW converter to add keywords, I would still urge you to create your sets with reference to a standardized set of topics, so that some pictures don't end up being more poorly described than others. On commissioned shoots where I need to add keywords, but can't justify the investment of time that deep keywording needs, this method suffices and lets me deliver on time.

ANOTHER GOOD REASON

There is one more reason to work on keywording: it makes you examine and think hard about your pictures, especially when you write about a concept they may illustrate. This can be very useful when you come to put them before a larger audience. One final tip: if you plan to sell your photographs as prints, include a field in which you detail the predominant colours in the picture. Many people choose a photograph, not on its artistic merit of narrative content, but because it goes with the colour of their front room. Make the job easier for the client!

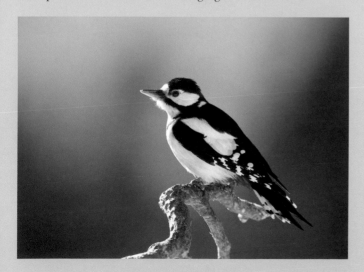

Great spotted woodpecker, near Posio, Finland.
Keywords include: Niall Benvie; Great spotted woodpecker; Scots pine; Finland; Posio; winter; black white; red blue; woodland; February; wild.
Nikon D3, 700mm, ISO 800, 1/800 sec at f/5.6

MONITOR **CALIBRATION**

If you are new to digital imaging, you may well have had some sage beseeching you to calibrate your monitor while you wonder whether it really matters that much. Perhaps you thought you would leave it until you were more confident. Sorry, but I'm going to say the same thing: calibrate it now! It's absolutely basic and will make you a happier photographer for several reasons.

WHY YOU'VE GOT TO DO THIS

The whole point of calibrating and profiling your computer monitor is so that it is standardized: when another person with a calibrated monitor looks at your image on their screen it will appear the same as it does on yours. For example, if you are making your own prints, remember that the people who make the profiles for the printer, paper and ink combinations do so on standardized equipment. If you want to print with profiles (generally the most consistent way), the print and screen image may be miles apart if the screen is not calibrated. Say your monitor has a marked green cast, when preparing the picture for printing you will add magenta so that it looks neutral, or natural. However, it is not a neutral picture that comes out of the printer, but one with a magenta cast. You don't *need* to print with profiles and you can spend hours making manual adjustments in the printer driver until the print is just right. Don't make life difficult for yourself when all you need to do is calibrate the display.

GAMMA

You may have heard something about PC monitors having a gamma (also represented as a tonal response curve) of 2.2 and Macs having a gamma of 1.8. Don't fret about this, whatever gamma is set by the monitor-profiling software, Lightroom and Photoshop will display the image at the right level of brightness. The other standard used by some high-end graphics displays, such as the NEC Spectraviews, is L*. This tonal response curve is more appropriate for LCD displays and, put simply, combines the best of both traditional gammas.

HOW TO CALIBRATE YOUR MONITOR

The process is simple. Stick a colorimeter to the display. As the calibration software runs, the colorimeter — the essential piece of equipment used to analyze the colours that the display generates — compares the colours it is reading from the screen with their known values. This generates a profile specific to that monitor reflecting the deviation. This profile is normally loaded automatically once the process is complete, although it's a good idea to identify where display profiles are stored and check regularly that the most recent is active. On a Mac this is in System Preferences>Displays>Color. On a PC it is in the Color folder within Drivers. LCD displays need calibrating much less often than the old CRT (cathode-ray tube) ones did, but it is still a good idea to do it every couple of months.

LAPTOPS AND PROPER DISPLAYS

It is increasingly common for photographers to abandon large computer towers in favour of increasingly powerful laptops and to use these connected to large LCD displays. If the graphics card of your laptop can manage, go for it. I use a 26in screen with a 17in laptop. It is really useful to have an 'extended desktop' where Photoshop palettes can be spread over two screens. Don't be tempted to do serious image editing on a laptop screen, even if it has been calibrated. The newer generation of LED laptop screens may improve their colour performance, but right now the majority simply don't have the gamut or dynamic range to allow critical colour or contrast assessments to be made.

Moricsala Island, Latvia.
Screens typically display a wider gamut of
colours than can be printed, but less than the
Adobe RGB or ProPhoto colour-editing spaces.
**Hasselblad XPan, 45mm with centre-spot ND
filter, Velvia 50, 1/2 sec at f/11**

WHAT TO BUY

In much the same way as putting
a cheap lens on an expensive body
is a false economy, so, too, is
connecting a powerful computer
to a budget monitor. Cheaper
monitors can't always be calibrated
satisfactorily and are unlikely to
show your pictures at their best.
Expect to pay more for your monitor
than you did for your desktop
computer. Don't skimp on the
calibration device either. You'll
save money if you buy one only for
calibrating the display (rather than
profiling projectors and printers
too), so buy a good one, such as the
EyeOne Display2 or the Spyder Pro.

USEFUL TERMS

COLORIMETER
The device applied to a computer
monitor to calibrate it for correct
colour and luminance.

GAMMA
A value which describes the response
of a computer monitor to the digital
input in terms of its luminance and
tonal range.

GAMUT
The total range of visible colours
and shades available on a particular
monitor or printer.

PROFILES
Sets of data which describe the colour
and luminance rendering of a monitor
or printer. Used to achieve consistent
results across output devices.

PRINTER DRIVER
The program that controls printer
performance, allowing colour to be
adjusted on the computer.

TONAL RESPONSE CURVE
A graphical representation of input
against output in an image. The Curves
menu allows manipulation of the curve
to adjust the contrast and brightness.

IMPORT, **NAME**, EDIT

At last, after all that preparation, we're finally ready to take a close look at what we have shot. So, lower the lights, boot up your computer and give the display several minutes to warm up and reach its full brightness. This is so much better than squinting at transparencies through a loupe.

You can wire the camera to the computer so that it acts like a mass storage device, although you'll find that the files transfer quicker if you use a card reader. Before removing the card, ensure that there are no files transferring to it from the camera's buffer – a warning light will flash on the camera if there are. If you pull out the card now, you are likely to corrupt the files. The same happens if you disconnect a card reader while it is exporting files. Placing red tape around the cable will make you think twice about doing this.

PREPARATION FOR IMPORT

Before you export the files, there are a few things you need to pay attention to now, so that everything runs smoothly later. First and foremost, it is vital that a) each imported file is assigned a unique name, and b) they are all going to the same destination for ease of editing. Before you do anything else, create a folder called something self-explanatory, such as 'RAW files to edit' (or if I still haven't persuaded you, 'JPEGs to edit'). This is where you will place the files when asked where to deposit them on import. I'd recommend that you create a new subfolder for each import for ease further down the line. Remember, these files don't yet have any keywords embedded, so you can't put them into one big folder (although if you use Lightroom to transfer your files, you have that option). I have opened the Preferences of my transfer application to specify where I want the files to go. It automatically progresses to the next number each time I import, unless I have downloaded files to another computer in between times.

Nikon transfer preferences.

Lightroom import options.

RAW file destination.

FILE NAMING

Here is where you have the opportunity to rename the many camera-generated file names (which may be prone to repetition) with your own choices (see far left). I prefer my camera manufacturer's own simple application, rather than Lightroom's more complex import options, in which I would have to remember to reset the start number each time I import. Crucially, here, the 'Reset to 1…' box must remain unchecked or you'll be back at square one. Since I know that I won't live long enough to create and then edit more than a million new RAW files, six digits will be enough. The drawback with naming at this stage is that since you haven't edited the files yet, there will be lots of spaces in the numerical sequence as you delete files that don't make the grade. I can live with that; but if you can't, then you will need to name on export from Lightroom under File Naming.

IMPORT

Lightroom, of course, gives many more, often very useful import options (see top left). For example, under File Handling, we can convert RAW files to DNGs and also apply a whole range of metadata, including copyright information and embedded keywords to all the images in that import. This is why it is a good idea to keep separate cards to use on different days or shoots, so that if you want to apply keywords at this early stage then the keyword set is relevant to all the images that you are importing. You will have another chance to do this later on in the Edit module. For those of us who are always on the lookout for a chance to back up work, you can do that on import, too.

Whichever application you use to bring the files onto your hard drive, you should now have them in a place where they can easily be found, ready for import by the editing application and the RAW converter (see bottom left).

Lightroom has some really useful editing tools and since its image catalogue is comprised of JPEGs (you choose the size) of the RAW files rather than the files themselves, it is pretty quick to scoot through a selection (if you have asked the application to make 1:1 previews on import) once you've given the previews time to generate.

On importing a folder of RAW files, you have several options concerning what happens to the pictures (leave them where they are) and, once again, what, if any, metadata you want to embed at this stage. As I said earlier, if I am doing a commission that demands only light keywording, this is the time that I would do it. Otherwise, I stick to my more comprehensive method (see top right).

EDITING YOUR PICTURES

Lightroom offers different ways to edit your pictures and to rank them. I've never really seen the point of doing this: if a picture is worth keeping, keep it, process and archive it. If not, place it straight in the trash, rather than hoping it will grow on you. Less-experienced photographers may want to be a bit more circumspect at this stage in regards to what they throw out and use a star rating to indicate their keepers. An old-timer like me, on the other hand, has taken so many bad pictures over the years that I'm pretty good at spotting one right away.

ROUND ONE

Initially, I do a 'first impressions' edit in the grid view of the Library module to identify complete non-starters on account of their composition or other considerations that don't call for a histogram analysis or sharpness check (see centre right). I click on the picture and hit the X key to flag it as rejected, then when I've finished, I select them all and delete them. Alternatively, I can press P to pick out the ones I want to keep. This is much more efficient than clicking through one picture at a time and deleting them individually at this stage. When you go to delete an image (or a set of them) Lightroom asks if you want it removed only from the Lightroom catalogue or from the computer altogether (see bottom right).

Remember that you have at least two more copies of these RAW files on other disks. So, be a devil and get Lightroom to lift the rejected RAW file out of its original folder and send it straight to the trash. There is no point in clogging up several disks with RAW files that will never be processed. If it doesn't make the edit, bin it now. If you think better of this later, the file can still be retrieved, until you overwrite its folder with the new, slimmer one (see page 57).

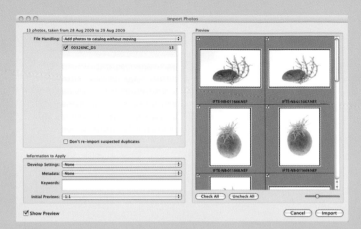

Importing into the Lightroom catalogue.

Photos flagged for rejection.

Lightroom delete options.

Compare view – C.

Zoom in to 100%.

ROUND TWO
Now, a more detailed examination of the remaining pictures can begin (see above, top). Lightroom allows you to view two pictures side by side – Y, then zoom in to 100% – Z to assess their sharpness (see above, bottom). It's really quick and reveals shortcomings not always evident when you examine the pictures individually. Keep an eye on the histogram top right, too, as it can forewarn of problems with tone or brightness, for instance, which you might have later when you process the file. The same system of flagging then deleting can be used or you can delete the files one at a time.

TRANSFERRING CATALOGUES
I've made the assumption that you will use the same computer you import the photographs onto to process them – in my case the laptop I take with me on shoots. This makes life simpler and means that you need only one catalogue. Yet many people, while enjoying the convenience of a laptop, prefer to have their main computer safely at home. Therefore, while the editing and keywording may have been done in the field, the processing itself takes place on another machine.

Let's assume that you already have your main catalogue on your main computer and that you are looking to incorporate pictures you've put in a separate Lightroom catalogue on the laptop. When you make an Export as Catalog command, specify an external drive onto which the catalogue will be temporarily stored for the transfer and, crucially, make sure that you check the Export Negative Files box. This means that the RAW file will also be imported.

If you don't, your catalogue will be exported but when, after importing that catalogue from the external drive, you go to Develop, a warning will appear indicating that the file is offline or missing because the files are still on the other computer. Even if you have put the RAW (i.e. negative) files on the main computer already, the same dialogue will appear since the updated catalogue doesn't know where they are.

Similarly, if you move files from the place Lightroom originally sourced them – perhaps onto external drives when you have finished processing them – Lightroom will tell you that the file is missing. To access it again, you need to re-import it from its new location.

BACK-UPS
Lightroom can be configured automatically to back-up the catalogue. This is important if you go down the parametric image-editing route since you rely on its integrity to be able to export finished images as and when they are needed, by returning to the RAW file with edit settings. If, however, your workflow entails the export of finished TIFF files (the format preferred by publishers), after which you rarely revisit the images in Lightroom, then you may decide to skip the option to back-up the catalogue every time you launch the application.

WORKFLOW

One of the reasons I took so long to switch to digital was my determination to have a comprehensive workflow figured out before I made the first capture, so I didn't end up with the digital equivalent of shoe boxes full of loose slides. I was also aware of the need to look after the data carefully and to back it up regularly. I'd watched less timid and more prolific colleagues wrestle with the octopus of their new productivity and flounder. It soon became apparent that there was no one 'correct' workflow, only ones that work and those that don't.

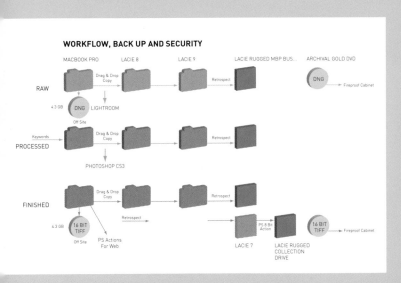

WORKFLOW, BACK UP AND SECURITY

Your workflow is likely to be very different from that of a press photographer, but you still need to produce an image collection that is secure, easy to search through, and easy to archive. Here is the workflow that I've used from the start; let's see how it works (see left).

RAW FILES

This three-tier system all stays in one folder on the hard drive, helpfully named Digital Imaging. Within it we have already seen the RAW subfolder where imported RAW files await processing. On import, I copy these complete, unedited folders onto two identical 1.5 terabyte desktop drives, replacing them with the slimmer selection post-editing in Lightroom.

Each day, more if I am doing intensive image work, I run the back-up software to update the record of the computer's hard-drive contents. With each sequentially numbered import, the size of the RAW subfolder grows. Once I have accumulated around 4Gb of new RAW files, these are converted to DNGs and burned onto two gold-coated DVDs for archiving. One remains in my office in a fireproof filing cabinet, stored in inert polyester sleeves, while a copy is retained in another building. The DNG files remain on the pair of hard drives and are transferred up to a new pair of larger drives when these are full.

It's worth remembering that although I don't embed keywords in RAW files or DNGs, since the filename (excluding the suffix) is the same as that for the finished files, if I need to

Running huskies, Tartu, Estonia.
A good workflow should be smooth, efficient
and able to take advantage of new developments.
Nkon D3, 24–70mm, ISO 200, 1/15 sec at f/20

Canoeists, Loch Tay, Scotland.
Coordinate the different stages of your
workflow to achieve the best results.
Nikon D3, 200mm, ISO 1000, 1/200 sec at f/7.1

trace a RAW file I can still search for it by proxy of the finished one. Assuming that the DNG files in these subfolders have now all been processed, that 'stack' of folders can be deleted from the hard drive, residing as they do on two permanent DVDs — and possibly two permanent (hard drives) — locations. If there were not enough folders to fill another disc, the surplus forms the bottom on the new stack.

ORGANIZING PROCESSED IMAGES

Mac users also have the option to colour-tag files and folders. This facility comes into its own once the RAWs are processed in Lightroom and exported as 16-bit RGB TIFFS to the Converted Files for Finishing subfolder. When they first come in, these are files that have been processed but lack keywords and any finishing in Photoshop that might be necessary — such as more extensive cloning than is practical in Lightroom. These are marked in red to distinguish them from files that have been opened, keyworded and finished in Photoshop. The work on these finished files, now coloured purple, is to all intents and purposes over, and they can be converted into previews for users. At both these stages, rough and refined, all the files are copied to the pair of desktop drives. The refined files replace the rough as I work through them. And of course, at each stage along the way, the computer's drive is being backed up. As you delete files, don't forget to empty the trash to free up space on the hard disks.

ARCHIVING FINISHED FILES

The final 'finished' stage takes place in the same Converted Files for Finishing subfolder; here I take one last look at an image before it is archived. If you return to a picture a few weeks after processing, you will see straight away if the colour is dodgy or if you were kidding yourself that it was ever worth keeping. Once again the image is opened in Photoshop, any adjustments are made, then the filename is coloured green. It joins the queue of other finished files in the stack waiting to be archived onto pairs of DVDs and copied to *three* desktop drives, one of which is connected to a second computer in the office. Another, 8-bit, version (made by running a Photoshop Action) is copied to a portable hard drive that allows me to carry my ever-increasing image collection wherever I go.

You should now be able to see the advantage of using the one folder system for finished files. With them all in one place and colour coded, I can see their status straight away, as well as how many there are to be archived. Once that is done, I can free up some computer disk space by deleting them. If your pictures are scattered around in a variety of folders, it's a much more complex job to keep track of the status of everything. Keywords, as we have already discussed in the previous chapter, make this system possible by removing the logic for having separate folders for different subjects or for different shoots.

ADAPT AND EXPLOIT

Tailor the workflow to suit your own needs; you may feel more confident than I do about data security and therefore cut out some of the back-ups. You may come to believe (as I do with each new release of Lightroom) that routine Photoshop work is unnecessary and that you can embed keywords at the processing stage. Perhaps one archival DVD is enough or you ask yourself whether you are really likely ever to revisit your old RAW files.

Whatever you decide, keep your eye on what's around the corner. For example, you may choose not to do so much dragging and dropping of files or backing up, so that the workflow is smoother. Auto-transfer of keywords from my text database would be really handy. A foolproof large-capacity data-storage system would save a lot of time and anxiety.

Does this all seem like too much work? Are you regretting going digital? Well, it's actually less work than processing, scanning, cleaning and keywording transparencies — something you'd have to do if you want an audience bigger than one. With a sound workflow in place and the discipline to follow it, many more of your pictures will have a chance of being seen by the world, unlike those boxes of unscanned slides or drives full of unprocessed RAW files.

PARAMETRIC IMAGE EDITING

The workflow I have described here does work; I have a very small backlog of unprocessed RAW files to prove it. However, it is informed by a film mentality in which the object was to amass a systematically ordered collection of finished pictures ready to be sent out at a moment's notice. Today, instead of filling filing cabinets with images (the vast majority of which were inactive most of the time) we do it in digital form with hard drives.

A BETTER ALTERNATIVE?

If you are a very prolific photographer and/or don't have a reason to distribute all your work as you shoot it (which a stock photographer tends to) the parametric model may be for you. Yet, before you get your hopes up, there is no getting away from keywording; that remains the vital tool for accessing particular pictures in your collection.

Here's an analogy; if you were a car manufacturer, you would be crazy to fill up your yard with all the variations on all vehicle models. Instead, you would take orders and, working from the basic unsprayed version, add colour and refinements on demand. Parametric image editing works on the same supply-on-demand principle. The RAW files are edited and processed as usual, but the files are rendered (changes applied to a copy of the original RAW file) and exported only when needed. Apart from the original RAW files, your RAW processor's catalogue or library of images, containing all the edit data, becomes your most important asset, not the exported TIFF files.

If you need a web-resolution version of that picture, rather than running a 16-bit file through a Photoshop Action, return to the RAW processor and export it again with different settings.

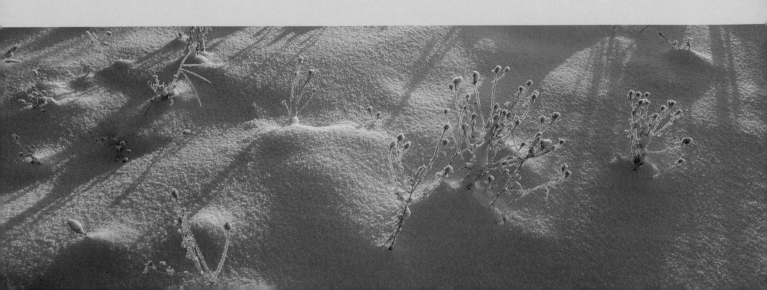

(*Above*) **Panel of broadleaved docks in the field studio, Scotland.**
There are many variations on the basic workflow I outline here. Adapt this one to suit your needs.
Nikon D3, 200mm, ISO 200, flash from below opaque Perspex, various apertures

(*Left*) **Frozen knapweed, Alam Pedja, Estonia.**
Make sure that your workflow can accommodate pictures from the back catalogue, such as this scanned panorama.
Hasselblad Xpan, 45mm with centre-spot ND filter, Velvia 50, 1/15 sec f/16

You can produce as many alternative versions of a picture as you like without ever degrading the pixel information of the original file, since you return to the source RAW file each time.

SECURITY ADVANTAGES

There are other advantages of this system. My current Lightroom catalogue of about 1,300 pictures, containing all the previews and editing metadata, is only about 62Mb. When it comes to back-up, that is a wonderfully small amount of data to protect compared to the gigabytes that are generated when I export 16-bit TIFFS (DNGs have to be stored and backed up whichever workflow is used). In that way, you can say goodbye to some of those temperamental desktop drives and hello to safer, smaller, solid state devices, such as high-capacity Flash sticks.

THE BIG DOWNSIDE FOR SOME

Nevertheless, you can't always do everything you need to do to a picture in the RAW converter. You'll also need a system for handling and storing stitched-together panoramas, multiple-layer images and ones that demand more extensive retouching than is feasible in the converter. You could still import these additional types of file into your catalogue when completed, so that they too can be subject to parametric editing. More practically, if you are a stock photographer who has to have regular and immediate access to finished files, exporting on demand every time is an extra step you may not welcome, even if all the image editing has been done already.

It seems likely, though, that as multiple terabyte drives fill with finished pictures, more and more photographers will look to this model to solve their image-management problems.

CRACK THE CODE
If your computer allows you to colour-code files, this will make it easier to track what stage they are at.

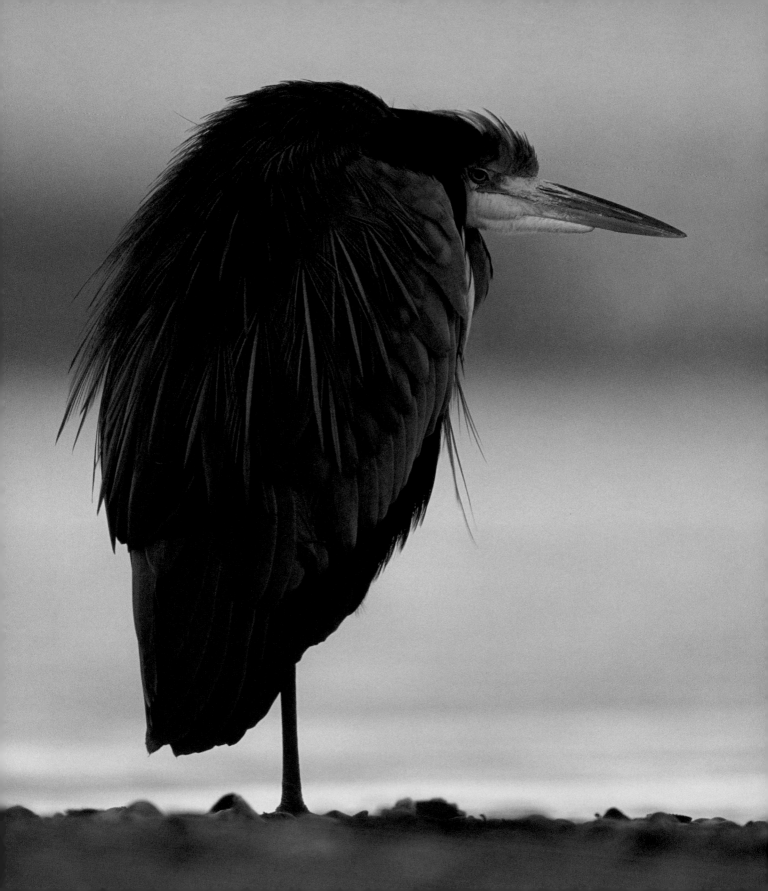

SLOW IS **GOOD**

I can hardly believe I am saying this, but, if you aren't careful, digital photography will come between you and your subject. Stay with me while I justify this; it is important to understand this if you want to continue to grow as a nature photographer.

PRODUCTIVITY

In the old days of film we had only one chance to get the picture right, since there would be up to two weeks between exposure and review. Now we need to be patient for only, well, two seconds. As you will be discovering, instant feedback accelerates the learning process, especially for new photographers and makes my job easier, too.

Apart from its obvious convenience and the instant gratification, there is another aspect of digital imaging that strikes a chord in cultures in which the work ethic is enmeshed in national identity. Shooting digitally means that you can always be productive and busy. Quite honestly, there is never any down time. If you aren't editing and keywording, you are processing or finishing, archiving or preparing digital files for 100 new uses. Evenings of relaxation, reflection and conversation – of doing something other than photography – become a luxury. So, if you are of an unsociable disposition, you now have the perfect excuse to be on your own; you're working. Yet it is from the rest of life, more particularly absorption in the natural world, that inspiration and ideas flow, not the computer screen.

Grey heron, Scotland.
It is impossible to know if birds feel boredom, but even if they don't, this one is giving a good impression of it. Saving heat is a more likely reason for its attitude.
Nikon F5, 500mm, ISO 200, 1/15 sec at f/4

INSTANT RESULTS

Digital capture harmonizes perfectly with our times. We itch for the LCD review as impatiently as we itch for the next SMS or e-mail (I'm as guilty as the next man). Snap judgments about what is worth keeping and what can be deleted favour the obvious over the subtle, images with instant rather than enduring appeal. I like to think I can spot a duff picture as soon as I take one, but pictures can 'grow on you'; with time, they may begin to make sense. Digital capture doesn't exactly foster reflection and contemplation, and, if we aren't careful, it can make fools of us all.

None of this would matter a megapixel if it didn't extend into the way we relate to our subjects and connect with wild nature, but it does, profoundly, and not always for the good. The culture of immediacy that goes with mobile phones, online shopping, digital capture, even fast food, is profoundly out of step with natural rhythms. We may be living faster, more dense lives, but natural processes continue at the same pace as they have always done, much slower than the pace of our lives.

IN PRACTICE

Here is an example of what can happen. Bird photography at the nest is now deeply unfashionable; its detractors argue that it has all been done before. Yet this is an absolutely central part of the subject's story and offers the photographer an opportunity to witness moments of drama and tenderness, comedy and pathos. As a genre, it has no more 'all been done before' than, say, Arctic wildlife or the Scottish landscape. Yet doing nest photography properly, which results in the fledging of a healthy brood, as well as pictures offering a new

insight, requires a huge investment of time: time finding the ideal nest, reading the adults' reaction as a hide is introduced, and putting in the dawn-to-dusk hours for days on end to watch the family in action. It is time that few of us, least of all working nature photographers, can spare and, anyway, what's the attraction when faster photo-opportunities are on offer instead? Sitting there all day for a handful of frames just isn't productive enough. Yet without this coverage, the account of a species remains incomplete.

The more we buy into the 'Now!' culture, where patience and restraint are viewed as weakness and indecision rather than virtue, the harder it is to fall into step with natural time. If you want to find out how this feels, go wild camping for a couple of days without your mobile phone or your laptop, or even just sit in a hide at a bait site for several hours. Experience how long it takes to get warm after the sun rises; watch how slowly the shadows from a branch move across a tree trunk; sit and wonder if the eagle's last visit to the bait an hour ago was the last one of the day or even the week. Above all resist the temptation to flick through whatever captures are already in the camera. You may be feeling unproductive, but you will begin to get a sense of natural time. Generally, it's slow – achingly slow in the absence of the distractions provided by what writer Robert Michael Pyle characterizes as 'the cheap tricks of modern life'.

ADVANTAGES

This is where seeing begins – there is little else to do, after all, except for studying what's around you. Let boredom kick-start creativity. A wildlife painter I know once told me that during workshops he noticed that many of his students have difficulty in seeing their subjects fully, in noticing things that can't be taken in merely by looking at them. This is hardly surprising when moving imagery – that most similar to how we witness the world – is fed to us as sight-bites by media controllers afraid that our infantilized senses will become bored if we are made to look at the same thing for more than a few seconds. Once, while working on a beach on the Outer Hebrides with the *avant garde* Norwegian photographer, Pål Hermansen, I became intrigued as he set about making a 30-minute video

of the chaotic flows of water over a thin layer of black sand and the patterns revealed in the pale sand beneath. What, on my part, began as an exercise in curiosity, then boredom, soon transformed into one of fascination and speculation. This was natural time in motion.

REDIRECTING OUR FOCUS

At the heart of this plea for caution is the simple fact that digital imaging inexorably leads to more time in communion with a computer than with our subjects, unless you resist it. There are also more practical considerations. It is all too easy to break concentration to review the last capture, then to miss a shot. When you see what you had in mind on the LCD, do you feel just as motivated to keep shooting as before? When we shot film, wasteful though it was, uncertainty meant that we kept on shooting and shooting, in the process often making pictures we never dreamed of.

Is there anything to be done? After all, I'm the one urging you to write keywords and process RAW files and all the other palaver. Perhaps there is. It is radical and I don't quite have the courage to do it myself yet, but maybe there is a simple answer: shoot less.

When the whole world is shooting so much of the same, why not concentrate on producing a very few, difficult and utterly memorable images. No artist ever made his or her reputation on productivity alone. Before the end of this book, I hope to sow a few ideas in your mind from which your own unique images may spring.

LICENCE
Nest photography often requires a licence and should not be attempted without permission.

European crane, Hula Valley, Israel.
Over nine hours, there was ample time to slow my mind down and to tune in to the acoustic repertoire of the cranes.
Nikon F6, 500mm, ISO 100, 1/125 sec at f/5.6

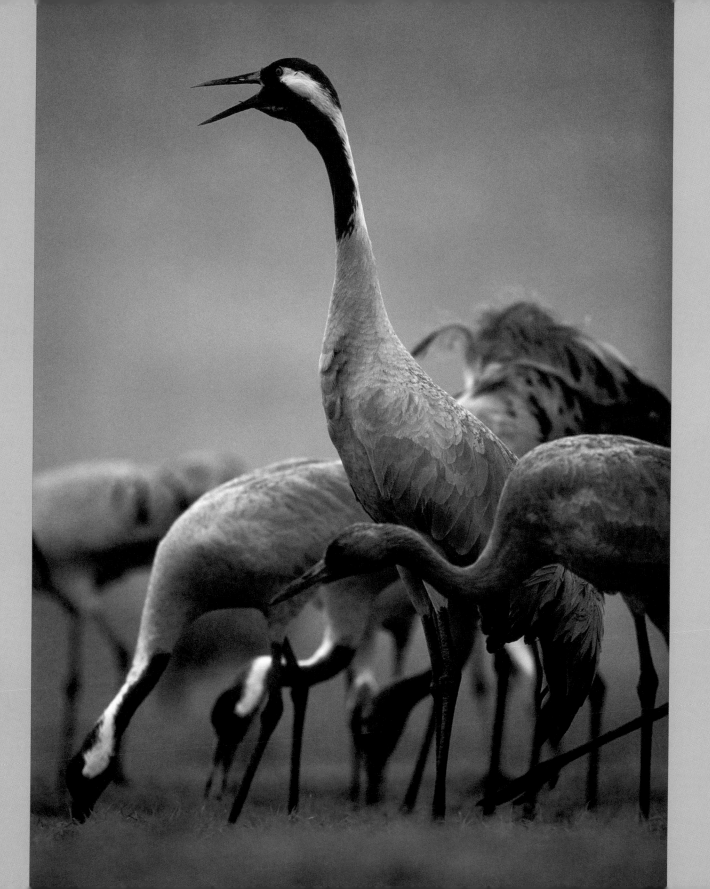

IMAGES FROM **THE EDGE**

Ever since I started to write about the concept of 'the edge' in outdoor photography almost 20 years ago, I've tested and re-tested the core idea – that we are drawn instinctively to 'the edge' time and time again. It has stood up to examination with one caveat: while the concept helps to define successful expressive photographs, it is less useful when it comes to defining what makes a great narrative picture.

DEFINITION

I originally hit on the idea of edges while trying to figure out why some pictures cause a limbic spark while others leave us cold. What, for example, makes Jim Brandenburg's picture of an arctic wolf jumping between ice floes an icon – an image whose appeal extends beyond the ranks of nature photographers? Well, let's analyze it. This is an animal on the edge; it's living in the Arctic wilderness of northern Ellesmere Island where there is no sign of any cultural influence on the landscape. The ice floe is neither land nor water, but something in transition from one to the other. The viewer begins to wonder why the animal is in this apparently dangerous situation. Even the lighting is ambiguous, suggesting a zone between day and night. This photograph exemplifies why the edge is such a powerful underlying theme in many of the most compelling images of the natural world.

The edge, defined, is a zone of transition in time, space or being. Put more simply, it's where change occurs and contrasts arise. Our visual system is set up to respond to these stimuli; present it with a static scene and it switches off after a while. If 'zones of transition' sounds a bit vague to you, try considering the topics we shoot over and over again; dawn and dusk (the edges of the day); autumn and spring (the transition between seasons); seascapes and silhouettes (the edge between land and sea and between land and sky); baby mammals and the old males (representing the edges of life); animals living in extreme environments, such as penguins and marine iguanas, (places where the gap between life and death seems narrow). These are all images from the edge, far away from the usual, familiar or mundane. They are pictures about 'the most' and most of us find them irresistible.

CONFLICT

There are two conflicting forces at work here. On the one hand, innate curiosity leads us to explore our own limits. This is perhaps why we gravitate towards the edge of the sea (especially exciting in a storm), rather than drift along the foot of the dunes; why we need to peer over the edge of a cliff or reach the summit of a mountain; these are edges in space. At the same time, it is drummed into us from childhood to keep back from the edge as it's dangerous. We learn to be responsible and to choose the safe option. Sometimes our wild side rebels, urging us to 'live dangerously', perhaps informed by the deeper understanding that there is no second chance – that we have only one life. In creative terms, this translates into the need to experience nature at its most extreme and to validate that experience by producing a photograph of it.

Salt marshes near Cadiz, Spain.
As we flew over these salt marshes, I kept my mind focused on 'the most' – in this case, the most convoluted drainage channels I could frame.
Nikon D3, 80–200mm, ISO 800, 1/1600 sec at f/4.5

The edge is also where the struggle between wildness and culture, anarchy and control is fought. In much of the West, there is a creeping trend to infantilize our relationship with wild nature, to protect us from it, to make it safe and palatable. The need to take responsibility for our actions therefore diminishes and with it our appreciation of the power of nature unmeditated by man. To that end, we are often prevented access to the edge – to visit places after dusk or to go to the cliff edge.

PUTTING IT IN CONTEXT

Is this really something to concern outdoor photographers? Well, it depends on how happy you are with second-best, whether you'll settle for the dunes or if you want to walk through the surf. If you are driven by a powerful urge to create, being denied access to the edge matters; I doubt if any of us is content to produce work we know we could have done better.

Since the notion of the edge is so deeply embedded, pictures that dance to its tune appeal on a instinctive level and don't require much analysis or explanation. So where does that leave the narrative, complex image whose appeal is more to the intellect than the gut? If edge pictures celebrate the most extreme contrasts in the natural world, complexity is preoccupied with its connections. What is going on beyond the frame is every bit as important as what appears in the photograph itself.

A complex composition is often modest in its scale and less visually dramatic in content. The subject may not be immediately apparent and indeed several may vie for attention. Yet if successfully executed, complex compositions can have a more enduring interest. Nevertheless they need to be in a form readable to an uninformed, but interested viewer. By showing the viewer that courtesy, we hope that it will be returned in the form of him or her spending time reading the picture.

Marsh tit on moose antler, Alam Pedja, Estonia.
While this shot hints at edge-of-life themes, the marsh tit's chances of survival were considerably improved by the stash of fat to be found behind the antler.
Nikon F5, 420mm, Velvia rated at ISO 100, 1/250 sec at f/4

day 2

KEEPING **BUSY**

We're all eager to be out and about with our cameras, but what if the weather is against us? When we look outside it's wet and blustery with no prospect of the sky clearing until early afternoon. Are we going to stay in and process yesterday's photographs? Certainly not. There are loads of things we can shoot, many of which will come out better in such conditions, rather than in dry, pleasant weather.

A DIFFERENT PERSPECTIVE

The good thing about a day like this is that it encourages an introspective look at the landscape: we're drawn more to what's at our feet than the bigger view. Here's a technique that can be used to identify your subjects (unless, that is, you already have a story in your mind and you are just looking for the right vehicle to tell it). It's a normal human reaction to want to make sense of what's around us — to know if it is a threat or not — and that process starts off by looking at shapes and identifying objects.

Imagine you are standing by a sea loch in the west of Scotland, if I ask you what you see, you'll probably reply rocks, seaweed, clouds, distant mountains, possibly oystercatchers and gulls; rather than greys, several shades of brown, bright orange, red, pale blue and vivid green. If you can switch off the instinct to look at the landscape in the first instance as a series of connected objects and instead consider it as a palette of colours you'll be starting from a different place from other onlookers. Seek out the most eye-catching colour, then look for others nearby that complement it. Build the picture with colours, rather than shapes, as your main reference.

FILTERS

In this sort of environment, which includes lots of slick rock and seaweed reflecting the pallid sky, you'll almost certainly benefit from fitting a polarizer in order to reduce haze and to saturate colours. Since I made the change to digital capture, the polarizer is the only filter I need the majority of the time.

My graduated neutral density (ND) filters, once used to narrow the contrast between bright skies and dark foregrounds, are pressed into service only where there is extreme contrast or when I am shooting frames for a panorama and don't want to shoot each element twice (one optimized for the sky, one for the foreground). This job can be done much better using Layer Masks in Photoshop (see page 106) or even the Graduated Filter tools in Lightroom. However, you can't replicate the effect of a polarizer so, if you want to see those colours without a haze, have one to spin.

WORKING WITH THE SKY

One of the reasons we are looking at our feet rather than the bigger landscape is the sky: here, it is pale to the point of being white. While that may be fatal to a colour photograph, the blank space can make a black and white one more interesting. The sky is *so* important in a landscape picture since it sets the emotional tone of the whole piece. A shot with a dark sky full of looming stratus clouds has quite a different feel to one with fluffy cumulus ones floating in a deep blue sky.

A white sky is something else again. For one thing, it brings a strong sense of tranquillity to a monochrome image, especially if other elements in the photograph, such as water, re-enforce this impression. A white space is also ambiguous — neither comforting nor threatening — leaving space for the viewer to make up their own story based on what else they see in the frame. Consider shooting more scenes under these conditions. Dawn and dusk can be wonderful, yet we end up

STANDING OUT

If it is a gloomy day, try setting your TTL flash to –1 EV and set the camera to underexpose by one stop, letting in less light. In combination, the subject will stand out from its darker surroundings.

APRIL SHOWERS

If it is raining, try to find a dark background to show the subject better and shoot with a slow shutter speed of about 1/30 sec to produce streaks.

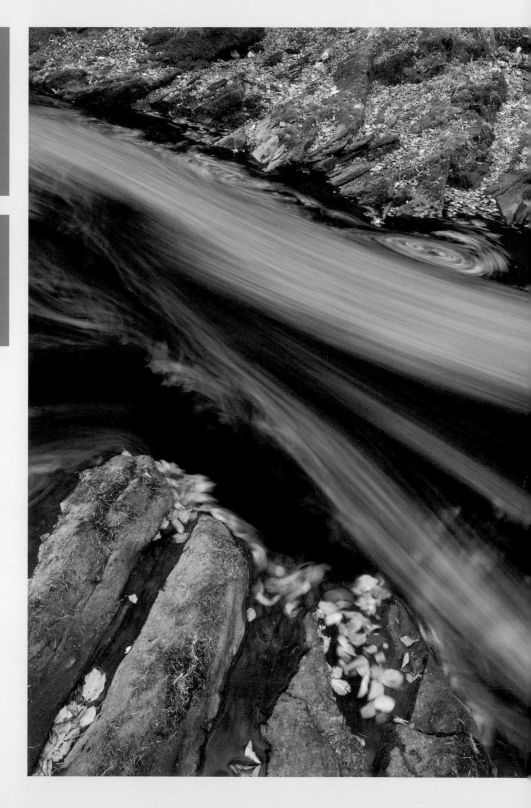

River North Esk, Angus, Scotland.
A storm shook the beech trees above these narrows so violently that they lost most of their leaves overnight into the river.
Nikon D2x, 17–35mm, ISO 125, 10 secs at f/13

with an emotionally one-dimensional view of the landscape if we only ever shoot in this dramatic light. There should also be space for the quiet and contemplative in your repertoire.

The shadowless lighting we get under these white skies is great for close-up work, but the lack of contrast can easily translate into flat photos. However, just because the sky is overcast it doesn't mean we can't find light and shade. In a wood, among some boulders or inside a cave you'll see a marked contrast between the gloomy interior and the relative brightness outside. Digital capture is much better at representing this contrast than slide film, recording more tones and brighter, more attractive images when clouds are low.

PROVIDING YOUR OWN LIGHT

While the wind is still up and there's an absence of animal life, we'll focus on lichens, seaweeds and other static subjects, perhaps contrasting them with moving vegetation or water. As soon as the wind drops, we'll get out the flash and softbox for pure drama.

If you believe, in the realm of nature photography, that daylight is king, think again. In the picture on the right, the clouds are beginning to break up slightly, but there remains a huge contrast between the sky and the clump of henbane we're about to photograph. We're going to use flash to help us out here, but not the little strobe on top of your camera. Battery-powered studio flashes are just beginning to catch on among nature photographers as they realize the beautiful lighting they can produce outdoors. With digital it is really easy and quick to reckon the exposure with these manual units.

BIG LIGHT

There is one simple rule of lighting, indoors or out: the bigger the light source relative to the subject, the softer the light and more mellow the shadows. There is little point in putting your TTL strobe into a big softbox to diffuse the light as it can light only a small part of the box, creating hard shadows. Compact studio heads, in contrast, have a bare bulb that throws light to every corner of the box, creating a big light source – just what we need here. If the breeze gets up we may need to use a hand-supported 3ft (1m) diffuser disc; otherwise it's the 4½ft (1.35m) softbox on a heavy stand with a 400 watts/sec flash head inside.

BALANCING DAYLIGHT AND FLASH

Exposure is simple. Start by determining the correct exposure (referring to the histogram) with the flash set at full power and the softbox as close to the subject as possible without it coming into frame. Select the camera's fastest flash sync. speed as your shutter speed. You could try setting a small aperture, say f/11, and adjust the ISO until you achieve a good exposure. Or, set the ISO and adjust the aperture. Personally I'd go for the first option.

You'll probably find that while the exposure for the subject looks great, the background is very dark. That's not a problem: flash is the principal light source and daylight provides the fill, so adjust the background exposure by lengthening the shutter speed (e.g. from 1/200 sec to 1/125 sec) until you like the balance. The combination of a low viewpoint and a dramatic backdrop somehow befit a plant of henbane's pharmacological potency.

(Above left) Henbane, Guillestre, France.
This potent and rather sinister-looking
plant begged for the dramatic treatment,
hence the low angle and the menacing sky
as a background. As an incongruous twist,
I lit it with very mellow, low-power strobe light.
Nikon D3, 17–35mm, ISO 320, 1/200 sec
at flash, f/18

(Above) Loch na Keal, Mull, Scotland.
Who wants a blue sky when foul weather
can provide so much more drama?
Nikon D2x, 12–24mm, ISO 100, 1/2 sec at f/14

(Right) Exposed wave-cut platform, Scotland.
Stone is the last refuge of the desperate
photographer on a wet and windy day.
So long as you can keep the tripod still
to avoid vibration, and your polarizing filter
free from rain spots, you're in for a treat.
Nikon D3, 55mm, ISO 200, 1/8 sec at f/20

THE ART OF **COMPOSITION**

Composition is more than simply organizing different elements in a rectangle, more than a jigsaw puzzle. We can amplify the power of the picture if we also consider 'significance' and 'weight'. The notion of significance recognizes that some elements are more central to the narrative or expressive aspects of the picture than others. Their size and position in the composition should therefore be weighted – rather like a sentence where the pauses and emphases are in just the right places. A 'jigsaw' composition, on the other hand, is like a sentence read in a monotone.

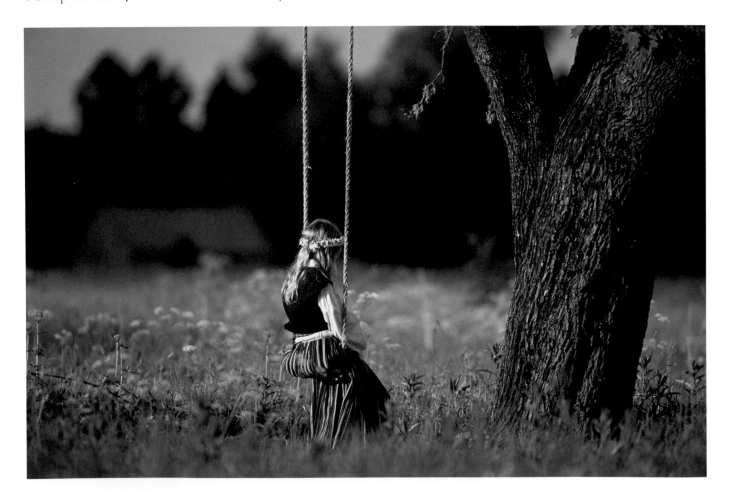

THE FOREGROUND IN PERSPECTIVE

'The big foreground' is a favourite compositional device for landscape shots. Using a wide-angle lens, the photographer moves in close to the foreground, giving it prominence and exaggerating perspective. If the lens is 20mm or wider (35mm-equivalent), the effect is almost always impressive – the viewer feels like they were at the photographer's shoulder.

Yet this technique is much over-used on subjects that do not merit it. If you are drawing the viewer's attention initially to the foreground, it should be at least as fascinating as what's in the background. All too often the photographer expects the viewer to be impressed by a lifeless stick or a stone, while a really interesting mountain or seascape in the background are diminished. The weighting of interest is therefore all wrong and the significance distorted. So, if you are looking to try the big foreground shot, find a foreground that deserves the treatment.

In contrast, photographs made with telephotos are more egalitarian since perspective is compressed and it is harder to emphasize particular parts of the scene.

LEADING LINES

Let's pick at another favourite compositional bone: 'the leading line' – a device for creating a sense of depth and expectation in a picture. Since we are working in two dimensions, we need to be pretty clever if we want to give the viewer the impression of three. The trick is to tap into their perception and understanding of perspective and to let their mind construct the depth from the clues provided. In order to do that, we may choose to 'lead' the viewer into the picture with a strong line. Yet that's not really enough: if the line just stops, fizzles out or, for example, leads to something dull, it's the visual equivalent of a *non sequitur*. Just as the big foreground shot needs something compelling in the foreground, the leading line shot needs a significant and interesting destination.

(Left) **Girl on a swing, near Paide, Estonia.**
The need to include the shaded cottage in the background (for its symbolism) meant that the girl occupied a spot away from a 'power point' which, given her demeanour, served the narrative just fine, see page 24.
Nikon F5, 500mm, Velvia 50, 1/60 sec at f/5.6

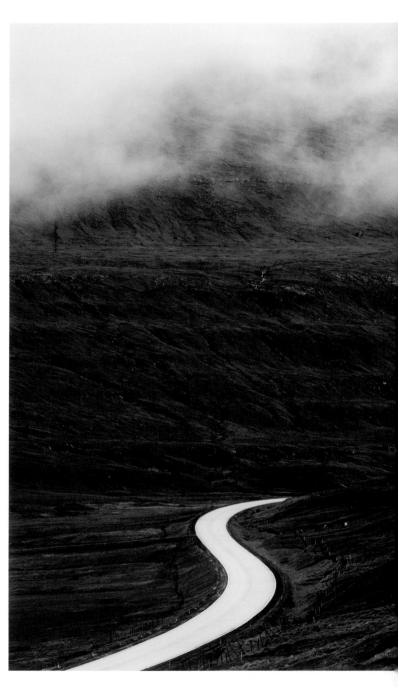

(Above) **Route 10 near Skalafjördur, Faroe Islands.**
It's a very strong leading line, but just what is it leading us towards?
Nikon D2x, 8–200mm, ISO 100, 1/25 sec at f/7.1

THE GOLDEN SECTION IS NOT A GOLDEN RULE

We have already seen that composition calls for more than intuition. We need to have a clear idea about the relative significance of each element as we put the picture together. Never more so than when it comes to that old stand by, the 'rule-of-thirds'.

In Western culture the appeal of the 'Golden Section' has long been recognized by architects and artists. In photography, this notion of harmonious balance is expressed in the rule-of-thirds. If a frame is divided by equidistant pairs of lines, two horizontal and two vertical, the points at which the lines intersect represent the most 'powerful' locations in the frame. The rule dictates that these are the places to put the subject for the most appealing composition as this is where our attention naturally gravitates towards. Fine, but let's think this through.

EXCEPTIONS TO THE RULE

The key word here is 'harmonious'. The rule-of-thirds works beautifully where the theme of the picture is balance, order, harmony and, above all, tranquillity. It's therefore perfect for the majority of expressive landscape pictures. Yet what if the picture has an altogether different mood, one of discord, marginalization, chaos or disruption? The only reason to apply the same compositional structures to this sort of picture would be to make an ironic comment? If the content is troubling then the composition should be too; it should defy normal expectations of balance and order, lending the subject that extra dimension of significance by its placement and weight.

Bank vole (controlled), England.
How better to portray a fast-moving animal in the process of escaping than by having half of it already out of the frame?
Nikon D3, 200mm, ISO 800, flash at f/20

One situation in which the rule-of-thirds rarely works, whatever the theme of the picture, is with a symmetrical subject. Placed off-centre, it just looks odd, particularly if it is round. Circular objects are hard to fit into the rectangular format at the best of times — hence the traditional popularity of the square format for portraits of people — so frame the subject in the expectation that you will probably be cropping the picture later.

THE WEIGHT OF THE SKY

Earlier today we touched briefly on the significance of the sky as an emotional barometer of a scene. But let's not forget that its positioning also has a big influence on how other elements in the scene are perceived. Allow the sky to dominate, say $\frac{7}{8}$ths of the frame, and elements on the ground seem oppressed under the weight given to the sky. Reverse that balance and the mood changes from oppression to isolation within the greater landscape (if the subject size remains the same).

LIVE AND DEAD SPACE

While these ideas are all relevant, if you are putting together landscape or close-up pictures there's another aspect of composition to be considered in relation to more active subjects: dead and live space. At its simplest, if a subject is looking or moving from left to right within the frame, more space to its right looks better; this is the live space. The space behind the subject is referred to as dead.

That is all very well until there is something interesting going on in the dead space — perhaps a fox creeping up behind the rabbit or the spray of water as a sea eagle catches a fish. The focus then shifts from the original subject towards the new one — the dynamic between these two elements. You might even want to say something about the precarious status of the subject by cramming it into a corner and surrounding it with dead space. That has a resonance unmatched in the mechanistic composition that would have the subject look wistfully into live space, losing the chance to say something more about it in the process.

To summarize, composition is as much in the mind as it is in the gut!

(Below) **Eider ducks, Montrose Basin, Scotland.**
Harmony, tranquillity, peacefulness:
all ripe for the rule-of-thirds treatment.
**Hasselblad XPan, 45mm with centre spot
filter, Velvia 50, 1/60 sec at f/11**

(Bottom) **Crested tit, Emajõe Suursoo, Estonia.**
On a carcass, crested tits are defiant little
birds: this attitude was best summed up
in a confrontational, face-on portrait.
Nikon D2x, 500mm, ISO 125, 1/500 sec at f/6.3

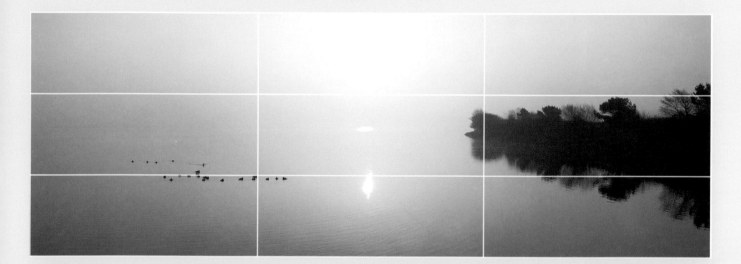

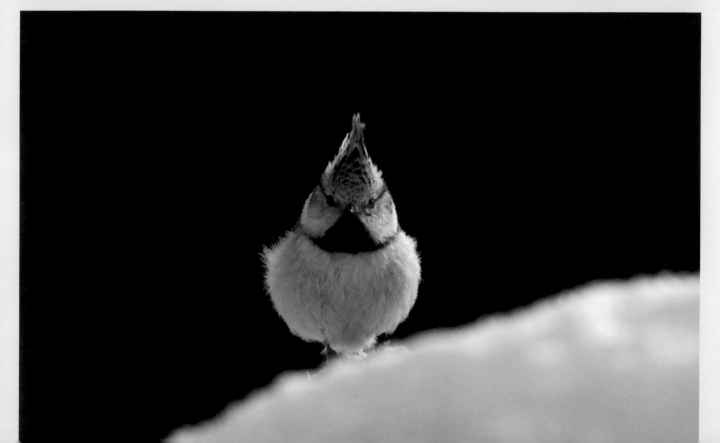

LIGHT MANAGEMENT

Bright and sunny weather is frankly less than ideal for photography. The light doesn't have much character, it's too high to provide any modelling – using light and shadow to show shape or texture in the subject – or for close-up work. Often there is also a mosaic of highlight and shadow to contend with. No problem. The ways in which we manage daylight are the same in principle, regardless of the subject, although it is a bit more practised to demonstrate with a small subject that isn't going to flee.

Black bearberry, Rondane, Norway.
I used a piece of opaque envelope stiffener to flatten the lighting and to reveal maximum detail on the autumn tundra.
Nikon D2x, 55mm, ISO 100, 1.6 seconds at f/16

NO CONFUSION WITH DIFFUSION

Earlier, I wrote about creating a large light source in the context of flash photography, see page 72. Well, it's just the same when we're working with daylight. If we want to see lots of detail, we need soft and diffused light rather than light that's hard and directional. This time, rather than a softbox, we'll use a diffuser to create it.

Personally, I favour corrugated, opaque, plastic envelope stiffener. It creates beautiful, even lighting, knocking a stop or so off the highlights while lifting the shadows by a couple of stops. This means that the whole tonal range of the scene can now be recorded. If you move the sheet back and forth, you'll see that the closer it is to the subject, the brighter the set and the lighter, or more open, the shadows. Move it more than 3ft (1m) away and the brightness is lost.

If you think that a diffuser is unnecessary and that you need only to cast your shadow over the subject to soften the light, try it, then compare that with the diffuser. There is often no comparison. The shaded picture just looks flat and lacks the subtle shading of the diffused one.

Simply using a reflector to lighten the shadows, rather than diffusing the whole scene doesn't work because you are doing nothing to control the trickiest part of the picture, the highlights, so you will produce shots that look grossly over-lit. So, a diffuser it is.

Heart-shaped granite, Skardalen, Norway.
Snow is so reflective that even on very overcast days it can be a struggle to expose mid-toned subjects well while maintaining detail in the snow. Sometimes, it is best just to accept this and let it go.
Nikon D2x, 12–24mm, ISO 100, 1/15 sec at f/18

SHINING BRIGHT

If you have no choice but to shoot in sunlight, place the sun behind the subject and use a white reflector to lighten the shadows (this is also known as lifting or opening).

SHADING

As well as managing the light on the plant itself, you may also need to do something about the light that is falling on the background, especially if you are shooting from the side and the background remains fully lit. In the case of plants, you can cast a heavy shadow over the background.

With people this can often be trickier. They can at least be asked to move and your first instinct should be to get them out of the sun. In the flat shadows, you can restore some sparkle with a white reflector (silver or gold is too sparkly unless the sky is overcast in the first place). You can also further heighten contrast (albeit still within manageable limits) by setting them against the open doorway to an unlit interior or another dark space. If the person is unable or unwilling to move, place the sun behind them and front fill with a decent-sized reflector. You could use a little TTL strobe, but the light is a bit too hard to be sympathetic. Nevertheless, this is often the only practical way to fill light moving subjects.

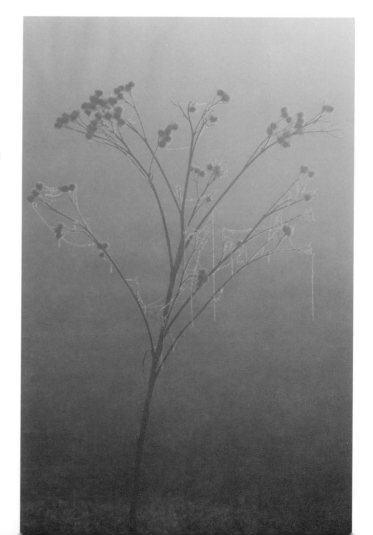

Lesser burdock, Tartu, Estonia.
The conditions have got to be pretty special before I will use direct sunlight for plant portraits. Early this cold April morning, they were.
Nikon F5, 500mm, Velvia 50 at 1/15 sec at f/11

TRANSFORMING YOUR IMAGES

So far, I've asked you to be creative and to make the most of whatever situation you find yourself in. In the same way, the adage that the best camera is the one you have with you at the time is irrefutable, although that's not to say that you can't wish for better light or for more resolution. This is where I want to introduce the idea of building an image up one layer at a time, transforming something that is fine today into something that is fantastic another day.

LAYERS OF INTEREST

Whether the picture is a narrative or expressive one, there are four main 'layers' of interest we can add to the base image to create something more compelling: light; life; precipitation; and colour. The opportunities to do this might not arise this week, next week or even next year, but when they do, you'll be prepared for them.

The following is an example of how previsualization works. Let's assume that we're in a pine forest in the middle of summer, at midday on a sunny day. There's not really a lot that catches the eye except, perhaps, that small, discrete group of trees with a nice form to them, but the light is harsh.

LIGHT

Let's consider the first of those layers of interest we could add: light. When you return in the evening, the sun is low, which is a definite improvement. Yet with a clear sky, the light is not as red as it was when there was a dark one. You stay on until after dark and light paint, see page 94. It looks impressive, but there's still something missing. So, you return again very early the next morning. Now your luck is turning: not only is the

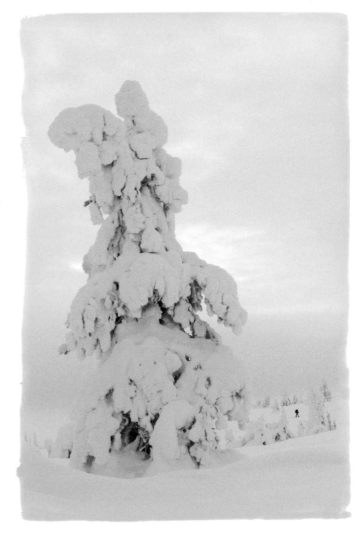

Crossing Riisitunturi National Park, Finland.
This retro treatment of a heavily photographed location was brought to life when my friend snow-shoed into the frame.
Nikon D3, 24–70mm, ISO 250, 1/80 sec at f/16

light much redder — perfect for the red trunks of the pines
— but as you approach, you spot a deer and frame it as part
of the composition, and the picture comes alive.

LIFE

'Life' in this context comes in several different forms, all adding
an extra dimension or another layer of interest to the picture.
Life is the difference between a calm sea and one with white
horses charging towards the shore. It is the concentric rings
moving away from where a fish has surfaced on a calm pond.
It can be the moment a sleepy seal yawns or just when a
salmon hurls itself up the falls. Life can even be the simple
presence of something with a beating heart in the picture.
In this last form, we need to be careful how we represent it.

Instinctively, we are drawn to life in a landscape. It is more
interesting than ice, wood or stone, on an evolutionary as well
as an aesthetic level. Yet how do we include it without drawing
all the attention away from the landscape? People are especially
problematic. So long as they are identifiable, even if they are
really tiny, we focus on them alone as we try to figure out
their story. If you want to include the animation of life in the
photograph, but don't want it to become the main subject, try
representing it as a blur — just enough to erase clear identity.
You could also try silhouetting it, if the lighting permits. If you
are really lucky, the addition of some precipitation may solve
the problem for you.

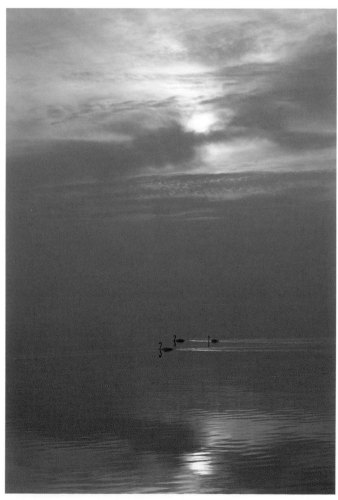

PRECIPITATION

The interest that precipitation adds to a photograph is so well recognized that one lens manufacturer used to supply a little sprayer with its macro lenses so that the photographer could create raindrops on dry plants before photographing them. After you've seen a photo of a dew-spangled dragonfly at dawn, you'll never want to shoot one in the middle of the day again.

In the case of our forest, although the deer has wandered away, we now have the spectacle of the sun rising through the fog that formed in the pre-dawn coolness. Even if there are no other layers of interest in an original scene, fog, snow, or even a lone rainbow may be enough to create the 'wow' factor. Viewers often respond well to the simplicity that these sorts of precipitation bring to images of the landscape. In close-up photography, dew drops and hoar frost also create the 'wow' factor by adding complexity.

COLOUR

When it comes to colour, we may need to come back to the wood in another season. Right now, everything is in shades of green. Yet, if we return in the autumn the palette will include reds, yellows, purples and blues. If we can combine these colours, along with the full-bodied light of dawn or dusk, early snows or a little fog, and some wildlife, we'll soon have a fully realized picture.

In reality, we can rarely hope for more than a couple of extra layers of interest at any one time and we should congratulate ourselves for managing even that. What is more important is ensuring that you cultivate a mindset that sees potential and can figure out how to realize it, sooner or later. Once you do this, you'll come to appreciate that working close to home is likely to provide more opportunities for layer-building than going to remote locations where you may get only one shot at it.

Sometimes you have to give in to the realities of where you live. For example, I know that if I need pictures in snow in my locality, I'll probably have a very long wait in today's climate and should probably focus on more achievable goals instead. At the very least, wake up to the potential of your home patch and milk it for all it's worth before chasing rainbows in far-off lands. The journey that you most need to make is into your imagination.

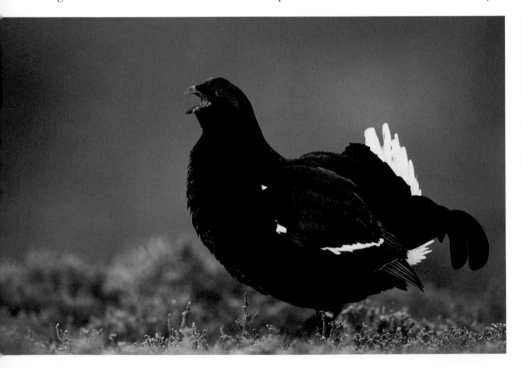

Black grouse, Deeside, Scotland.
A black grouse lek is one of the most exciting avian spectacles in the UK, with the males gathering to joust and impress the females. Add an extra layer of interest by waiting until your subject calls.
Nikon F5, 300mm, 1/30 sec fill flash at f/4

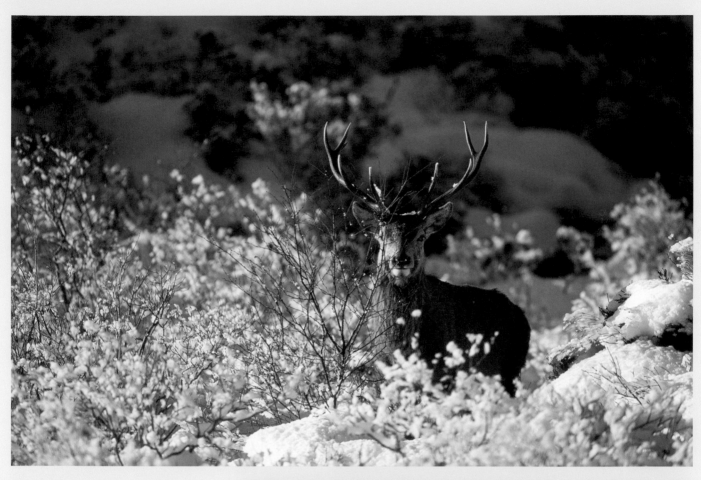

(Above) **Red deer, Glen Affric, Scotland.**
I have loads of photos of brown stags against brown hillsides; here was the opportunity to add precipitation and colour into the mix.
Nikon F5, 500mm, Velvia 50, 1/125 sec at f/5.6

(Right) **Four-spotted chaser, Alam Pedja, Estonia.**
A chilly night had not only rendered this dragonfly immobile, but also caused a heavy dew that added to the interest of the scene.
Nikon F5, 200mm, Velvia 50, 1/2 sec at f/11

MORE THAN ONE

One of the things I like about digital photography is the way in which it encourages each of us to redefine what a photograph should look like and how we should present it. The real creative, of course, has never been held back by 'shoulds'. Yet for most of us, it's only now that we are beginning to step out, confidently tackling more difficult subjects and undertaking new ideas without fear of being eaten alive by critics. The clamour of people doing new things is drowning out the drone of convention.

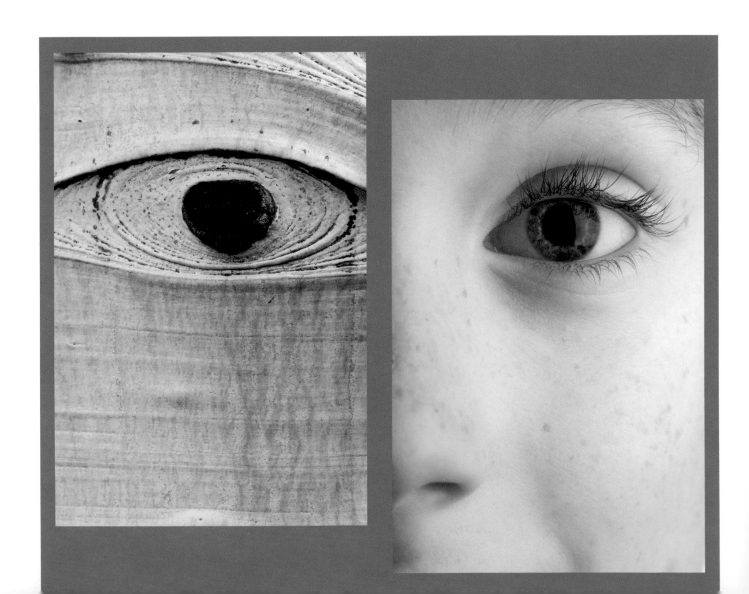

(Right) **Ostrich plume, polypody and broad buckler ferns in the field studio.**
These elements began as field-studio portraits. They were 'cross processed' – replicating developing slide negatives in colour negative developer – in Photoshop to create the colour contrast, then composited onto a single page.
Nikon D2x, 55mm and 200mm, flash, various exposures

(Left) **Aspen knot and Eliot's eye, US and Scotland.**
I brought these elements together to illustrate the schism with nature many children experience today.
Nikon D2x, 55mm, 200mm flash, daylight and flash exposures

Why not stop thinking about one picture at a time and instead think about bringing two or more together to form a single piece of work? Here are three main approaches to start with.

PAIRS

Yes, we have mounted pairs of pictures together for years. Sometimes we have even been a little pretentious and called them diptychs if they folded in the middle. However, so long as we were shooting on film, pairings were more in the realm of graphic design than photography. Now is the time to shrug off those labels. You can do it too, on a single page in Photoshop, creating your own design with your own raw materials and your own insights, then printing it as one piece of work. This is still photography!

Give a bit of thought to what you want to pair and why. I can think of three big themes to explore straight away: cause and effect; parody; and echo. Remember, the point is to make something greater than the sum of its parts. The pictures should resonate together for people to understand one because of what they see in the other, or for an idea to bounce back and forth between them.

In order to do this, you need to think not just about what's in front of your camera, but what you've already shot or could shoot in the future to pair with this picture. There can be a certain amount of overlap between parody and echo – the notion that people come to look like their dogs makes it a natural topic for pairings – but drawing parallels between

things in the natural world and human invention (such as burdock and Velcro®) is more in the realm of echo. Whatever: the label doesn't matter, just as long as we have these themes in mind when we are assessing subjects for pairing.

THEME VARIATIONS

Over the years, I have taken thousands of close-ups of bark, water, lichens and a hundred other fascinating, but largely ignored subjects. Both public and publishers have been assiduous in their disinterest in them. This is not surprising. However intriguing to the photographer, each one is like a small chunk of chocolate to a ravenous man; alone, they just don't satisfy.

The effect, however, changes altogether when you create a single image composed of several of these vignettes. Typically, I put 9 or 12 on a vertical panel assembled in Photoshop. By doing this you are, in effect, creating a whole bar of chocolate. This approach is great for representing both temporal and morphological variation, including seasons, flow patterns,

SIZE MATTERS
When you open your image in Photoshop, make sure you create the background page with a size that fits standard paper dimensions.

tree bark and rocks. I use it especially to show the variety that occurs within one species or rock type as it makes the subject an individual, no longer just 'birch' or 'granite'.

Simply because they gain strength in numbers, it's no excuse to be slack when you photograph individual elements: each should be able to stand critical scrutiny. Amassing the pictures is only half the job. The different elements then need to be arranged on the page in much the same way as you would compose a photograph, allowing yourself to be guided by your understanding of the relative weight and significance of each picture. If each is equal, then you are safe with a very regular composition.

COMPOSITING

Here's a dirty word if ever there was one amongst nature photographers. Rest assured that I'm not advocating alteration of the facts in images purporting to represent actuality, rather the bringing together of related, but isolated subjects in one frame.

I'm often asked for pictures that illustrate the concept of biodiversity. Yet as anyone who has tried can attest, getting even a few different species in one frame, all well-lit and in focus is next to impossible in most locations and rarely satisfies the brief. My solution involves photographing a wide variety of plants, invertebrates, amphibians and reptiles on location using the field studio with a brilliantly backlit white backdrop, then compositing them on a single white page to represent a community. Due to the background, no-one is likely to think that all these creatures and plants appeared side-by-side in nature. If anything, there will be the mistaken assumption, that they were moved to an indoor studio. Usually, the viewer can appreciate that it is a representation of diversity in one place, rather than a record of a particular space.

It's not hard to make these images look stunning when you can place each element just where you want it. Yet if the work is to have any scientific value, you should reflect what you saw: a plant growing in open water and one that grows in rock crevices need a few other species in between to reflect the transitional habitats. Be consistent, if you are photographing a variety of species, shoot each at the same magnification ratio with the front light from the same side.

Dandelion seed heads, the field studio, Scotland.
A composite of five images of two plants. When different elements are photographed in the field studio it makes it easier to illustrate time lines.
Nikon D2x and Nikon D3, 200mm, ISO 100 and 200, flash, various exposures

Here's a tip: keep a record of these ratios, so that you can make use of pictures from different sessions in a composite at a future date – most macro lenses have a scale showing this. In single-species assemblies you can even photograph the elements from different distances to create an image that, thanks to the perception of perspective, appears to have depth, even though the background is pure white.

(Right) **Birch bark panel, Sør Trondelag, Norway.**
In order to illustrate diversity within a particular species, a single panel provides a neat solution.
Nikon D2x, 200mm, various exposures

(Below) **Roadside flowers in Naturpark Kaunergrat, Austria (composite of nine images shot in the field-studio).**
To illustrate the huge diversity of flowers in the High Tirol, I shot these individual elements with the same lighting and at the same magnification then 'arranged' them on a single page in Photoshop.
Nikon D3, 200mm, various exposures

BETULA

THINKING IN **BLACK & WHITE**

I confess that I've never done an honest day's work in a darkroom. Like many other people, I never got into black & white when it meant mixing a whole lot of lethal-sounding chemicals. Digital capture has changed all that. The ease with which we can convert RAW files to monochrome, and the quality of prints that can be coaxed from a desk-top printer with three different sorts of black ink is encouraging more and more hardcore colour shooters to dabble. Every so often you'll make a good image, but for consistency you need to think a bit harder at the outset about why you're reaching for the conversion tools.

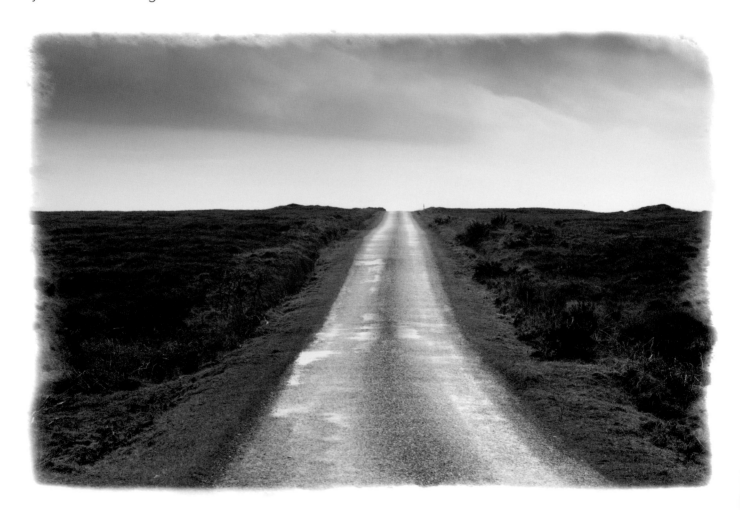

DECIDE AT THE OUTSET

Ideally, whether we finish a picture in colour or black & white is – or should be – informed by narrative or expressive intention. Colour, in some respects, is the natural choice for narrative images as it adds to the photographer's descriptive vocabulary. Yet, as we know from badly written literature, a dull story isn't made any more interesting through the use of fancy language. So, ask yourself whether colour in the picture lets you tell a more complete story or whether it simply confuses. Are your feelings about this place or scene made any clearer because of the use of colour? If the answer is no, then do what thousands of photojournalists have done before you and produce the picture in black & white. Just don't get into this habit of dismissing colour as a vulgar distraction, if for no other reason than that is our own visual default. There has to be a pretty good reason to switch to black & white.

Ruined farmhouse near Brechin, Scotland.
I like the way that fog reclaims the landscape, fading elements into white.
Nikon D2x, 12–24mm, ISO 100, 1 sec at f/16

ANOTHER SIDE TO THE LANDSCAPE

One of the most compelling reasons is the quality of 'otherness' that results when a scene is rendered in black & white – it is held at a distance from our normal perception; it is not quite familiar. This provides a greater emotional depth to your pictures. The sort of colour landscape photography that fills magazines and calendars tends to portray the landscape as benign, even subdued, a playground where we can safely come and go at will. In monochrome, however, there is a strong hint that a landscape may have another aspect, one in which we are as vulnerable to natural forces as any other creatures, subject to no more compassion than a water-smoothed pebble or storm-thrown spruce. Menace is not a given, but black & white allows that it may be a possibility.

(Left) **Single-track road, Islay, Scotland.**
Although this image tends to lean towards melancholy, the road's ascent to a brightening sky offers hope and invites questions about what is visible from the top – another bleak bit of moor, as it happens.
Nikon D3, 24–70mm, ISO 800, 1/400 sec at f/11

ON THE ATLANTIC'S EDGE

Let's use the following scenario as an example: imagine that we are now standing, facing into an Atlantic gale with the light fading fast; thinking in black & white is simple pragmatism. Whatever colour that may have earlier been reflected from the slick black rocks has long gone. The sea, without hindrance between here and the coast of Labrador, is in a fine state by the time it hammers into this volcanic headland. A black & white photograph is the practical response, but it also underlines the sense of exposure and vulnerability.

Most colour photographers have a strong preference for shooting in the full-bodied light around dawn and dusk, when the sun gets below our brows and floods us with the possibilities of day or night. Transience is implicit in these pictures, a sense that even if the scene is a little overwhelming, it will soon be dark and out of sight, or sunny and harmless, depending on when the picture is shot. When we think in black & white, however, the colour temperature of the light – whether the tones are warm or cool – is unseen and it becomes easier to imply immutability and permanence in the absence of explicit clues given by the light's hue. It is hard to imagine a more unchanging scene than this elemental one before us. Black & white is *so* much more than the solution to a gloomy day.

THIS IS PERSONAL

From the days of Ansel Adams onwards, black & white photographers have been cut a lot more expressive slack than those who work in colour. The bizarre contrasts evident in some of Adams's work are no more representative of how things look in nature than tobacco-tinted Cokin filters are, yet it's the latter that receives the criticism. Fortunately for us, there seems to be an expectation that black & white workers are more than mere recorders; it is almost expected that we will put our personal stamp on a scene. There is an understanding that thoughtful black & white photographers are not simply novices who haven't yet learned the language of colour. If we are clear in our minds from the start about when to use black & white, then we won't come across as colour snappers on a day off.

We are inclined to think of black & white as being particularly relevant to landscape photography, but it also has a place in wildlife work.

Black & white fell out of favour for wildlife work for a long time and understandably so: colour is vitally important in the natural world, whether it indicates ripe fruit, issues a 'keep clear' warning, signals fitness or provides camouflage. However, some photographers are beginning to understand the potential of black & white to make the viewer re-examine a subject they thought they were already familiar with.

The Atlantic puffin, for example, has a vividly-coloured bill that would seem to make it a natural choice for colour. So why portray it in black & white? Simply because most people never see past the bird's gaudy bill and its orange feet. The majority fail to see the whole bird. Also, black & white effectively emphasises the 'otherness' or the fact that it is a wild animal, re-enforcing the difference between their world and ours. While human society continues to evolve quickly, animal societies remain relatively unchanged over a long period — a timelessness suggested by black & white.

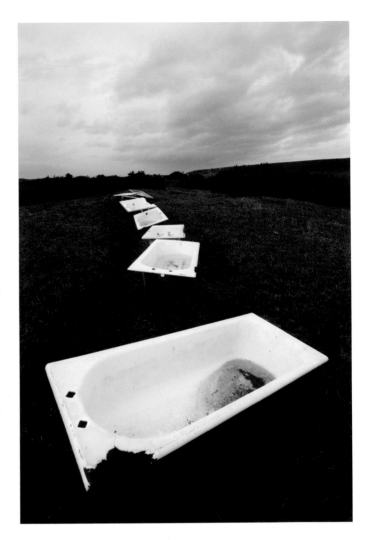

Drinking baths for cattle, Wester Ross, Scotland.
I processed this picture to increase the contrast between the baths and the surrounding dark moorland.
Nikon D3, 17–35mm, ISO 640, 1/40 sec at f/18

DATA HEAD
Even if your camera has a greyscale or black & white mode, it's better to shoot colour, then convert it later so you have more data to work with.

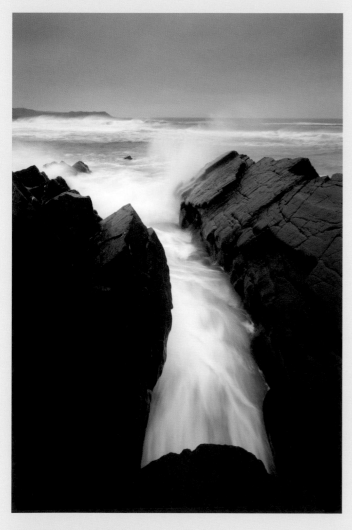

Saligo Bay, Islay, Scotland.
Not long until dark and the Atlantic carries on
its work of ages. It has to be in black & white.
Nikon D3, 17–35mm, ISO 1000, 1/2 sec at f/13

Courting ravens, Alam Pedja, Estonia.
I wanted to create a high-key, romantic look,
so I used an infra-red filter from Alien Skin's
Exposure application.
Nikon D3, 500mm, ISO 800, 1/1000 sec at f/5.6

BLACK & WHITE
When shapes are more important
than the colours in a picture, try
converting it to black & white.

Forsinard, Sutherland, Scotland.
Hasselblad XPan, 45mm with centre
spot ND filter, Velvia 50, 1/30 sec f/11

PAINTING WITH **LIGHT**

This is too good a chance to miss: snow on the ground, snow on the trees and a clear sky above. Before we get down to processing some pictures, we've just got to go light painting. Unfortunately, photography can involve an awful lot of standing around waiting for things to happen. This time, rather than waiting for the light, we're waiting for darkness.

A few photographers were successful light painters in the days before digital, but the thrifty majority I counted myself amongst found the high wastage rate hard to bear. With that impediment removed, monuments and trees across the land are being painted by photographers using powerful lamps.

THE ESSENTIAL TECHNIQUE

Light painting uses artificial light sources to illuminate subjects during low light or night-time photography. The camera's shutter is left open for a length of time determined by the ambient light and the photographer's wish to include elements other than the main subject – typically longer than ten seconds. During that exposure, the subject is illuminated with tungsten balanced light, anything ranging from a head torch through to a several million candle-power spot lamp.

The aim is to balance the lighting I can provide with the available light. That's why we are standing around freezing; we're waiting for it to get dark enough to shoot. If we try too early, we won't be able get a long enough exposure to have time to 'paint' the trees and the ambient light will overwhelm that from my torch. If you leave it until it is very dark, you'll need to dramatically increase the exposure time.

Communications hotspot, Croick, Scotland.
Late on a June evening, I laid my spotlight on the floor of this call box so that it lit the white concave ceiling. Some of the reflected light spilled out onto the adjacent postbox.
Nikon D3, 24–70mm, ISO 200, 8 secs at f/7.1

LONG EXPOSURE

I advised you to enable the Long Exposure Noise Reduction (LENR) feature on your camera on day one (see page 15). That advice holds, especially as you will get extremely cold waiting for the camera to process a ten minute exposure (it will be ten minutes before you can take the next picture). It would also be a real blow if you find you got the exposure wrong.

So, as soon as the exposure time exceeds 30 seconds (to show background detail), turn off the LENR until you've figured a good exposure, then put it on again. Even then, you may prefer just to leave it off altogether and use noise reduction software at the processing stage. Ideally, set up the shot as it's getting dark and make all your exposure adjustments while you can still see where the camera is.

THE IDEAL COAT OF LIGHT

In an ideal situation, you will be able to paint the subject from both sides to cancel out the worst of the shadows. Yet in deep snow or with a big subject, that may not always be practical. It's more important to keep the torch moving to avoid the development of hot spots. Don't use an LED light source as it lacks the warmth of tungsten light and, as such, makes it hard to create rich background blues.

This is the one occasion that I'd advocate RAW shooters switching from the Auto White Balance to Tungsten setting on the camera, just to make the picture easier to process. Tungsten light is very yellow, so the White Balance setting will render anything not lit by a tungsten light very blue as it strives for neutrality. Illuminated parts of the scene come out in their daylight colours. Try this with an LED source and you'll lose the colour that suggests night.

MOVING ON UP
Keep the torch moving over the subject to avoid hot spots, and paint from left to right.

Tykky-covered spruces, Riisitunturi National Park, Finland.
Once it's dark enough to balance your torch light with what's left in the sky, you'll have to work quickly to avoid very long exposures. So, identify your composition beforehand.
Nikon D3, 24–70mm, ISO 800, 25 secs at f/5

Dead Scots pine, Glen More, Scotland.
Gloomy skies that, during the day, make for an uninspiring backdrop, at dusk provide a rich blue foil to the warm light cast on the subject, in this case, from a head torch.
Nikon D3, 17–35mm, ISO 640, 30 secs at f/6.3

PROCESSING IN **LIGHTROOM**

Let's try processing RAW files in Adobe Lightroom. Other applications can do as good a job, but, like Adobe Photoshop, Lightroom is likely to become the industry standard 'digital workflow solution' sooner rather than later. Some photographers use three or four different applications for editing, importing and RAW processing. On principle, I prefer to compromise slightly (although not on the RAW processor) for the convenience of having everything I need in the one application.

ORIGINALS

Following on from the earlier discussion on parametric image editing (see page 55), let me restate an important principle: none of the image adjustments you make during RAW processing affect the original file. The image you work on in Lightroom is simply a preview of what the file will look like once the edits are rendered; the file is a copy of the original RAW file with edits applied. That is fundamentally different from doing work on a rendered file in Photoshop. By then you are bashing pixels. You may be bashing a 16-bit image, but pixels are degraded nevertheless. It is therefore always desirable to do as much as possible in Lightroom before exporting a file. You can do just about everything you need to.

THE SCOPE OF THIS TUTORIAL

Since this class is not primarily about Lightroom, we will only focus on the essentials. Specialist books can fill in the fine detail. We've looked at editing in the Library module already and will now use the Develop one to process our pictures. Slideshow, Print and Web are very useful for outputting images for those purposes, but in the time we have, not so relevant (see top, far right top). We'll speed things up by using the shortcut keys whenever possible (PC keystrokes are in parentheses).

The palettes are laid out in a particular sequence for a very good reason and it's best to follow it, starting with Basic. You will find it very useful to press Y now and again to view the before and after versions of the picture. If you wish you can also revert to any previous adjustments in the History palette on the left.

THE ESSENTIALS

• **Temperature** (see bottom, far right). These sliders allow you to define the overall colour balance of the photograph. Unless you have to match colour in your images to known values (such as in product photography), white balance is largely a matter of taste and plausibility. If your display is calibrated, you can set whatever balance of colour temperature and tint until you think looks right. If you are not happy with Lightroom's initial estimate of these values, try using the White Balance tool to sample something in the frame you would like to be neutral — the same values in each colour channel (red, green and blue). You could use a grey sky or a rock, although avoid using a white surface in the shadows since that is likely to have a blue cast and using it for reference will make the whole picture too yellow. Some photographers place a non-reflective grey card in the first picture they shoot in the sequence, then sample from that image. That is useful if you want the colours to be neutral, but if you do this with sunrise or sunset shots, for example, all the warmth will be neutralized too. If you make any adjustments to temperature after you have made other adjustments in the Basic panel, you will have to revisit them as white balance values can impact on Exposure in particular.

Ready to start editing in the Develop mode.

Before and after views.

Sampling color temperature.

• **Various sliders** (see top, overleaf). The next set of sliders is where we set the light and dark point of the picture. They map whatever RAW data the camera captured across the width of the histogram to produce a pleasing picture. If you underexposed the shot you will have a lot less data to map; one 'exposed to the right' provides the maximum amount of editable data.

• **Exposure** As you click on the Exposure slider, hold down the alt key. Any 'clipped' areas that are overexposed will be displayed. If the overall look of the picture is too light, you can bring them back within histogram limits by moving the slider to a negative value. Even quite overexposed images can be rescued in this way. However, if you need to lighten a very underexposed picture, where inadequate data was captured for the highlights, you risk introducing digital noise in the darkest areas. Use the Exposure slider to optimize the data you have. If the look is not quite right, don't worry, you can refine it later.

• **Recovery** Sometimes, moving the Exposure slider to save overexposed values can make the whole picture too dark. Recovery acts only on the lightest levels, allowing us to bring them back within histogram limits with minimal effect on the other tones. We can let go of the bright specular highlights, such as those from sparkling water, while non-reflective ones, for example, pale feathers on a bird's back, should show detail. Once again, you can hold down the alt key as you slide to see what's happening.

• **Blacks** We're going to go slightly out of sequence now, avoiding Fill Light and heading straight to Blacks. The default setting of 5 is fine for most pictures, but if you really need to lighten a dark picture, a setting as low as 2 can help. Clipped shadow areas display when you hold down the alt key as you move the Blacks slider, although these are less important than clipped highlights.

If, after adjusting the Blacks, you feel that the darks are still a bit dark, use the Fill Light slider to lighten them. To maintain healthy contrast in the picture, only use it at low settings; I rarely go beyond 10.

• **Brightness** Perhaps you've optimized the capture data with the previous settings, but the picture looks a little light or dark. No problem, you can make a small overall adjustment with the Brightness slider; just leave contrast refinement to the Tone Curve later. I prefer not to adjust Brightness until I have made my Presence settings as they can affect tonality.

• **Presence** (see right, centre) With these three sliders we can manage mid-tone contrast and sharpness, as well as the look of the colours in our shot.

Clarity is great for adding edge contrast to pale subjects, improving the impression of sharpness along the way. A good starting point is somewhere around 20. A negative setting creates a gentle soft-focus effect and is ideal for some portraiture.

Vibrance is a sophisticated version of Saturation. This makes muted colours stronger without rendering saturated colours even richer, except at high settings. It's clever as it recognizes skin tones and exempts them.

If you want to give an overall boost to the picture's colours, use Saturation. However, unlike Vibrance, it's not selective and the effect is easily overdone. It's actually more useful for removing saturation from a picture, when set to negative values.

ADDITIONAL TOOLS
Before going to the Tone Curve, let's pay a visit to the tools nestled beneath the histogram (see bottom, right).

R This brings up the Crop Overlay option, which is very handy for levelling squint horizons. Unlock the padlock, unless you need to maintain the picture's aspect ratio in the crop.

N (see far right, top). This unlocks the Spot Removal tool. If the background in a set of pictures is quite uniform and the subject hasn't moved, you can speed things up by cleaning up the first picture, selecting the others (while holding down the shift key), hitting the Sync… button, then checking only Spot Removal. Sometimes, it is still quicker to do this even if the subject has moved slightly and now has six fingers. Just select the spot that has caused the offending duplication and hit backspace to remove it.

Exposure adjustment.

The histogram after optimisation.

CUTTING THROUGH
Learn Lightroom's short cut keys to speed up operations. X – Flag as Rejected and Z–Zoom into 100 per cent are perhaps the most useful two during editing.

Cropping – R.

Dust busting – N.

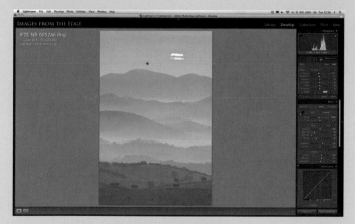
Using the Graduated Filter tool to darken the sky.

Using the Adjustment Brush to darken the sun.

Use fn with the arrow keys to move one discrete block at a time over the picture, so that you're not missing anything or going over the same area twice (Home, Page Up, Page Down). If you press H, you can temporarily hide the targets to let you see if the programme has made a good choice of location to heal or clone from. If not, simply click and drag the source circle.

• **Graduated Filter** (see centre left). Since we are all professionals here and don't give our subjects red eyes, let's pass over to the Graduated Filter – M. This is so much more precise than one you would put in front of your lens, but you still need to have detail in each channel to achieve the best results. If you want to draw it straight down over the picture, hold the shift key as you do so, otherwise you can rotate the angle of gradation using the central line that goes through the 'pin'. Click on the pin so that you can make live adjustments and review their effect. Edit boldly – remember you're not working on the original image so you can return as often as you like to tweak adjustments.

• **Adjustment Brush** (see bottom left). If, in spite of all your earlier work, there remain small parts of the picture in need of further work use the Adjustment Brush – K. It is perfect for localized editing within a whole set of parameters – perhaps a face that is too pale or eyes that are too dark. Maybe a spot of colour needs to be boosted or suppressed. It also employs pin markers to show the starting point for a local adjustment. As you will see when we reach the Hue Saturation Lightness (HSL) palette, local colour difficulties may be better dealt with there.

• **Tone Curve** (see overleaf top). The 'optimal' distribution of capture data across a histogram may not necessarily produce the look you're after. If you cut your photographic teeth on transparency film you may still hanker for pictures with high contrast and saturation. With the Tone Curve you can create that contrast, but its real power lies in the way particular areas whose tonal value you want to lighten or darken can be targeted. Start by clicking on the Target Adjustment tool in the top left of the Tone Curve palette. As you move the mouse over the image, the tonal level under the cross hair is shown on the curve.

Move the target to an area representative of the tones you want to affect, then use the up and down arrow keys to lift (lighten) or lower (darken) the curve. It is possible to generate a much more precise tonal curve than by just using the sliders. If you feel you've gone wide of the mark, use the History palette to return to an earlier state or double-click on Region to reset all the sliders to 0, or on the slider names to reset one at a time.

The Tone Curve.

TARGET TOOLS

Another form of targeted control is the Hue Saturation Lightness (HSL)/Color/Grayscale palette (see centre right).

• **Hue Saturation Lightness** (see centre right). This is perhaps the most useful tool. Again, we are provided with a Target tool with which we can select a colour in the scene whose HSL characteristics we want to change. Perhaps a colour is oversaturated relative to the others in the picture. Perhaps a subject's nose looks on the wrong side of sobriety and the red needs to be reduced. These adjustments, of course, affect all the parts of the image containing the selected colour, so for local edits the Adjustment Brush may be a better option.

If you need a pure white background (as I do in my field studio work) and are having difficulty separating a pale subject from it, the HSL tool is often the best way to darken the chosen subject without affecting the background.

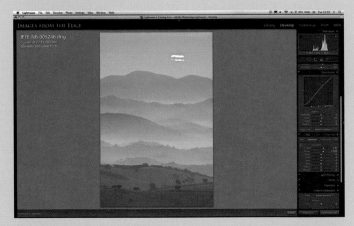

Adjusting colour-specific saturation.

• **Detail** Sharpening (see far right, top). Received wisdom says that you shouldn't sharpen your pictures until they are sized for final output. That's true to the extent that different-sized prints require different amounts of sharpening, but it takes no account of the inherent softness of RAW files. The sharp JPEG preview you saw on the back of your camera is likely to look softer when the RAW data is brought into the converter, so you'll need to add some sharpening to correct this, irrespective of later use. Just don't overdo it.

Some camera models seem to deliver sharper-looking RAW files than others and lenses designed for digital cameras often render more detail than those that are designed for film cameras. Furthermore, an image with high contrast may look sharper than the same scene under flat light. The point is that there

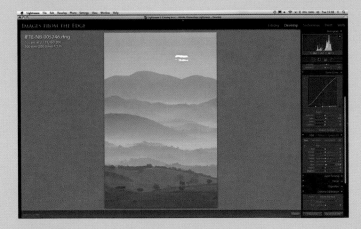

Sharpening.

Presents – including the two for sharpening.

Noise reduction.

Vignetting control.

is no one setting I can recommend to suit every combination of camera, lens, lighting and subject. However, there are two sharpening presets (look above the History panel) that work well in many cases.

Sharpen Portraits: this is useful, not only for people, but for any subject where you want to increase the edge detail of important areas yet minimize the sharpening of smooth ones. Use the Masking slider to determine how much protection is given to smooth areas.

Sharpen Landscape: In contrast, this has a 0 Masking setting (although you are free to move the slider). This is the preset to use if your picture has lots of fine detail in it. Remember that these are both just starting points. Your final choice of capture sharpening should be informed by the other considerations already mentioned. Either way, you'll need to have the picture at 100%, so that you can see what you're doing. You may also find it easier if you hold down the alt key as you move the sliders: this turns the image to greyscale and makes your choices a little simpler.

• **Noise Reduction** (see centre left). While you have the picture pulled up to 1:1, take a look for noise (the digital equivalent of film grain). On older cameras it could become an obtrusive problem above ISO 400, but the latest generation are much quieter, even if you accidentally underexpose the picture. High Noise Reduction settings can smooth a picture to the extent that it starts to look unsharp, so I rarely set either slider above 20. In reality, most noise vanishes anyway in the trauma of offset printing – which is how most books and magazines are printed.

• **Chromatic Aberration** Have you ever looked through a pair of cheap, high-powered binoculars and noticed a purple halo round the edge of an object? This is caused by chromatic aberration, which is when different colours become focused on different planes. The same thing can happen, mainly with wide-angle lenses, when edges meet a very bright background. Often you'll see it when fine branches are shot against a bright sky. Lightroom offers two separate ways to tackle this. You can use the sliders, (red/cyan often needs to be set to a minus value

– try the mid-twenties; blue/yellow goes the other way) or the Defringe Command. This automatically removes any colour fringing either to Highlight Edges – where very bright highlights are prone to generate a magenta fringe, or All Edges – perhaps the more useful of the two. Don't attempt this unless the image is displayed 1:1 as the correction is hard to assess otherwise.

• **Vignettes** (See previous page, bottom left). Sometimes a misaligned lens hood or filters placed too far from the lens's front element intrude into the frame, subtly darkening the corners of the photograph. Recent versions of Lightroom acknowledge that some users actually like this and provide a set of tools to allow the user to refine the look. Ordinarily, however, we use the Amount and Midpoint sliders to lighten the corners of the picture. Unless your camera tends to give a colour cast to all your pictures, you can, without shame, leave the Camera Calibration settings well alone. 'White background' processing is exampled in the following screen grabs (see pictures on this page and far right, top).

AFTER PROCESSING

The processing is finished. We've been back and forth through the pictures, tweaking here and there, using the Synchronise Setting button to apply the same settings to groups of similar pictures. Now we're ready to export the files. Perhaps you have gone down the parametric route and will export only on demand. That's probably the way of the future, but I still prefer to have a finished file on hand ready to send out rather than have to do it under pressure when time is short. I still have the drive space after all.

If you are confident that you will never again need to do anything to the file in Photoshop, save yourself a lot of space and export as 8-bit. Personally, that seems a waste of hard-earned data to me: in an 8-bit file there is no wriggle room, no extra data that be edited without it affecting the whole (see far right, centre).

So, in this workflow we'll export as a 16-bit TIFF, without compression, into the Adobe 1998 space. I can then throw away gamut and bit depth to my heart's content as I prepare web, projection and print versions with Photoshop Actions

Highlight warning in red.

With blacks adjusted.

With adjustments to Prescence mode.

Select Colour Darkening.

Export options.

(page 150), but at least I will be starting off with the maximum amount of data. Rather than using Actions, the practical alternative for re-exporting the file in different colour spaces, formats and sizes exists here too.

CONTACT SHEETS

Although the Print and Web modules are beyond the scope of this workshop, I do have to mention printing contact sheets within Lightroom, now that Adobe has made it more complicated in Photoshop. Previously, under File>Automate>Contact Sheet II, we could point the application in the direction of a folder or disc of images and it would automatically generate neatly laid out thumbnails (complete with file names) of the pictures. Any time I sent out pictures on DVD, a contact sheet provided a quick visual reference for the recipient and acted as a delivery note for myself. In the latest version of Photoshop (CS4), contact sheets are now in the form of PDFs and are created in Bridge.

Lightroom is perhaps the easier option to use when making contact sheets. First, you'll need to put all the files you want to appear on the contact sheet in one folder. If they are already in your catalogue, select them all and put them into a folder you've created for the purpose (click on the + symbol beside Folders in the Library module). It is probably neater, although slower, to burn the DVD first, then import its contents.

The files are now all in Previous Import under Catalog. Select them all and change to the Print module, then under Template Browser, click on 4x5 Contact Sheet. Under Layout on the right panel you can specify how many pictures per page you want. I'd be inclined, under Photo Info further down the panel, to select Filename so that is printed too.

If you use the Draft Print mode, you're handing over colour control to the printer which, as we'll see later on, is not always a good idea. Switch off Draft Print Mode and you can enjoy access to full Adobe colour management. The main advantage of the Draft Print mode is speed: Lightroom uses the previews generated when the pictures were imported. If you want full colour management, Lightroom refers back to the original RAW files (TIFFs or JPEGs if that is what you imported), greatly slowing down the process.

PHOTOSHOP FUNDAMENTALS

With every new release of Lightroom, the need for Photoshop for everyday imaging work appears to diminish further and further. This is certainly the case with the full version that I describe in this book. However, there are still lots of things you'll need this ultimate imaging application for if you want to do increasingly creative things or even relatively simple chores.

CONFIGURATION

Before we push open these doors, let's just make sure that you have the application set up properly. Go to Edit>Color Settings. For reasons we looked at earlier (see page 15), the default sRGB Working space is limiting. Most imaging professionals expect files to be delivered in the Adobe 1998 (Adobe RGB) space, then make the conversions themselves. So, under the Settings Menu, select one of the Prepress presets — I've selected the one for Europe. If it doesn't display for some reason, click the More Options button on the right of the window. Not only does that change the RGB working space to Adobe 1998, but it configures everything else to assist with proper colour management.

Unless you're preparing files for an offset printing press, don't worry about the CMYK working space. This is referred to when you soft proof — create a file that roughly mimics how the printed output will look — with the CMYK option (see page 152), but since each printing press and paper stock needs its own CMYK profile, it is unlikely that you will be able to see a totally accurate soft proof on screen anyway. For bureau printing and your inkjet printer, this setting isn't relevant.

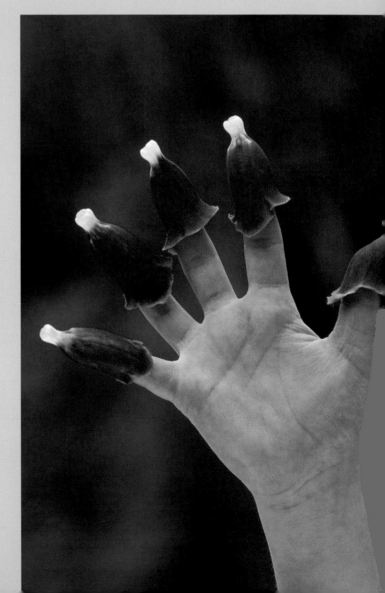

Finger flowers, Scotland.
If you are scanning old transparencies you will almost certainly need Photoshop's Stamp and Healing tools to repairs scratches.
Nikon F5, 80–200mm, Velvia 50, 1/30 sec at f/5.6, white reflector

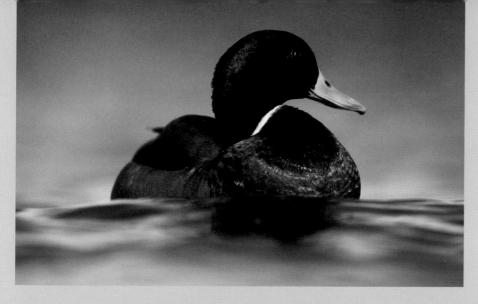

Mallard duck, Linlithgow, Scotland.
Dust spots, hairs and marks are
especially noticeable on diffused
mid-toned or light backgrounds.
**Nikon F5, 500mm, Velvia at ISO 100,
1/500 sec at f/5.6**

If you are fortunate to have all the finished files in your system in one working space (ideally, Adobe 1998), you can leave Color Management Policies, RGB, at Preserve Embedded Profiles. If you have a variety, keep things consistent by selecting Convert to Working RGB for images coming into Photoshop.

BEYOND-LIGHTROOM CLEANING
• **The Stamp tool** The Spot Removal tool in Lightroom is fine for removing spots, but for anything more extensive, or very close to detail, you don't want to copy as this is slightly limited. This is a pity because, as we've seen, doing this in Lightroom is non-destructive. However, doing it to a rendered image containing living pixels in Photoshop is going to damage them, unless you clone on an Adjustment Layer. So let's proceed with caution. If the offending area is quite small, then straightforward cloning of an immediately adjacent one may do, and will keep damage to a minimum. You can manage the the brush's size with the square-bracket keys, and its hardness or softness by holding down the shift key as you press these.

• **The Healing Brush** This tool works by sampling the pixels around the spot you've clicked on, then generating replacement pixels that blend with those. It is quick, but if you use it too close to an edge you want to retain, it may smudge. You can go in first with the Stamp to remove problem areas that join those you don't want affected. If you want to create a selection within the picture that contains the problem, the cloning work will be constrained by the limits of the selection.

• **The Patch tool** Neither cloning with the Stamp tool nor the Healing Brush are much good for dealing with larger grievances, such as utility poles. For those I'd recommend that you use the Patch tool. When it works well it is more seamless than the other two, and also more likely to match the texture of adjacent areas. Yet there has to be clear water between the edge of the Patch and any important detail, so you will need to get out the Stamp tool first and clone out where the two meet.

LIMITS
Creative work aside, that is pretty much the end of Photoshop's involvement in my image production these days. In terms of correcting global contrast, colour work and spot removal, Lightroom has taken over all these roles in a non-destructive environment. Yet before you tell yourself that you really don't need Photoshop and start spending the money elsewhere, remember that it has some very powerful tools that you may not want to be without.

<div style="background:gray">

DOUBLE TROUBLE
Whenever you open a Photoshop file start by duplicating the Background layer. Mistakes are less serious if the origional background is untouched.

</div>

ADJUSTMENT **LAYERS** AND **LAYER MASKS**

It's useful to show you these features of Photoshop together as they are often used in conjunction. While doing as much as you can in Lightroom is the ideal, you shouldn't be nervous of pushing pixels around in Photoshop, so long as you work with a 16-bit TIFF version of the image, which gives you as much data as you need.

ADJUSTMENT LAYERS

An Adjustment Layer allows you to edit the image non-destructively until you decide to flatten the image or to merge it with other layers. Until then, you can make any number of refinements to it without harming the original data (see top right). Amongst the different types of Adjustment layers available from the menu at the bottom of the Layers Palette, the one I reach for most often is Curves.

CURVES ADJUSTMENT LEVEL

I've already sorted out the picture's contrast in Lightroom. What I want to do here is to darken the sky since it doesn't quite have the menace the scene calls for (see top, bottom). With the Levels displayed – cmd L (crtl L) – I can see that everything is within the histogram, but the sky is just too pale.

I didn't use the Graduated Filter in Lightroom, or one in front of my lens, because I would have darkened the tops of the hills as well as the sky. By using a Curves Adjustment Layer, then painting away parts of its mask, I have precise control over which areas are darkened and by how much.

Levels displayed.

Making a Curve Adjustment level.

Curves dialogue box.

Mask filled with black.

Mask painted away to reveal darker sky below.

The Curves box (see top left) appears when I make the Adjustment Layer. To darken the sky – indeed, the whole picture – I drop the curve down from the centre until the sky looks dark enough. Clearly, I don't want the rest of the scene darkened, so I can either 'paint' away parts of the Adjustment Layer's mask to reveal the original foreground and hills, or hide the mask and paint it back in over the sky. Let's go with the first option.

LAYER MASK

In the Adjustment Layer, the Layer Mask is currently white, so you can see its effect (see centre left). Fill it with black – cmd backspace (ctrl backspace) – and the effect disappears. We're now going to paint away parts of the mask to reveal the dark sky below (see bottom left).

Near the bottom of the Tools palette, set the Foreground to white – you can toggle between black & white by pressing X. If another colour altogether is set as Foreground, just click on the tiny icon above it to reset. Working with a large, soft-edged brush, paint with white on the black mask to darken the sky – make sure that you've clicked on the mask first. It's a good idea to reduce the opacity of the brush as this gives you the option to go over tricky areas several times and helps your adjustments appear more seamless. On the mask icon, you will see that when you reduce opacity, parts of the mask you have worked on are shown as grey rather than white.

GRADUATION
Except for the time taken to do this, this method of darkening the sky is superior to using graduation ND filters in front of the lens.

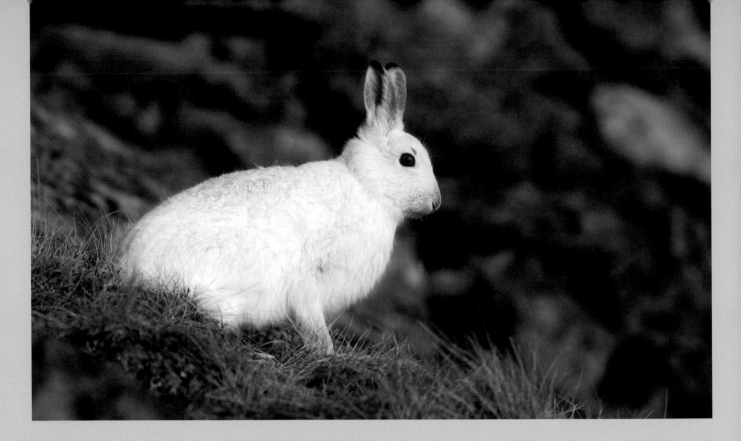

One of the advantages of working with Layer Masks — either independently or as part of an Adjustment Layer — is that if you make a mistake or change your mind, perhaps over-darkening a patch of sky, you can easily restore it by pressing X and painting it back in.

Sometimes it is handier to make changes to the whole picture — leave the Adjustment Layer Mask white, then re-paint the subject with black, as I did with this mountain hare (see pictures across this spread).

If you have exposed the picture carefully and taken full advantage of Lightroom's suite of tools, the number of occasions when you'll need to use these tools will be rather few. I was struggling to find examples from my catalogue that could be used here as an illustration. Some photographers are keen on high dynamic range (HDR) shooting where a string of identical pictures shot at different exposures are blended together to create an image with detail from the darkest shadows to the brightest highlights. However, this often looks phony; while we may perceive this range with our eyes, our conditioned expectations of how things look in print are different.

Mountain hare, Glenshee, Scotland.
Nikon D2x, 420mm, ISO 200, 1/500 sec at f/4.5

BRUSH WORK
It's best start with brush opacity at a low setting and gradually build up the effect.

The starting point.

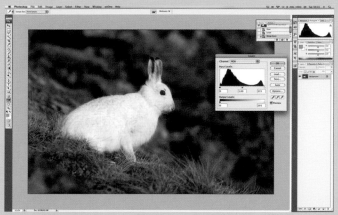

The flattened image.

Making a Curves Adjustment Layer.

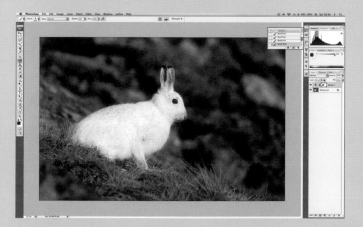

Painting away part of the Curves Adjustment Layer Mask.

SMART OBJECTS

If you interested in bringing together several pictures on a single page, Smart Objects is *the* tool for the job. So long as you don't try to make the picture bigger than the original, you can resize it non-destructively using the Free Transform command – cmd shift T (ctrl shift T) – to your heart's content until it is rendered. This is a real boon if you are creating a panel with several images on it as it is not always easy to be sure of the precise dimensions of the composite elements at the outset. With Smart Objects, you don't need to worry.

QUICK SUMMARY

We'll use Smart Objects for some work tomorrow evening. In the meantime, here's a quick overview:

Create a Photoshop document the size you need – cmd N (ctrl N) – then use the Place command under the File menu to specify which pictures you want to import. As you do so, they are automatically converted into Smart Objects and the Free Transform handles are applied. You can move the image around the page, make it smaller or rotate it. To maintain the picture's aspect ratio, don't forget to hold down the shift key. These elements remain editable without detriment until Rasterized (when they are converted into a bitmapped image), at which point they revert back to normal.

HOW SHOULD WE CRITIQUE
OUTDOOR PHOTOGRAPHY?

Let me tell you what led me to this particular line of enquiry. A few years ago, I walked into a plush Scottish art gallery where a small oil painting on a display easel immediately caught my eye. I took a closer look, incredulous. There, selling for a substantial amount of money, was a perfect copy of one of my published tawny owl photographs, faithful in every detail to the original transparency.

ART DEFINED

On that same day, I tracked down another 'original' oil painting by the same artist of the very same image, selling for a similar price through another gallery, this time up in the north of England. Copyright infringement aside, this episode rankled on two counts. The artist was shameless in claiming someone else's vision as his own, that much was obvious. However, more troubling was why this scene in oils was considered 'art', whereas my original photograph wasn't. I'd always imagined art to be more about the message than the medium; clearly I was wrong. If the received wisdom that images become art by being hung in a gallery is true, what hope is there for nature photography to be taken seriously when few important galleries are willing to give it wall space?

It seems to me that one of the major obstacles to critical discussion about nature photography, practised with creative intent rather than for mere visual gratification, is the absence of a literature on the subject. While other photographic genres have attracted critical examination of their origins, evolution, guiding ideas and practitioners, gaining acceptance by the art

Common gull, Sør Trondelag, Norway.
In this business the beauty of a 'song'
is often greatly exceeded by the volume
of its 'performance'.
Nikon D2x, 500mm, ISO 200, 1/160 sec at f/5.6

establishment along the way, wildlife photography is bereft of such an analysis. The period during which it has become a mass-participation activity has coincided with a time when contempt for ideas is rife and attempts to apply rigorous thinking and analysis are derided by those terrified of intellectual labels. The result is critical anarchy in which most attention is paid to those whose core competence is self-promotion.

FUNDAMENTALS

Central to any dialogue about art is the question of what constitutes 'good work'. What makes up the critical framework we need to distinguish the enduring from the ephemeral?

We can't look to the art establishment for help. 'Art', when generally discussed, is highly anthropocentric; if the work fails to comment on the human condition, it is seen as inadmissible and dismissed as sentimental. Thoughtful nature photography acknowledges the primacy of natural process and comments on relationships within the natural world or between it and us. Ignorance of the natural world, and our place in it, on the part of a metropolitan-based art establishment is at the heart of the problem: critics just don't know how to read it.

Perhaps our work could be judged, in part, by how reactionary it is. A good deal of contemporary mainstream art is profoundly self-absorbed. Often, the subject is little more than a vehicle for the artist to tell the viewer all about themselves. This has not always been the case as the vast

catalogue of religious art testifies as does work created for private patrons in which the purpose was to make a statement about their status.

Nature photography, in contrast, has always leant more towards preoccupation with the subject rather than self. True, there is now the need for more subjectivity in this genre but ultimately, the picture remains first and foremost about the subject. The photographer acts as translator for the viewer, leading them towards an understanding of wildness, yet leaving space for ambiguity. The photographer's role is to show what happened, rather than what happens. It is this very ambiguity and subjugation of the self that merits thoughtful nature photography the title of reactionary. If you accept this premise, what are the characteristics of the photographs that give it form? How can we mild-mannered nature photographers become reactionaries?

NATURAL VERSUS CLICHÉS

We can start by working hard to produce images that are true to natural process and expression rather than aesthetic convention or commercial imperative. Nature isn't always tidy and well lit. Squirrels aren't always cutely nibbling nuts nor lions throttling wide-eyed ungulates to death. Yet owing to the ubiquity of these clichés in print and the lack of critical comment on them, it is easy to fall into the trap of believing that these are the only worthwhile representations to be made. For the nature photographer, a unique vision is not enough. He or she should also seek out and portray unique experiences, thereby acknowledging the individuality of the subject and reminding us that it is not just subject matter. Respect for the subject, I believe, is heightened by taking the trouble not only to learn its name, but to follow its life for some time – the surest way to gain that vital fresh insight.

Had images of natural pathos and drama entered the public consciousness as profoundly as Steve McCurry's *Afghan Girl*, many more nature photographers may have moved beyond focusing on technique and equipment, and dreamed of the photograph's power to communicate. Nevertheless, good technique is the clear voice in which the subject is introduced to the viewer and, in an ironic way, the high technical

standard of much contemporary nature photography is itself a reaction against the inarticulate mumbling of 'work' created in other genres and mediums by artists with self-knowledge and perhaps even insight about their subjects, but only very rudimentary skills with which to express it.

THINKING WITH YOUR HEAD

Perhaps the single most important attribute of a 'fine nature photograph' is its ability to engage the viewer's intellect as well as their heart, to lead them into lines of enquiry about what is happening beyond the frame. This is the subject's story, not the photographer's. Many professionals complain that the plethora of quality stock is making commercial survival ever harder; indeed today, it is a buyer's market. Yet what people have needed since our earliest days is narrative. People crave good stories, stories they haven't heard before. All too often the stock pictures that have tended to define nature photography in the public mind are superficial. They look fabulous for an instant, but they don't endure because they are generic and don't trigger enquiry or wonder in the mind of the thoughtful viewer. The photographer who has a story to tell and the technical skills to present it in a new and fresh way has nothing to fear from their 'competition'.

Photographers are often reluctant to talk about their work, sometimes wisely, but not everyone knows how to read the pictures. There is no shame in helping people to do so and also in making words part of our creative output, too.

Meadow cranesbill in the field studio, Montrose, Scotland.
Nothing more than photography – until it is painted or put up on a gallery wall.
Nikon D2x, 55mm, ISO 100, sec at f/16

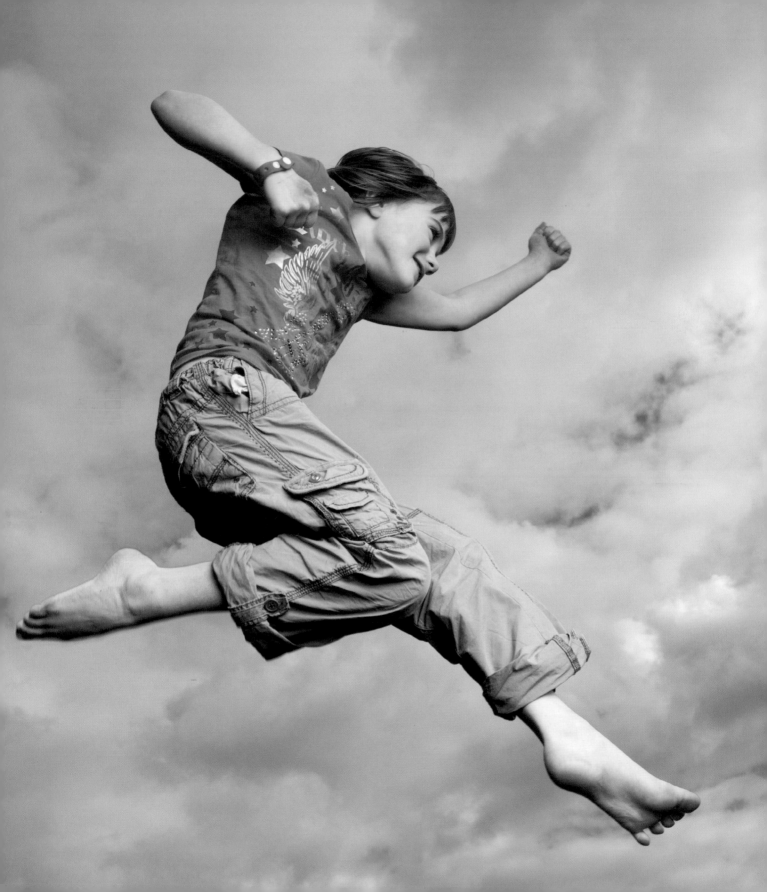

CREATIVITY TAKES TIME

By standards of 'normal' behaviour, spending hours or even days in a hide on land or in water, waiting for a bird to appear, is considered slightly eccentric. 'You must have a lot of patience', people say sympathetically, when in fact I'm just stubborn. Usually, it is not worth trying to explain why hide time not only makes sense, but why, from our perspective as wildlife photographers, we often feel compelled to do it.

MOTIVATIONS

The reasons we take ourselves to these peripheries of 'reasonable' behaviour are as numerous as those of us willing to do so. Sometimes, there may be an economic imperative, at other times the resulting kudos acts as a motive. There may also be a strong desire to see and photograph what no other person has ever witnessed. Whatever the motivation, the driving force is creativity and in some of us, the urge to create can be as powerful as any of our other basic instincts.

Creativity in the context of writing has been characterized as 'the successful resolution of internal conflicts'. Yet for us photographers it is more about the urge to realize a vision, to show other people what we have seen or imagined. The more powerful the urge, the more crushing a missed opportunity is. An unexpected consequence, in my case at least, is that virtually all my acquisitive instincts for material objects have reformed over time into a lusty greed for new ideas and experiences, and a drive to make pictures out of them. I envy nobody their possessions, but there are many whose experiences I long to have as my own.

Flying girl
Push yourself to the limit and you will find that you can achieve things you didn't know were possible.
Nikon D3, 55mm, ISO 400, fill flash in a 135cm softbox, 1/125 sec at f/16

LIMITATIONS

'Nature-photo banquets' around the world offer you the same spectacular photo experience as thousands of others before you. Those of us who avoid these banquets can find our diet pretty lean, unless we put a lot of time and work into researching sites and waiting in the hide to see if anything appears. If you have limited holiday time each year, working your own patch in depth becomes the only realistic option. Pictures come slowly; experiences are hard won. This is certainly the best training for when you do have the opportunity to feast somewhere with abundant photographic opportunities. Yet living on that rich diet all the time demands ever more spectacular encounters if the level of creative satisfaction is to be maintained.

DRIVING FORWARD

We can draw parallels with people who take part in extreme sports, such as base jumping or slack lining. 'We have strong evidence that the feelings of being elated and excited because you are moving toward achieving an important goal are biochemically based, though they can be modified through experience', comments Professor Richard Depue of Cornell University's Laboratory of the Neurobiology of Personality and Emotion. He believes that differing levels of, or sensitivity to, the neurotransmitter dopamine goes a long way to account for the fact that some individuals are highly motivated or 'incentive-reward' driven, while others are less focused on particular goals. What motivates extreme-sports participants, and perhaps those with a highly developed creative drive,

is the need to experience the sensation associated with the stimulation of the dopamine system. I know from personal experience that a strong sense of well-being descends for a couple of days after I've created some new work that I'm happy with. However, like the base jumper who has to find ever more daring places to launch from for his or her dopamine hit, so the difficulty of producing new images that trigger this response ever increases.

A further twist is added by another neurotransmitter, serotonin, often referred to in the context of Seasonal Affective Disorder (SAD) or 'winter blues'. Here, reduced levels or activity of serotonin (stimulated in part by the brain's reaction to short days and darkness) can lead to people becoming more irritable and volatile than usual. At these times, the response to dopamine is heightened. Reviewing my collection, the majority of my favourite pictures have been taken during the winter. That may be simply because I like the colours and simplicity of winter, but it could also be due to the fact that the effect of these pictures was more powerful when I first saw them compared to how I felt about the shots taken in the summer months.

So, in winter, I can now characterize myself as 'serotonally-deprived' and blame my endless pursuit of new images on my dopamine system. The obvious solution is to book the ultimate safari, to a place where lots of wild animals and close encounters are guaranteed. Yet that would offend other instincts. Perhaps I'll just stay at home and try to come down from the dopamine. After all, creativity is also about finding new solutions to old problems.

ANOTHER PERSPECTIVE

As photographers, our creativity amounts to more than the images we make. The photographs are the final outcome of the process, but if we can take pleasure at each stage in their creation, there is more chance of satisfying our creative urge. In other words, the journey should be enjoyed as much as the destination.

While more and more dramatic encounters and exciting opportunities may be craved by photographers working in the expressive mode, those pursuing narrative images have a different problem: finding inspiration in the first place. Rather than inspiration, which has a super-natural connotation, let's think instead in terms of 'source'. Given that there are very few completely original ideas in the ether, the chances are that your narrative image is going to be drawn from an existing idea, reprocessed by your creativity, then produced as a novel piece of work.

But where are the sources? Well, in terms of style, the wrapping paper used to make the idea interesting to a potential viewer, that may come from other photographers in different disciplines; clearly the field-studio work in this book has roots in studio portraiture. I pick up other ideas from mishearing things on the radio or in speech, which are then translated into signs, or from reading non-fiction. Travelling beyond your everyday environment can often cause a creative re-boot in your brain. I've found that photographically unproductive trips are often the richest for new ideas or different ways of thinking about what I've done already.

Each stage of the process of making and having your work seen has scope for creativity, something that photographers who view their work as business are at risk of overlooking.

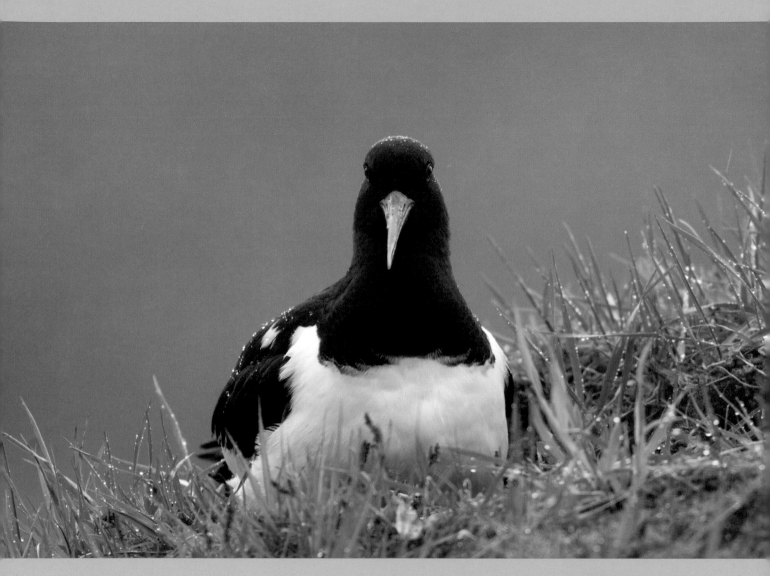

Oystercatcher, near Vinje, Norway.
If you are stuck at home and unable
to get out with your camera, use your
time wisely and plan your next shoot.
Nikon D2x, 700mm, ISO 200, 1/250 sec at f/5.6

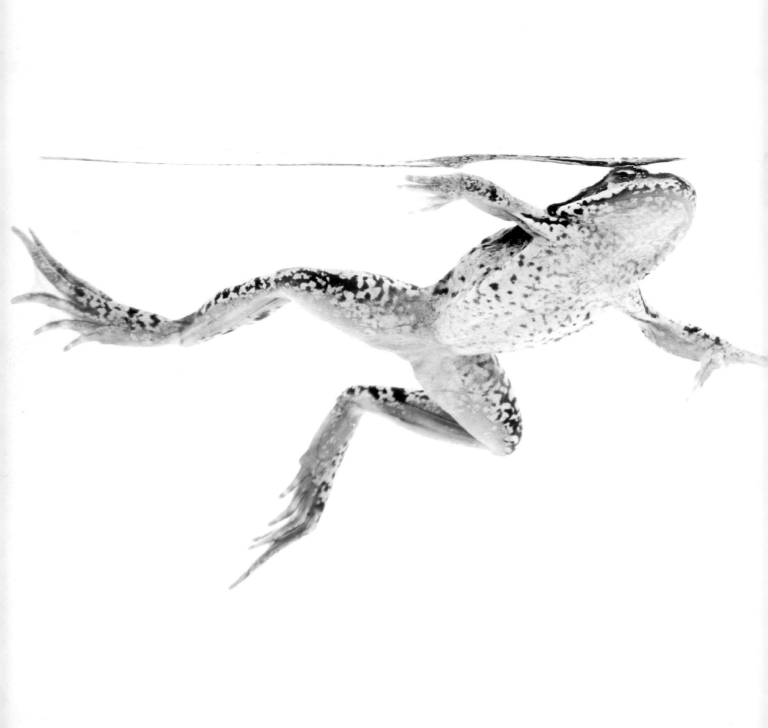

day 3

THE FIELD **STUDIO**

Thanks to all that bedtime reading last night, we've not managed an early start this morning. Dawn has been and gone, and now it's just another grey and green summer's day with a light breeze, but that's not a problem. Today, we are going to use various field studios that allow us to work independently of the weather and make some beautiful pictures in the process.

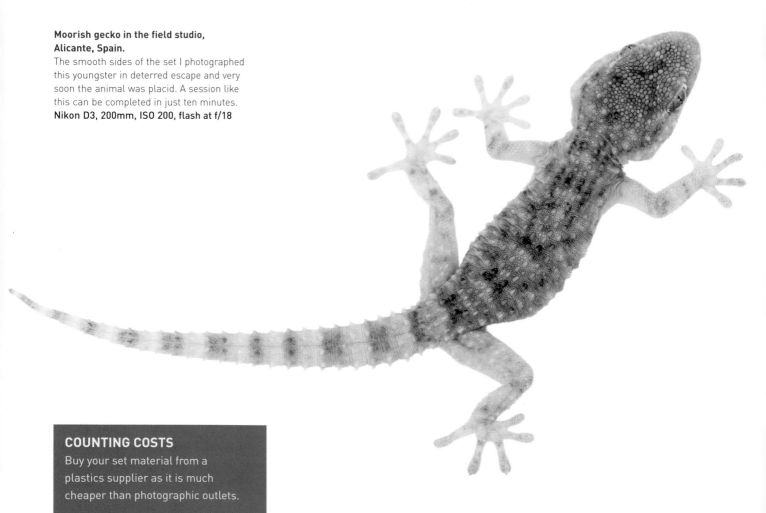

Moorish gecko in the field studio, Alicante, Spain.
The smooth sides of the set I photographed this youngster in deterred escape and very soon the animal was placid. A session like this can be completed in just ten minutes.
Nikon D3, 200mm, ISO 200, flash at f/18

COUNTING COSTS
Buy your set material from a plastics supplier as it is much cheaper than photographic outlets.

We are going to photograph the subjects in situ against a backlit, pure white background (with the exception of underwater subjects). These nearly shadowless portraits not only describe the subject in amazing detail, but they also reveal its translucent qualities. The pictures have a glow absent from conventional white-background work carried out in the studio, and a verity borne out of being made in the field. Without the context of its environment, the subject becomes an individual rather than simply a member of an ecosystem.

ORIGINS

My own line of inspiration traces back to the great American portrait photographer, Richard Avedon, whose 1947 portrait of a boy and a tree in Sicily led him to understand the sheer strength of the simple white background. Susan Middleton assisted Avedon in the mid-1980s, and '...became fascinated with the idea of making a portrait of a plant or an animal that could evoke the same kind of emotional response in the viewer that a fine portrait of a person could'. She and her colleague David Liittschwager's work on endangered species over the intervening years has been driven by the belief that it is possible to do this. The pair often use plain backgrounds to dignify their subjects.

What we're going to do today, then, should be seen as the continuity of a tradition — albeit one in another genre — rather than something ground-breaking and radical. I really enjoy this cross-pollination of ideas and influences. It is interesting to note just how many popular nature images feature very pale, sometimes white, natural backgrounds. We are simply taking the next step and producing a pure, clean background in-camera.

TOOLS

I use a pretty fancy set-up for this work because I do a lot of it and I like the control I get with the gear that I use. You can arrive at the same results (albeit less conveniently) with a couple of old manual flashguns, synch. leads, some Perspex (Plexiglass) and plastic envelope stiffener. It really is as simple as that. In time you could also add some relatively inexpensive clamps and stands to compensate for having only one pair of hands.

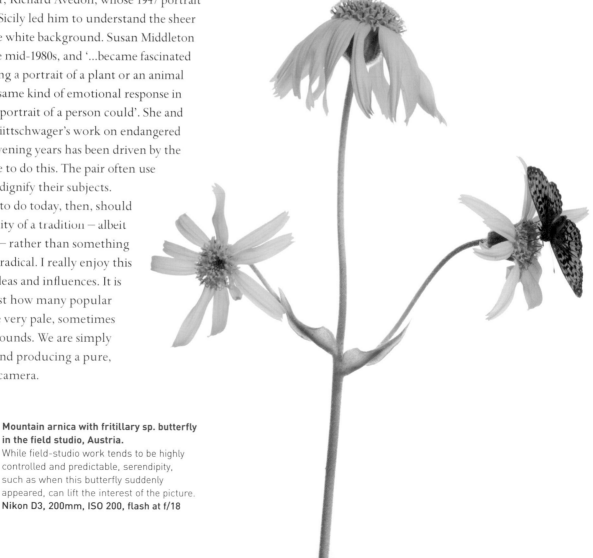

Mountain arnica with fritillary sp. butterfly in the field studio, Austria.
While field-studio work tends to be highly controlled and predictable, serendipity, such as when this butterfly suddenly appeared, can lift the interest of the picture.
Nikon D3, 200mm, ISO 200, flash at f/18

FINDING YOUR MODELS

Let's keep in sight what we're trying to achieve: a portrait that stops the viewer in their tracks, encourages them to look really closely at the subject and perhaps even to feel awed by its beauty. The toughest part of the job is not technical, it's about finding the specimens that have personality. Plants do have personalities, which manifest in things such as their vigour, freedom from disease, and pose — resulting from the balance between their leaves, flowers and stems. Some specimens simply look better on set than others, so it's best to audition hopefuls by first placing the piece of Perspex behind them before committing to a screen test. Invertebrates, in some ways, are more inscrutable, so it is a matter of working with a variety of models, each for a short time, and seeing which has the best attitude on set.

BALANCING THE LIGHT

I first started making white-background plant pictures in the late 1990s, but on film it was very hard to consistently balance subject and background exposure. Digital capture is hugely enabling in this respect. We are looking for a background that has a value of 255 (white) in each channel. Not a bit grey, nor pure white in the middle and dimming towards the edges, but 255 from corner to corner. We are effectively cutting out the subject in-camera, so the picture can be laid out on a page or as part of a composite without any further work. In practice, it is sometimes hard to light a large piece of background Perspex from corner to corner. In these cases, ensure that the background immediately around the subject is 255 in each channel (set your camera to blink a

highlight warning if necessary), then paint out the corners in Lightroom using the Adjustment Brush. Although it's best to save yourself the extra work and get it right in the first place.

BACKGROUND POSITIONING

The distance between the subject and the background is crucial. At the correct exposure, the backlit Perspex is 255 in each channel, regardless of whether it is positioned 4in (10cm) or 40in (1m) behind the subject. A certain amount of light coming from behind spills forwards and makes the subject glow. Obviously the effect will be stronger the closer the background is to the subject. If the subject is pale or delicate in the first place, it is likely to become very hard to separate it from the background at the processing stage.

The rule is really simple: for opaque or dark subjects, keep the background close; for all others move it further back. If you minimize the influence of forward spill by distancing the backdrop, it is even possible to photograph white flowers on a white background successfully.

Cornfield 'weeds' in the field studio, Scotland (composite of ten images).
Assembling a montage is itself a creative process, but remain true to the subjects by maintaining the same magnification ratio and natural associations.
Nikon D2x, 200mm, ISO 100, flash at f/20

GETTING EXPOSURE JUST RIGHT

We want to blow out the background so that it's white, but only just or we'll find it difficult to manage forward spill of light. Even a third of a stop can make the difference between pure white and pale grey. Don't plug in your front-fill flash until you've determined the correct exposure for the background. Set the flash and camera to manual and make a series of test exposures, adjusting the aperture, the flash's output or the ISO by one-third of a stop each time. The shutter speed should be the fastest one your camera can synchronize with manual flash.

The histogram should show all the background blinking overexposed, but none of the subject. There will be a distinct lack of values on the left side of the histogram, yet so long as some levels have registered in the second quarter you'll be able to bring back the darker tones during processing. Next, turn on your front light. Although I use a flash head in a small softbox these days, you can fire the flash through a piece of opaque envelope stiffener for a similar quality of light. The stiffener should be closer to the subject than the flash to achieve the

gentlest feathering. Check the histogram again to make sure that no parts of the subject are overexposed. Move the fill back and forth until you've struck a good balance between showing translucence and front detail.

Don't worry if the picture looks a bit wishy-washy, you've captured as many levels as possible and made your cut-out in-camera. It will turn into something beautiful in Lightroom.

WORKING WITH INVERTEBRATES

While plants are relatively straightforward, bugs are less so. For these I use a curved, clear or opaque set suspended from a stand. I can position it to shoot a subject either from the side (as I would a grasshopper) or from above (which is more appropriate for the majority of beetles). The clear set is used if the animal is too translucent to appear directly on the white Perspex and needs some distance from the background. In these cases, I put a softbox behind the clear set and it becomes the background. Equally, you could point a couple of flashguns at a big reflector.

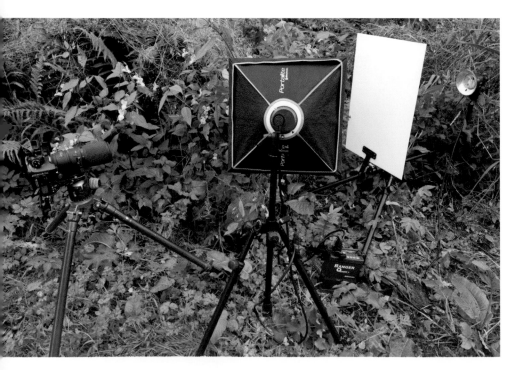

STICK WITH IT
Old, manual flashguns are just fine for this work; don't waste money on TTL guns.

Field-studio set for flowers, Scotland.
This is my current set-up, using the Elinchrom Ranger Quadra system with two heads (one inside the softbox).
Nikon D3, 28mm, ISO 800, 1/200 sec at f/8

Harebell in the field studio, Montrose, Scotland.
Take time to find the most elegant and also
the most representative specimen; it's on its
own in the frame with nowhere to hide.
Nikon D2x, 55mm, ISO 100, flash at f/16

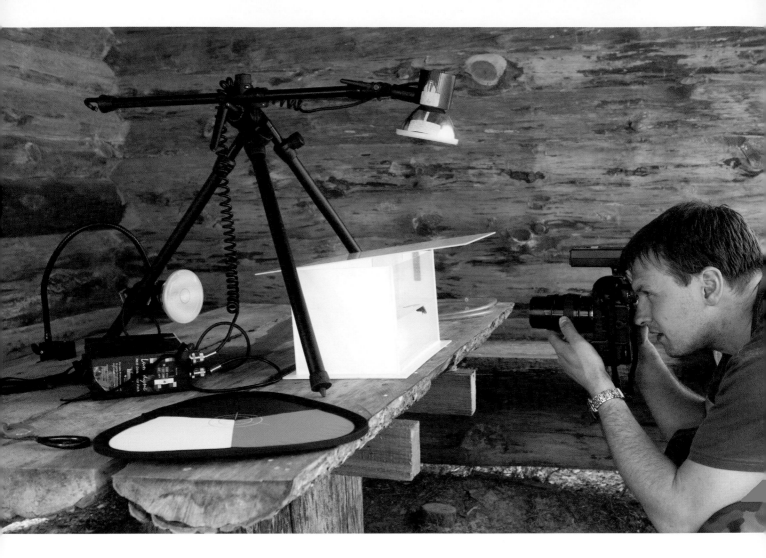

Jaanus Järva photographing a smooth newt inside the field tank.
Most amphibians and aquatic invertebrates are photographed in this set. A diffuser on the top of the tank helps to keep the lighting shadow-free.

I like to keep the animal's time on set to a minimum and therefore prepare everything before the creature is caught and transferred. If you are unfamiliar with a species, it's best to work with an entomologist who can tell you if its behaviour suggests that it is stressed. If it is, the session ends straight away and the creature is returned to its spot. Purists may disparage the moving animals at all; however, in light of the casual destruction of many sorts of wildlife on the roads, in the course of agriculture and industry, and even in our own gardens, a short spell on the celestial set is comparatively harmless. Our side of the deal is to make sure that people see the pictures and, if not care, at least take an interest in the subject.

AMPHIBIANS

Frogs, newts and toads are highly charismatic subjects, never more so than when they are in their element. Yet amphibians worldwide are dying of chytridiomycosis, and many populations are in catastrophic decline. Help to prevent its spread by using

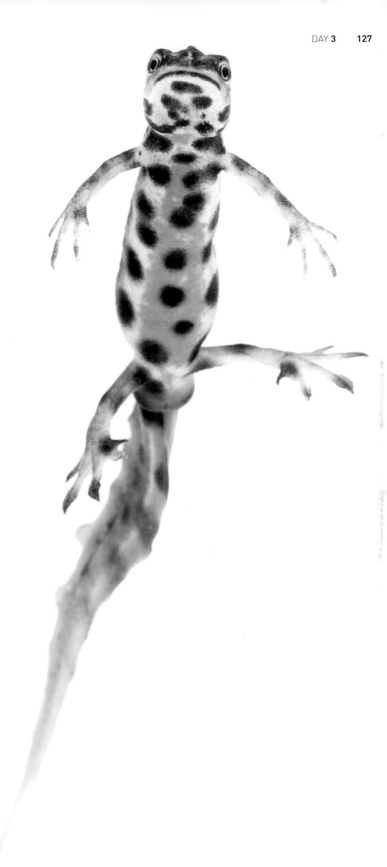

Smooth newt in the field studio, Alam Pedja, Estonia.
My friend and I set up my 'wet' studio in a shaded picnic
hut close to a pond full of newts in the forest. Set time
was kept to a minimum and soon this fellow was back
in the pond trying to impress the females. If nothing else,
at least we were very impressed by him.
Nikon D3, 200mm, ISO 200, flash at f/20

purified water in your tank and by using new nets for dipping
in each pond. It is also important to place the bottles in the host
pond to warm or cool the water to the same temperature.
Put up your set in the shade and don't discard the water after
the shoot near watercourses with amphibians. Clean the tank
thoroughly after each shoot, and avoid handling the amphibians
with your bare hands.

So long as the subject is quite small, build a small tank
with Perspex. It is less fragile than glass and its tensile strength
is greater. As a result, I can get away with a front pane that is
only 1⁄16 in (1.5mm) thick.

If you're worried that flash is going to cause lots of reflections,
don't be. Since I'm aiming to expose the background as pure
white, any that might show there will be blown out. Front
lighting comes from a single diffused flash above the tank; its
angle ensures that there are no reflections from the Perspex
in front of the animal. And since you're probably shooting at
about 1/200 sec at f/22, ambient light won't show either.

What is more of a problem are small specks on the surface
of the Perspex. When it is cleaned, it generates a static charge
that draws dust, pollen and fibres from the cleaning cloth.
Best to keep a small squeegee on hand to burst the bubbles that
form on the Perspex as the water changes temperature; you'll
get rid of some of the fibres in the process. Also, be aware that
Perspex is very easily scratched. Where these scratches coincide
with out-of-focus parts of the animal, they will show up clearly.

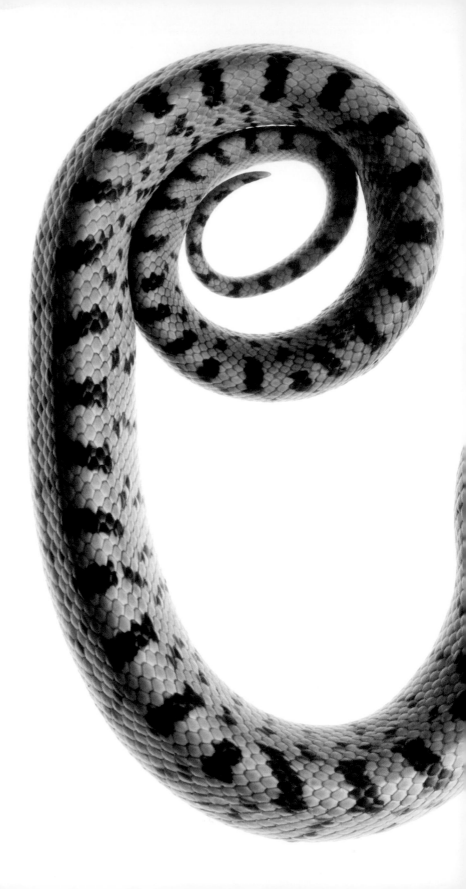

**Young ladder snake in the field studio,
Alicante, Spain.**
It is the form of the subject itself, rather
than a photographic composition, that
provides the interest in field-studio pictures.
Nikon D3, 55mm, ISO 800, flash at f/16

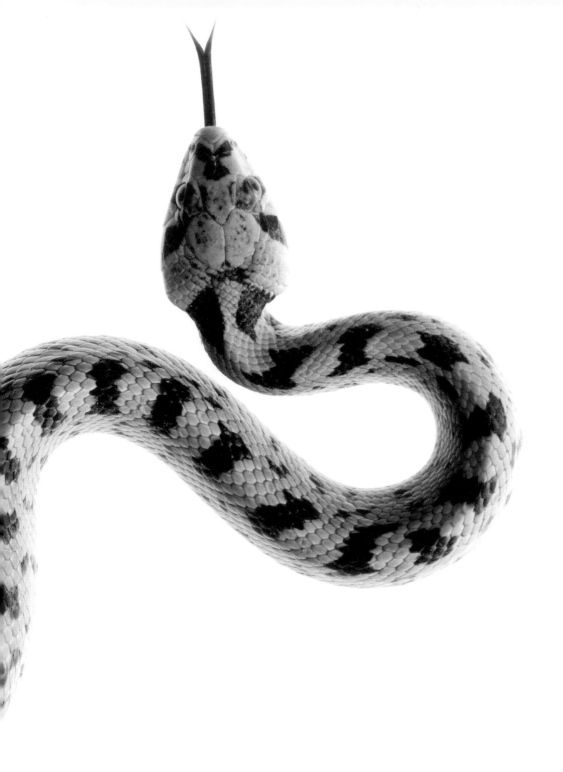

PROJECT **PHOTOGRAPHY**

The world is awash with great imagery, but so much of it feels like snippets of overheard conversations, leaving you yearning to hear more. If you want an audience to hear about your passion, put a project together, then sit them down and tell the whole story. Coherence of style, themes and vision is what gets work noticed and published.

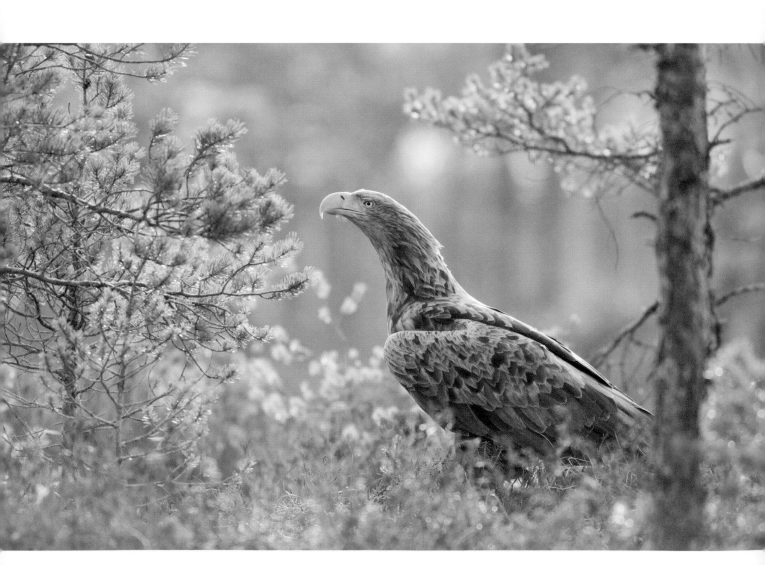

Safe urban playground, Scotland.
I emphasized the bleakness and poverty of experience offered by this playground by de-saturating the colours; old and faded had the right negative connotations.
Nikon D2x, 80–200mm, ISO 100, 1/4 sec at f/16

CREATING YOUR OWN PROJECT

Whether the project is one of the biggest nature-photography projects ever run – or a more modest neighbourhood initiative, the basic steps and principles remain the same.

FORM THE TEAM

If you want your project to have an impact, you'll need to team up with others who share your passion and have the complementary skills to take the project to another level. These skills include writing and editing, stills photography, videography, new media and sound, and marketing. We can achieve much more in collaboration than by working individually; whether you are a professional or a recreational photographer putting the project together in your spare time.

DESCRIBE WHAT THE PROJECT IS ABOUT

If you are looking for financial support, nothing is more off-putting than a woolly concept or a lack of ambition. You should be aiming to describe your project in just one sentence. Wild Wonders of Europe summed up its vision neatly, 'Unseen, unexpected, unforgettable: revealing Europe's natural crown jewels to 700 million Europeans and to the World.' It's simple, to the point and certainly ambitious.

IDENTIFY YOUR TARGET AUDIENCE

Plan how to make your message appealing to your audience. Clearly, a teen audience requires the work to be produced and presented in a very different way from a more mature, gallery-going one.

Sea eagle, Alam Pedja, Estonia.
Project photography can be as simple as highlighting the importance of an undervalued species or part of the world.
Nikon D3, 700mm, ISO 1600, 1/640 sec at f/5.6

SEEK ENDORSEMENT

Let's face it, nature photographers are not famous, even the famous one. We need the credibility that can be lent by respected organizations to validate our project in the mind of potential funders. Ideally, endorsing partners are looking to gain from the project's success, perhaps because it reinforces their own message.

FINDING FUNDING

This is tricky. Normally, it is easier to get goods and services in kind rather than hard cash, and unless you present the project professionally, not even that is likely to be forthcoming.

There are two main routes to funding you can explore: foundations and corporations. There are several different organizations that distribute funding to what their Trustees

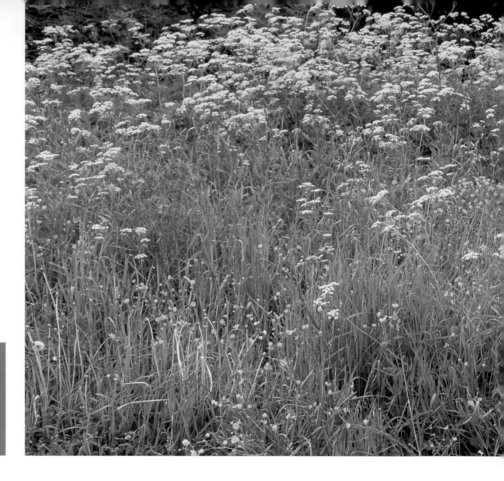

Estonia girl at the forest edge.
This is a picture from the Rewilding Childhood project, looking at how children in different parts of Europe experience wild nature today. With a context, a picture like this has a chance of being seen as something other than obvious decoration.
Hasselblad XPan, 45 mm with centre-spot filter, Velvia 50, 1/60 sec at f/5.6

SPEAK OUT
Good photography is a powerful tool to get your voice heard. Use it to lobby for things you care about.

judge to be worthwhile initiatives. Very few of these are relevant to our field, but the application process is cut and dried: fill out the forms, send them in and then wait to see what happens. It's always worth a try.

CORPORATE

Big companies are inundated with requests for funding and, in truth, unless you have built a relationship with a particular company in the first place, you're unlikely to get past the main reception. Having said that, it can be done, as Wild Wonders of Europe proved, by offering a deal which the companies would be foolish not to take up, either because of the excellent PR or the many economic benefits the project could generate.

In addition, many companies give out corporate gifts, which sometimes in the form of books. You will find that book that has been produced specifically for that particular company – one coming out of your project – has a great deal more kudos than a consignment of best-sellers from Amazon. It also allows the company to parade its credentials much more effectively.

Whichever route you decide to follow, you will need a detailed budget that can be defended line-by-line to potential funders.

COMPLETE IT WITHIN THE SET LIMITS

Ultimately, completing a project within the limits set by the funding may mean that you have to use your own money for the project, but at least a team of people could pool their financial resources to achieve more. The key question you need to ask at the beginning of the active phase is, 'Now that we know how much we have to work with, what can we do?' If you are unable to find any external funding, then your ambitions will just have to be scaled back. Yet if the concept is strong enough, it will gain interest as the work is done and distributed. Sometimes you just have to get started and see where it leads you.

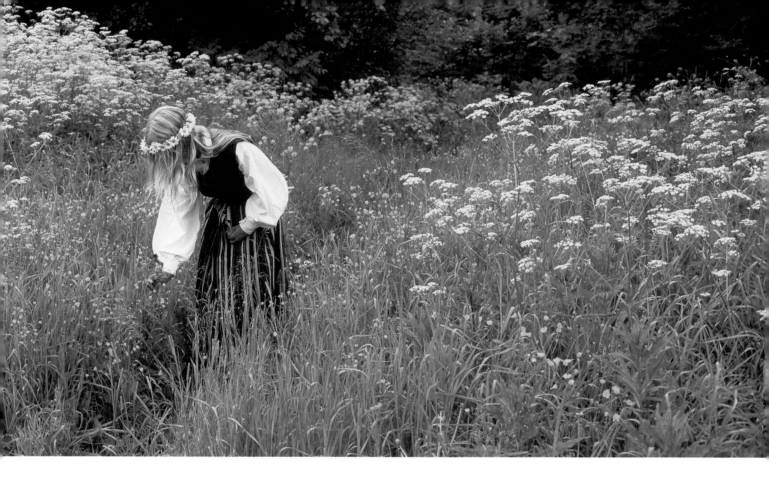

EXPLORE YOUR DISTRIBUTION OPTIONS

Today, distribution no longer need entail the huge expense of book publishing and gallery exhibitions. Indeed, these outlets create only a limited number of 'impressions' compared to the web. It may not be as 'nice' as having a hardcover book or prints on a wall, but if the project is a hit on the web you've a better chance of traditional media taking an interest, too.

DON'T LOSE SIGHT OF CREATIVITY

I used to think that gravitas and formality were the essential characteristics of a good proposal. In fact, I've seen that what people really respond to are great ideas with potential to reach a lot of other people that are described with passion, originality and honesty. These principles should inform the whole project.

Project photography is liberating since you are not limited to shooting 'what will sell' or what a stock library is likely to accept. The photography is there to serve the project and you can be as creative as you like, as long as it makes sense in

the project's context. In other words, a few random concept pictures on their own probably aren't going to be noticed, but put them into the mix with video, audio and some well-chosen words and they suddenly make sense.

It is looking increasingly likely that professional stills photographers will work more and more as part of production units rather than as individuals. So, if this is a profession you want to get into, first go and find your team.

MAKE SOME NOISE

When you are shooting the project don't overlook the importance of sound in storytelling. Get a sound recordist on board; it is a special skill.

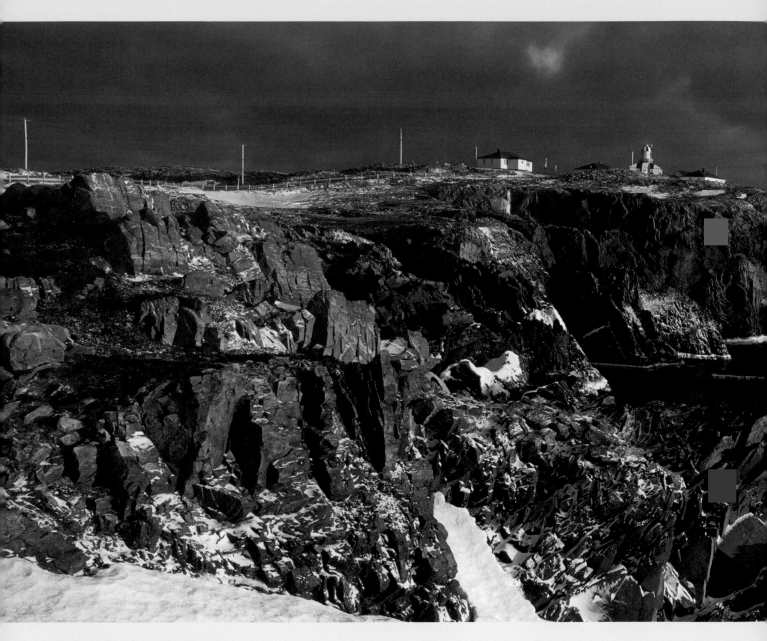

Near Cape Bonavista, Newfoundland.
The utility poles have really caught the
early morning light beautifully. It is easier
to remove these, if you wish to, in Photoshop
rather than Lightroom.
**Hassleblad XPan 45mm with centre-spot
ND filter, Velvia 50, 1/8 sec at f/11**

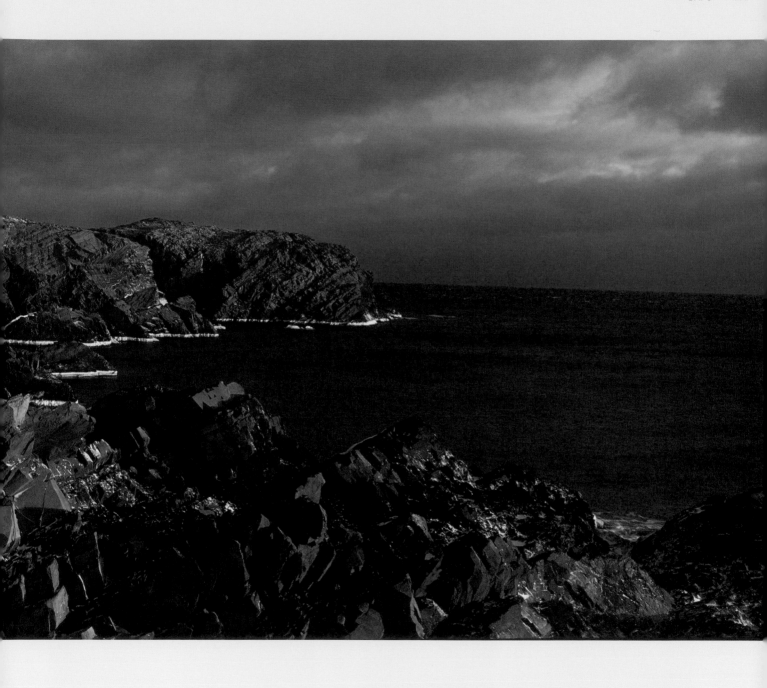

A **BACKWARD** GLANCE

What we are about to do is subjective, creative and exciting. Some traditionalists might even regard it as a bit subversive. It's certainly not something you can do in your RAW converter. So boot up Photoshop – we're going to have some fun with manipulating colours.

Kittiwakes, Lofotens, Norway.
Nikon F5, 420mm, Velvia 50, 1/30 sec at f/5.6

Adjusting hue/saturation.

Twisting the Blue curve.

Applying Paint Daubs.

WHY, SOMETIMES, OLD IS GOOD

Well, it's for the same reason we convert some images to black & white: the process creates an emotional dimension absent in the 'straight' picture. The aim is to make a more effective expressive image. In these examples I want the viewer, to immediately think, 'Ah, this is something from the past that I have a vague recollection of'. To achieve this we need to create a particular look (separate from the content) that harmonizes with the viewer's visual associations with things past. On the most obvious level, we can do that by converting the picture to black & white, then sepia-tinting it. More subtle, but perhaps also more evocative of our own early days, is the use of the palette of faded colours, often biased towards magenta, which is associated with childhood snapshots.

The Polaroid transfer process, more than any other, is fabulous for making these pictures of memories. Yet, putting aside the availability of the necessary equipment and materials, it is an incredibly fickle and expensive process with a high failure rate and no possibility of replicating a success other than by scanning prints. After wasting a lot of money, I began to look for a digital solution that would mimic some of this process's look.

MAKING IT HAPPEN, DIGITALLY

There are many ways of recreating this look in Photoshop. The stages I describe here provide just one option. We're going to work on a scanned photo of kittiwakes in the Lofoten Islands. Many seabird populations are in serious decline, so I wanted to create a nostalgic look to evoke the feeling we get when we look at old photographs of animals dear to us, but long gone.

To start, let's duplicate the background layer – cmd J (or ctrl J on PCs), then apply a Hue and Saturation Adjustment Layer to it (see top left).

We'll reduce opacity to -55. Once you're satisfied that you've got the right value, Merge Down – cmd E (ctrl E), then duplicate that layer. Now apply a rather strange Curves Adjustment Layer (see centre left).

This is where we are going to introduce the odd change in colour, or colour shift, reminiscent of old colour snapshots. Select the blue channel before dragging the curve into the shape shown on the previous page (see centre), then select the red channel and boost red.

Once again Merge Down and duplicate when you're happy with the look. You can turn off the eye icons in turn on the Layers palette to see how the image is changing. We are already heading in the right direction, but the image is still way too 'clean' compared to a Polaroid transfer print and needs to be manipulated a bit (a digital capture would be even smoother). You'll be surprised at how much image degradation you need to apply before any noise becomes visible in the final print.

MANIPULATION

If the file is 16-bit, a number of filters in Photoshop will be unavailable, so convert it now to 8-bit. If this was a digital capture, I would add Gaussian Noise from the Filter Menu, setting it to about 5. Yet this scan has enough noise — a 'roughening' of the pixels — of its own. Instead, by working on the second layer from the top with its icon off, I'm going to create some texture that will blend later with the layer above it. Paint Daubs breaks up the image while retaining reasonable amounts of detail as shown on the previous page (see bottom).

Since this is applied to a layer below the top one (its duplicate, without Daubs), I can alter the strength of the effect by reducing the opacity of the top layer, which effectively acts as a mask (see top right). How much image degradation to apply is a matter of personal taste, as well as the final output media. There is no point in adding texture if you are going to print on canvas. In addition, some textured stock removes the need for any work beyond colour adjustment. To finish the image, I'm looking to re-enforce the idea of 'past' with a frame, so I choose one from a Photoshop plug-in (PhotoFrame) that resembles a disintegrating emulsion (see centre right).

While Polaroid transfer-purists may rightly scoff that this is a pale shadow of their craft, the digital method is accessible and affordable to many more photographers. It also goes pretty far down the road of memory evocation. Yet there is much scope for refinement, too.

Reducing the intensity of the Daubs effect.

Layers with finishing frame.

Colour noise at ISO 6400 provides texture.

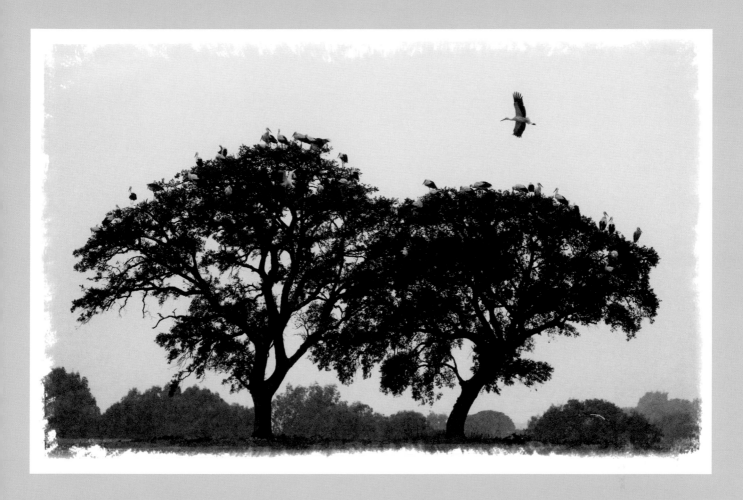

White storks, near Seville, Spain.
Nikon D3, 280mm, ISO 6400, 1/400 sec at f/5

ALTERNATIVE WAYS BACK

Perhaps the more conventional route to nostalgia is via the sepia tint. You can do this within Lightroom using the Presets and Grayscale tools, or in Photoshop with a Black & White Adjustment Layer. There are also many plug-ins that will apply a variety of monochrome effects. Yet before you start running any of them, again ask yourself the questions we spoke about when discussing black & white photography (see page 89).

My justification for the shot on the previous page (see bottom), was simple: it was a timeless scene with the light and the colours giving little clue to the season or the time of day. As it was shot at ISO 6400, lots of colour noise appeared in the darker areas. When the image had a Black & White Adjustment Layer applied in Photoshop, the noise created a stippling effect to give a more 'organic' look than is normally associated with digital images. The frame harmonized with the rough-and-ready background.

FONTS, FRAMES AND FOXING

Thoughtfully used, frames can enhance the feeling or mood of a photograph, especially if the theme is 'old' since it gives it a much more finished appearance. Sometimes a photograph actually needs a frame, not for expressive reasons, but because it blends unacceptably with the page. This is especially the case with high-key images, where contrast is low but brightness is high, or those with pure white backgrounds.

FRAMING YOUR SHOT

White background shots tend to work best when the subject is discrete – that is, it doesn't meet the edge of the frame – or where there is minimal contact, for example, with a plant's stem. Problems arise when we try to shoot compositions in which many elements come to the frame's edge, such as in the picture here of the common chameleon. By virtue of the animal's environment, it wasn't possible to make a discrete composition. Place that photograph on a white page without a frame and it is inconclusive. A frame, even a simple 3-pixel-wide black keyline, contains it and makes the cut-off branch and stems more understandable. This technique allows you to successfully photograph many more subjects than you would be able to without the containing keyline. However, in contrast to usual field-studio pictures, once you draw boundaries around the image you need to give thought to compositional weight and significance since the subject itself is no longer the composition.

KEYLINE

Creating a keyline in Photoshop is easy. Once you've made all your chosen adjustments to the picture, flatten it – Layer> Flatten – then duplicate the background layer – cmd J (ctrl J). You don't need to do this, but it makes it easier to undo mistakes. With that top layer active, select the whole image – cmd A (ctrl A) – then go to Edit>Stroke. Here you can define

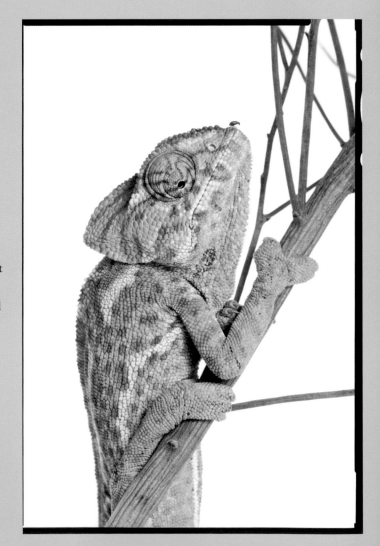

Common chameleon in the field studio, Spain.
Nikon D3, 200mm, ISO 250, flash at f/18

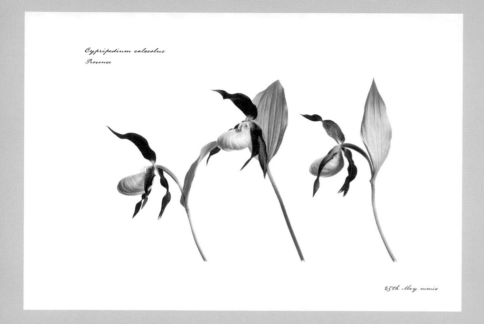

Cypripedium calceolus
Provence

25th May mmix

Lady's slipper orchid in the field studio,
Queyras, France.
Nikon D3, 105mm, ISO 500, flash at f/22

the colour of your keyline, even sampling a colour from the subject, and specify its width. Between three and five pixels is usually enough: you don't want the picture to look funereal. To hide the selection, press cmd H (ctrl H) — this makes it easier to see what you are doing. Once you are satisfied, flatten the image again and save it.

UNPOLISHED

For a more rough-and-ready border, choose its colour in the Foreground colour picker near the bottom of the Tools palette, then select one of the more exotic brushes low down on the Brushes palette (press B to get the Brush tool up first). Slowly work your way round the edges of the frame, distressing it at will. While this may give you the taste for making frames, the effect is fairly crude compared with those found in a Photoshop plug-in, such as PhotoFrame, which is described below.

MAKING AN OLD ILLUSTRATION

We've already briefly looked at using edge effects to emphasize the theme of a picture. Let's focus on this in more depth now to recreate the look of an old botanical illustration. In the same way as painters are often praised for creating something that looks 'just like a photograph', we deserve some credit for making something that looks 'just like a painting'.

Create a new page.

Using the Place command to import an image as a Smart Object.

The starting point is a field-studio portrait of three lady slipper orchid blooms shot in Provence, France. In this particular case, the flowers were growing side-by-side, but I could equally have brought elements from separate images onto the one page as Smart Objects (see page 109).

Once I have made a new document — cmd N (ctrl N) — using a Custom preset for the size of paper I want to print on, I select Place under the File menu and choose the picture I want to be brought into the document as a Smart Object, as shown on the previous page (see centre).

Imported image ready for scaling.

ADJUSTMENTS

Remember that until such time as I render the layer, I can make as many adjustments to the size and rotation as I like without progressively damaging pixel information, so long as I don't exceed the original image dimensions. If I do need it to be larger, it's best to interpolate the file — creating more pixels — first in Photoshop for a better result before converting it to a Smart Object, as shown on the previous page (see centre).

If I want to shrink the image, I can do so by dragging the corner handles around the edge of the 'object' while holding down the Shift key to preserve its aspect ratio. Since I'm happy with the current size I press return (see top right).

We're going to have to do something about the ends of the stems. It wasn't so bad when they met the edge of the frame in the original picture, but now they look too photographic. We'll erase them so that they fade more into the background. Yet as soon as you go to do this, a warning appears reminding you that you can't do anything like this to a Smart Object. So if you are sure that you don't need to resize it further, hit OK to rasterize it (see second from top right).

THE FOREGROUND

The Foreground on the Tool Palette should be set to White — X if it is currently Black (or press the reset icon above it if it is neither). Now use one of the irregular Brushes from the Brush palette with a low-opacity setting gradually to paint away the end of the stems (see third from top right).

Rasterising the Smart Object.

Rough brush for helping with edge effects.

Merging the top layer with the one below.

Choosing a frame from the PhotoFrame Library.

PhotoFrame layer.

Adding text.

FINISHING TOUCHES

Already the image is beginning to appear less photographic. The next stage will complete the illusion. We are going to create a sense of the old by 'foxing' the edges of the image. Foxing is that uneven browning and spotting that you often see in old documents and cheaply printed paperbacks that have been displayed for too long.

One of the best ways to create this is by using the plug-in from OnOne called PhotoFrame which provides lots of highly editable templates to work from. Before you can use it, however, you'll need to duplicate the white Background layer – cmd-J (ctrl J), then Merge Down the top layer with this Background Copy – cmd E (ctrl E). If you omit this, you will be trying to put the foxing on a transparent part of the layer, since the layer with the orchid was smaller than the background in the first instance, as shown on the previous page (see bottom).

So which edge effect will we use? Acid Burn sounds most promising, so let's try one that has a diffused edge but is quite even all the way round (see top left). If you are using 'canned' edge effects, rotate the preset by at least 90 or 180 degrees so that it is not instantly recognizable, for example, acid_burn_ controlled_09. Once we're happy with the extent (it needs to go right to the edge) and the clarity of the foxing, we need to decide on its colour. Try starting with colour values in the region of Red 240, Green 230 and Blue 170, and adjust them as necessary. If it is too subtle the colours won't show; too strong and it will look more like an edge effect than proper foxing. I prefer to be a little heavy-handed at this stage as I know that I can alter the opacity of the PhotoFrame Layer to refine its strength later on (see centre left).

As a final touch, we will add a title to the picture using a font created from handwritten 19th-century manuscripts. (You can buy this and other fonts on-line.) Keep the font layer beneath the one with the edging effect so that it doesn't look superimposed. The stock you will ultimately print this on needs to be sympathetic to the mood you are trying to create – that of an ancient document – so a more matt than gloss paper would be best (see bottom left).

SIGNS OF OUR TIMES

The next stage is to make our own signs using Photoshop. Although at first glance these may look like official ones, their purpose is quite different. They are there to express or to provoke discussion rather than provide information. My own signs tend to be on the subject of our often uncomfortable relationship with nature. Sometimes they are satirical or funny, sometimes mocking. Either way they are a highly effective way of getting an idea across.

GENESIS

The process of coming up with ideas is not too difficult. It starts with you and the issues that you feel strongly about. Look at familiar signs, slogans and labels and identify those you can parody to make your point. While we may change the wording, we need the particular combination of words, shapes and colours to be instantly recognizable to the viewer. We're going to play upon the associations we currently have with these signs, but reinterpret their message or put it in an unfamiliar context. This is a bit like trying to explain a joke; your friends will tell you if the idea works or not.

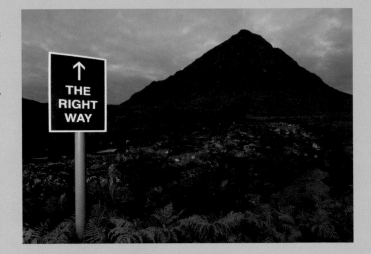

(Top right) **Spoof tourist sign, Glen Etive, Scotland.**
I made this sign to encourage viewers to ask themselves how they would feel if their viewpoints and compositions were prescribed rather than the result of their own vision.
Nikon D2x, 12–24mm, ISO 125, 0.8 sec flash at f/14

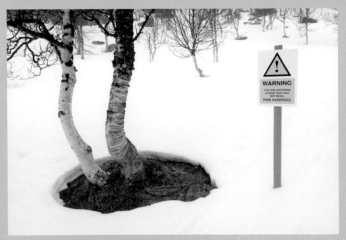

(Right) **Risk assessment sign, Skardalen, Norway.**
Nikon D2x, 12–24mm, ISO 100, 1/30 sec at f/14

Sizing the page.

Create a black triangle...

...then add a yellow one inside it.

PUTTING A SIGN TOGETHER

The widespread culture of risk assessment seems to irk many people. So, we're going to make up a sign, then plant it in a tranquil Norwegian forest. The aim is to cause the viewer to reflect on how they would feel if, in time, even places like this need to be assessed? And what does that say about nature and us? When I say 'plant it', I mean just that: the signs are physically erected and shot on location. Apart from anything else, it's fun to talk to people who come along during the shoot and find out what they think about the issue.

Not many of us have printers capable of making something larger than A3+ (13 x 19in/48.3 x 32.9cm), so let's make that the size of our image – cmd N (ctrl N) – and set the printing resolution to 300ppi (see top left).

If you are used to a dedicated design programme, such as Adobe InDesign or QuarkXPress, you may well find this method primitive. However, relatively few photographers own either of these applications, so let's make do with the tools we have in the full version of Photoshop.

HOW TO DO IT

There is no one standard Risk Assessment sign, but the striking combination of yellow and black, along with an exclamation mark, all have associations with warnings and hazards. Select the Text tool to create the warning triangle (font Wingdings 3, size 950, colour black) (see centre left).

Next, make a much smaller triangle well away from the first, otherwise it will not appear as a separate text layer. Colour this yellow using the Color Picker (try R 253, G 207, B 83) (see bottom left).

Click on its layer in the Layer Palette, then press V to change from Text to Move tool and, with the second triangle's layer still selected, move it above the first. Press T again, then size the yellow triangle until the border looks right. It may take a few alternations between T and V to get everything lined up properly. Finish the triangle off with an exclamation mark (T, font New Times Roman, size 500), as shown on the next page (see top). We'll need a box to contain the text. We could do this with the Marquee tool, but the Rectangle one – U – is

a better option since we can make a box with rounded corners more easily (The Rounded Rectangle option when you click on the Rectangle tool icon in the Tools palette) (see centre right).

Put up a grid to help with the alignment and spacing — cmd " (ctrl "). Fill the shape with the same yellow that you used for the triangle (double click on the left icon in that layer and use the dropper to sample from the triangle).

All that is needed to complete the image is to add your own wording. You've already established in the viewer's mind that this is some sort of official sign because of the shapes and colours that you've used. Don't spoil it now with a wacky font. News Gothic MT looks the part (see bottom right).

FINISHING TOUCHES

Once the sign is printed (we'll look at that process in detail later, see page 152) you need to mount the print so that it will remain flat during the shoot and won't buckle in response to humidity. Perhaps the best material to use is the plastic composite Forex. Unlike foam board and other lightweight or fibre-based materials, Forex doesn't readily buckle. Normally, I use lengths of grey plastic downpipe to support the sign, securing it with a strip of self-adhesive Velcro.

POSITIONING AND PHOTOGRAPHY

All this work is for nothing if you plant the sign at the wrong spot. The setting has got to work with what you are saying with the sign. I have shot this 'Risk Assessed' sign in a number of places now, each one as benign, welcoming and harmless as I could find. The 'Right Way' one, mimicking a visitor-attraction sign, was placed at one of the most heavily photographed mountain locations in the UK. My aim was to get photographers to think about how they would feel if access to these iconic locations was regulated and their experience circumscribed. In these pictures, the setting is just the foil for the sign. We can emphasize this by lighting the sign with a flash fired through a big diffuser and subduing the background in the process.

Add the exclamation mark...

...then a yellow, rounded, rectangle.

Finish with text.

The layer sequence.

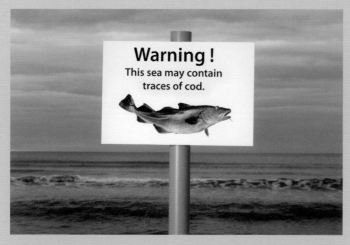

Reflecting on the state of our seas, Scotland.
I photographed this sign near dusk by mixing daylight with flash. This let me render the sky more darkly; this seemed more appropriate for the message.
Nikon D2x, 55mm, ISO 100, 1/10 sec flash at f/10

TEXT EFFECT

I confess that I'm rather fond of Photoshop's text tools. For someone without the time or inclination to learn a 'proper' design application, they allow the user to create quite sophisticated text as part of their image, albeit without the convenience of a design programme.

Whether you are creating text or using Photoshop to lay out image-rich pages, press T to launch the Text tool. Along the bar you can select the text's orientation, the font that will be used and its size. Rather like Smart Object, text can be sized and resized without degrading until its layer is rendered. Don't be afraid to click on the icon at the left of the text-size box and, with the text highlighted, use the mouse to adjust the font size rather than laboriously guessing and typing it into the box.

I often buy fonts online for specific projects and once they are downloaded and stored in the Fonts folder in my Library, they are accessible in Photoshop's drop-down list. Font choice is quite subjective, but a certain amount of common sense is also involved. Something like Futura STD Light, for example, looks incongruous alongside anything ancient. A font that has an element of decay as part of its design, for example LazurAntiqDisplay, sits much better.

If you need to add only a few words to the picture, simply click on it and type away. If the font size, style or colour are wrong, highlight what you've typed and make the necessary adjustments. I quite often sample from key colours within the composition to harmonize image and type.

A useful feature in this respect is the Difference Blending mode in the Layers palette. For example, say that you have a composition with lots of contrast in it, do you choose light or dark type? Select the Difference Blending mode for that layer and the type will behave the opposite way to the pixels beneath it, modified by the font colour. Lay black type over a predominantly dark scene with a bright area in the middle and, in Difference, dark areas will have pale type while the pale areas will have dark type.

For more extensive areas of type, draw a text box by clicking and dragging the Text tool over the image. You will then be able to make use of the Character and Paragraph Palettes (next to the Text Warping one) that lets you refine layout and word spacing.

CREATING **PANORAMAS**

Panoramas are much more popular and easier to make than ever thanks, in part, to brilliant stitching software. If, like me, you find it hard to pre-visualize how the final picture will look, make a letterbox-shaped mask to look through to help with the composition. We no longer need to compose panoramas as if we were shooting film, in a particular aspect ratio or with straight edges. The software allows us to be much more expressive than that.

RETHINKING THE PANORAMA

Firstly, let's take, for example, shooting a panorama of a slope. Conventionally, you could frame it either vertically and miss out a lot of lateral elements, or horizontally and overlook most of the slope. Tilt the camera on its side and the slope becomes a plain. It is possible to take a series of exposures from the top of this slope to the bottom, and assemble them like a series of steps. Liking or disliking the stepped edges of the picture is no more than a matter of convention: we don't see scenes constrained by straight edges any more than we see them surrounded by stepped ones. Once you break away from this convention, many opportunities to take 'cross sections' of the landscape present themselves.

The imported, merged, images.

Selecting the images to be merged.

Add a black background for the image.

PHOTOSHOP'S PHOTOMERGE IN PRACTICE

This Atlantic oak wood on the island of Mull was growing on quite a steep hillside, something that I wanted to represent in a panorama. I sent seven processed DNG files to Photomerge in Photoshop and let the application assemble the image using the Auto Layout option (see previous page, bottom left).

I shot each element as a vertical; this reduces the problem of converging verticals, gives more data to work with and will ultimately provide a bigger file to print (see previous page, top).

I merged the seven layers – shift cmd E (shift ctrl E) – then created a new layer – cmd J (ctrl J) – and put it below the other one containing the merged elements.

At this stage you may want to tidy up the edge slightly if it is too ragged by using the Polygonal Marquee tool (click on the top layer first and use 0-pixel feathering for the Marquee) to select the offending edge. Once you have completed the selection and the 'marching ants' appear, fill it with the bottom layer's colour. If you are relaxed about the stepped edge, simply fill the space with white. Filling it in with black, as I've done

here, may appease more conservative viewers as the work is ultimately bounded by straight edges (see previous page, bottom right).

It's more exciting and challenging to create panoramas of wild animals. Normally, we are focused in so tightly on the creature and what it is doing that we fail to notice the many interesting things going on around it. It's also a great way to represent the subject as part of its environment without shrinking it to minuscule proportions.

Once you've taken the shot of the animal, quickly pan to each side of it to secure the other pictures for the panorama. It's best to do this with a levelled video head. To give yourself space to crop a ragged edge, frame a little wider than perhaps you normally would. You may be lucky and be able to shoot vertical elements, but when time is short count yourself lucky just to get the others done horizontally.

**Atlantic oak forest, Mull, Scotland.
Nikon D2x, 55mm, ISO 100, 0.8 sec
at f/11, seven frames**

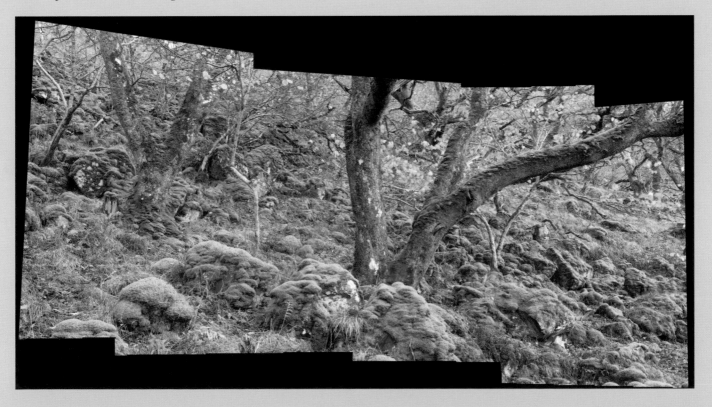

SAVING HOURS **WITH ACTIONS**

Imagine that you have fifty 16-bit RGB TIFF files, each about 70Mb, that you want to send to a magazine. As well an 8-bit version, you think it would also be a good idea to send a low-resolution copy of each file, so the editor can preview the submission more quickly. Do these preparations manually and you'll have a good hour's work ahead of you. Run a couple of Actions, however, and the job can be over in just five minutes while you get on with something else.

Now, some chores can be done in Lightroom. If you have already gone down the parametric editing road simply re-export the file with different settings, see page 58. However, that relies on you having all your pictures in the Catalogue and that they can be easily found there.

CREATING YOUR ACTION

The following explains how to write the Actions for the two tasks outlined at the start. The first, 16- to 8-bit, is very simple. Open a picture (in this case a 16-bit digital capture) and in the Actions palette – Window>Actions – click the Create new

action button at the bottom. Name the Action and select the folder you want it to live in. Everything you do from now will be recorded until you press the stop button. Next, go to Image>Mode>8 Bits/Channel.

That's the only step in this particular Action, so you can do a Save As command and send the copy to a dedicated 8-bit file folder. Whatever you do, don't use Save or you'll overwrite the original file. Doing this will make it easier to locate and delete the files after they have been dispatched. Finally, you *must* close the file before pressing the Stop Recording button on the left or you'll have loads of files on your desktop open all at once.

There are a few more steps involved in writing the preview Action. We'll size the pictures to 768 pixels on the vertical axis (so for a vertical picture the width is about 538 pixels; 1,154 pixels for a horizontal one). These will fit on most current displays without the viewer having to scroll.

It starts off as before: Actions>Create new action and this time we'll call it 768 High (see previous page, bottom). Then it's Image>Mode>8 Bits/ Channel (this Action will work even if the file is 8-bit already).

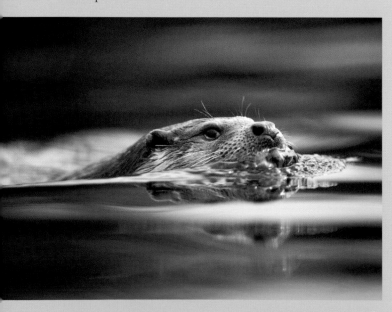

Captive otter, Netherlands.
If you need lots of different versions of a picture, let Photoshop Actions do the work.
Nikon F5, 300mm, Velvia at ISO 100,
1/125 sec at f/4

Image resizing.

Unsharp masking.

Creating a Droplet.

Now, return to the Edit menu and when Convert to Profile presents its dialogue box, select sRGB as the Destination Space. Under Image>Image Size, I size the picture to Height 768 in the Pixel Dimensions box (see top left).

Ignore Document Size as it's not relevant here. While the Bicubic Sharper method of resampling is recommended for image reduction, it can make the picture look over-sharpened. Stick to the default, Bicubic. Sharpening is optional and it's likely that if you applied sharpening presets in Lightroom, you won't need to do it again here. Let's assume that you haven't (see centre left).

Filter>Sharpen>Unsharp Mask brings up the dialogue box. We don't need to be as careful with sharpening for these previews as other more critical uses, so the USM method is adequate. Amount 50, Radius 0.8 (don't overdo this one), and Threshold 4 should be fine. We're just about finished, so press Save As a JPEG, level 10 or 11 in a dedicated previews folder. Don't forget to close the file – cmd W (ctrl W) – before you stop recording the Action.

MAKING THE ACTION A DROPLET

Clearly, Actions can speed things up, but not by much, if you have to open each image in order to run one. That's where Droplets come in; if you drag a batch of image files over a Droplet it will run the Action contained in it on every picture without you doing anything else. Since the image is never fully displayed on screen, the process is fast, even with large files.

Before you can create a Droplet, you'll need an Action for it to run. Go to File>Automate>Create Droplet to bring up an intimidating dialogue box, (bottom, left). Save Droplet In is simply asking where you'd like to store it. You are also to name the Droplet. For consistency use the same one you've given to the Action. I have a folder dedicated to Droplets and drag them on to the desktop for ease of access when they are needed.

Next under Play>Set, select the set that contains the Action you want to make into the Droplet and under Action, locate the Action itself. You don't need to check any of the following boxes. Destination is asking you where you would like the file to go after it has been processed. Click OK and the new Droplet appears in the folder you have asked it to be delivered too.

PREPARING FILES **FOR PRINT**

Making your own prints is fun. It is not always cost-effective when you factor in the expense of the hardware, consumables and your time, but that's not really the point. Printing is the final stage in the image-production process and when you've exercised close control over every other stage, why not this one too? So let's take a look at how to prepare a file for print using Photoshop, and how to print it with a desktop printer.

FIRST, SOFT PROOF

I'd recommend that you start off by soft proofing the picture. This process simulates on screen how a print will look when it's made with a particular printer/paper combination. It can never be a perfect simulation because you are comparing a backlit RGB screen image with one printed in four colours (CMYK) on reflective paper. Nevertheless, soft proofing provides a good indication of which colours may not look as good in print as they do on screen — it effectively prepares

Bring up the Gamut Warning.

Dwarf cornel, Jotunheimen, Norway
Sometimes, glorious on-screen colours can't be matched by your printer.
Nikon D2x, 200mm, ISO 100, 0.6 sec at f/18

Greyed areas show colours that will be clipped (restricted).

High Pass sharpening dialogue box.

The High Pass Layer with Soft Lighting blending mode selected.

Sizing for print.

you for disappointment. Don't worry, it's not that you've done anything wrong, just that there are certain colours in the RGB colour space that can't be fully expressed with CMYK inks. There's a big difference between the extent of the Adobe RGB editing space – the colours that my monitor can display – and what can actually be printed on one of my favourite papers with my eight-ink desktop printer. Having said that, not every picture has colours out at the edge of the colour space. Often you'll see little or no difference between the original image and the soft proof. If there are lots of vivid greens and reds in the picture, they will almost certainly grey out when you run a Gamut Warning – cmd Shift Y (ctrl Shift Y) – to identify problem colours, as shown on the previous page.

In order to soft proof you need to specify the combination of printer and paper. To do this you'll have to make a custom profile – View>Proof Setup>Custom, then make your selections (don't forget to save the profile). You can then toggle back and forth between the normal view and the soft proof with cmd Y (ctrl Y) (see top left). Unfortunately, if there are colours that have died, you can't just go back into the file and increase their saturation as they are already unprintable. You may want to use a Hue Saturation Adjustment Layer in Photoshop and reduce saturation of the problem colours by clicking on Editing and selecting them there (see centre left). Doing this will take you back to square one in terms of flatter colour, but the colours may then be less prone to block when they are printed. Normally, I leave them untouched and accept what the soft proof shows.

RESIZING

Before we size the picture let's speed things up by converting to 8-bit mode if you are still in 16 – Image>Mode>8 Bits/Channel. Next, on to Image Size in the Image menu (see bottom left).

This is the one occasion that you need to pay attention to the Document Size part of the Image Size dialogue box. First, decide what printing resolution you need. The received wisdom suggests that you should always use 300 pixels per inch. So, if the pixel dimensions of the file are 3,000 by 6,000 you can make a print 10 by 20in (250x500mm). With larger prints people don't tend to look at them as closely, so you can comfortably drop it

back to 240ppi or even 180ppi for those with a longer viewing distance. You'll get a bigger print with the same number of pixels if you use a lower resolution and need to interpolate less.

Now, put in the dimensions according to your paper size, bearing in mind that you'll probably be left with a margin if you want to fit the whole image on the page. If you need more pixels you can safely interpolate a digital capture – essentially invent more pixels – by 100% more with specialized software. Under the Bicubic options select Bicubic Smoother.

SHARPENING

Now that you have arrived at the final print size, you may want to add some sharpening, depending on what has already been applied in Lightroom. There are many alternative methods you could use, but High Pass sharpening is as good as any and simple to use. Duplicate the Background Layer – cmd J (ctrl J) – then from the Filters menu, choose High Pass from the Other subset. The Radius setting determines how far from an edge the sharpening will apply: set it to 4; you can modify its effect later if it is too strong (see previous page, top). The top layer is now grey until you select Soft Light or Overlay from the Blending Options, as shown on the previous page (see centre).

One of the nice things about this method is that you can easily adjust the intensity of the sharpening simply by reducing the opacity of the layer. Overlay is a bit more aggressive at the outset than Soft Light: with the latter, you may not need to reduce opacity.

PRINTING WITH PROFILES

We're now ready to print. Your choice of paper should reflect the subject matter: glossier papers for photographs with bright colours, wide contrast and, well, a photographic look to them; pearl or matt papers for less literal, more subtle images with softer colours.

We're going to print through Photoshop using profiles, rather than allow the desktop printer to handle the colour management. This method gives you the best chance of matching the soft-proofed on-screen image with the print. A profile describes the characteristics of a particular printer and paper type. Assuming that you are working on a colour

Page setup.

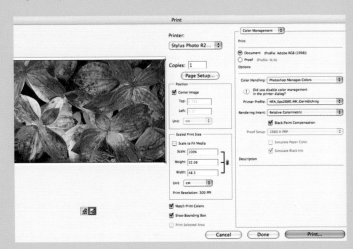

Photoshop Print dialogue box.

Printer dialogue.

Selecting the print media (paper).

Selecting the print resolution.

Crucial – switch off the printer Color Management.

calibrated screen, it also provides the information needed for a match. The accuracy of 'canned' profiles supplied with the printer is often very good now, removing the need to generate your own. However, these are normally for use only with the printer manufacturer's own paper and ink. If you want to use other stock, first ensure that profiles are available for download and that they have one for your printer.

Go to Page Setup and chose the paper size and the printing feed method. Heavy art papers, for example, normally need to be inserted one sheet at a time, often through a different feed from lighter ones. Now orientate the print correctly, as shown on the previous page (see top left). Here we are in Photoshop's Printing dialogue box where, incidentally, we could also have done the page setup (see previous page, centre).

Pay close attention to the controls on the right. Color Management must be selected and under Print, Document checked. We want Photoshop to manage colours and when we select that option, a helpful reminder to disable printer colour management comes up; we'll do that shortly. In Printer Profile select the combination of printer and paper. The two forms of Rendering Intent – Relative Colorimetric and Perceptual – each have advantages, but the latter is a better bet with highly saturated colours. You can preview this in Photoshop, but you can't if you print through Lightroom. Finally, Black Point Compensation is automatically selected.

Now on to your printer's dialogue box, which appears when you click on Print. If you use more than one printer with the computer, select the right one from the long drop-down menu and go to Print Settings (see previous page, bottom left). Here you can specify the type of paper (see top and centre, left). Make sure that you have the right sort of ink in the printer – newer printers have different sorts for matt and glossy stock and your paper type may be greyed out. If this is the case, change the ink to the correct type. When you click Advanced, you can specify the Print Quality: 1440 dpi is optimal.

We're almost there. For the final, crucial, step, return to that long menu and drop down to Color Management. Click Off (No Color Adjustment) or else all your careful profile selection will have been for nothing – then click Print (see bottom left).

DIGITAL BEAMERS

The choice of projectors has become even more complicated with lots of apparently similar digital beamers performing quite differently. Unfortunately, most of them are unsuitable for projecting high-quality photography. If you are used to the on-screen quality of a projected slide, cheap beamers will leave you very disappointed. Nevertheless, ever more affordable hardware and software are narrowing the quality gap, assisted by the massive presentational advantages of the digital medium. To get the best projected image possible we need to think about five separate things, each one with a bearing on the others.

THE LAPTOP

Whether you use a Mac or a PC, an important consideration is whether your laptop's video card is capable of supporting the native resolution of the beamer you plan to use with it. Until quite recently, 1024 x 768 (XGA resolution) was standard, but newer high resolution (SXGA+) projectors have a native resolution of 1,400 x 1,050 pixels. Connect a 1,024 x 768 laptop with an under-powered video card to one of these and the beamer will underperform. In reality, many modern laptops can support devices whose native resolution is greater than their own. My own 17in one (1,680 x 1,050 pixels), for example, is normally connected to a 1,920 x 1,200 LCD display.

Your laptop should connect to the beamer by a DVI lead, rather than a VGA cable. The latter requires conversion of data from digital to analogue, degrading the image in the process.

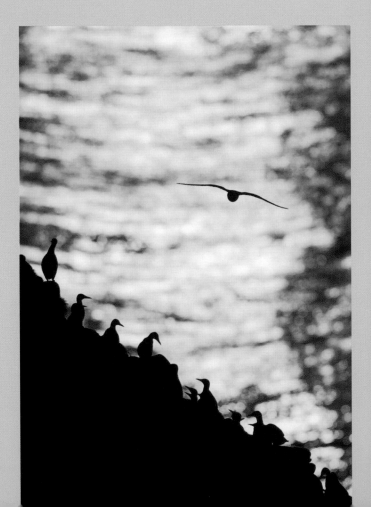

Guillemots and fulmar, Stonehaven, Scotland.
Often colours that are too vivid to print can be projected. Others may be very hard to render accurately on screen.
Nikon F5, 500mm, Velvia 50, 1/250 sec at f/5.6

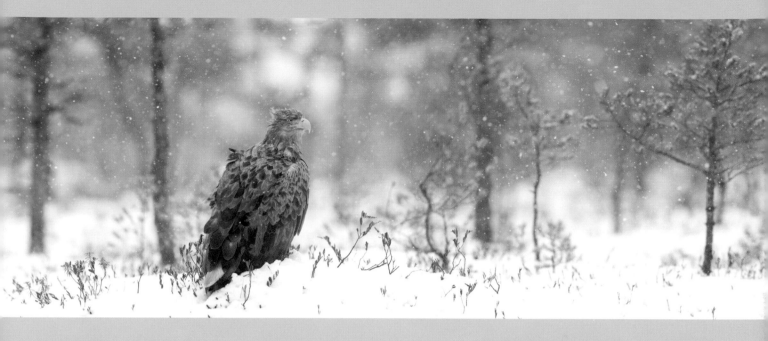

SOFTWARE

A host of programmes are available for the two main platforms and although you may want to invest in a top-end application, like Final Cut Pro, a lot of fun can be had with much cheaper ones. As a Mac user, my first choice is currently FotoMagico by Boinx. Amongst other things, this allows me to pan across images and zoom into particular parts of them (you need higher-resolution files in the first place, of course). PC users have many more applications available to them.

THE BEAMER

Ask yourself whether you really need to go to the additional expense of an SXGA+ machine. Is the difference really visible in a darkened auditorium? Even with a professional 1024 x 768 model, the pixels of a 13ft (4m) wide screen image are clearly visible from around 16ft (5m) away. On the other hand, with some SXGA+ models you may need to go as close as 6½ft (2m) before they can be discerned.

How many lumens do you need? The more the better. In pitch darkness, a 2500 lumens machine with a moderately fast lens can produce a bright 13ft (4m) wide image and a tolerably bright 16ft (5m) one. Be realistic about the size of venues your beamer will be used in most of the time. It might

Sea Eagle, Estonia.
Before slideshow applications that allow a pan across the image, projecting panoramas was either very complex or simply unsatisfactory.
Nikon D3, 700mm, ISO 1000, 1/600 sec at f/5.6

make more sense just to hire a more expensive 5000 lumens if and when required and to use a more modest one the rest of the time. In addition, even 'pro-sumer' models rarely accept interchangeable lenses, so you may end up with the beamer in the middle of the audience. Nevertheless, some machines are very quiet, so this would not be a big problem.

CALIBRATING THE BEAMER

We've already discussed the importance of editing your pictures on a calibrated display. The question we need to ask is: it really necessary to calibrate your beamer too? Some devices generate a profile based on the values shone onto them, a method that takes no account of the characteristics of the projection surface. More expensive devices analyze the colours and tones reflected from the screen, producing a more accurate profile.

The audience is the final user of the projected image; therefore, what really matters is if it looks good on screen — whether this is achieved with a preloaded profile, one generated

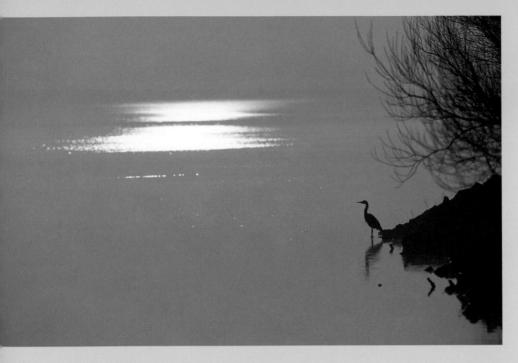

(Left) Grey heron, Montrose, Scotland.
Make your files larger than the native
resolution of your projector so that you
can zoom into them if your slide show
application permits it.
Nikon F5, 500mm, Velvia 50, 1/125 sec at f8

(Right) Pine bark, Sel, Norway.
Digital projection allows us to make
hugely more complex presentations
than was ever possible with slides.
Nikon D2x, 200mm, various exposures

specifically for the combination of screen, laptop, application and beamer, or purely by guesswork. With my own set up, I've found that the high degree of accuracy achieved with a preloaded profile from the beamer's manufacturer doesn't merit the additional expense or indeed the stress of calibrating at every venue.

FILE PREPARATION

The colour gamut of the majority of digital beamers falls within the sRGB space. Therefore, to get the most accurate colours on screen the files need to be converted from Adobe RGB to sRGB, the sRGB profile selected for the beamer, and the machine set to sRGB image mode.

Below are the different steps you should record into an Action to speed up the preparation of files for projection.
- If the original high resolution file is in 16-bit, go to Image> Mode>8-bit.
- Next, go to Edit>Convert to Profile and select sRGB.
- Size the image (Image>Image Size). Enter the dimensions that you need (in the case of an SVGA+ beamer, 1,050 pixels vertical axis – for vertical as well as horizontal pictures).

- Apply Unsharp Masking (Filter>Sharpen>Unsharp Mask) to suit the image (it's wise to do some tests and project them to see which levels look best). The benefits of other, more sophisticated ways of sharpening are not really visible in a projected image. Alternatively, if you are a parametric disciple, in other words you prefer to export on demand in the required form rather than sourcing and resizing files already stored on external disks, Lightroom offers three presets for Output Sharpening at the export stage: Save As a JPEG at Quality 10 or 11. Then, close the file before you stop recording the Action.

So that's the how to, but it's only half the story. The potential to share pictures with large outdoor audiences through the use of digital projection is exciting and only just being realized. There is none of the expense of street exhibitions, and shows can rapidly evolve into performances. Since these methods are still relatively novel and can attract a huge web following, some savvy corporations have staged promotions in the form of projection on buildings, knowing that they'll find their way onto social networking sites and that they can connect with their customers that way. Just let your imagination go to work.

PINUS

audience is more interested in hearing about the subject than about me and try to remain objective. It's very easy to slip into self-indulgent anecdotes about how hard you worked for a particular shot, when in reality most people don't care.

SCREEN TIME
In the self-indulgence stakes, the two biggest crimes are related to music and screen time. No matter how fantastic a picture is, it's asking a lot of an audience to look at it for more than 30 seconds. Indeed, few of my images stay on screen for more than ten seconds. If you are making a complex point, do it with several images, not just one. Alternatively, you can help matters by slowly panning across or zooming into an image as you deliver the commentary. Just keep the audience with you.

MUSIC
Whether it is used as part of an audio-visual show or as an overture to a spoken presentation, music is very problematic. Unless the pieces you choose are relatively unknown, the chances are that people will have heard them already and made their own associations. If you use that track to achieve a different interpretive effect the viewer can be left confused or annoyed. Many viewers don't like being told how to feel about what they are seeing on screen by the choice of music.

If the music is necessary, tone poems or incidental music scored for films may be more useful than well-known pieces. Perhaps by working with a sound recordist, you could try creating a natural sound scape instead.

DELIVERY
There are various technical aspects of delivery that can make the difference between a bored and an inspired audience. The most convincing speakers are those that speak without notes, suggesting that they are completely on top of their subject. When it comes to presenting with slides, there is even less excuse to use notes or cue cards. Each of your pictures should act as a cue, therefore every slide should be relevant to the story. Unless I've been asked specifically to speak about my feelings or experiences, I work on the basis that the

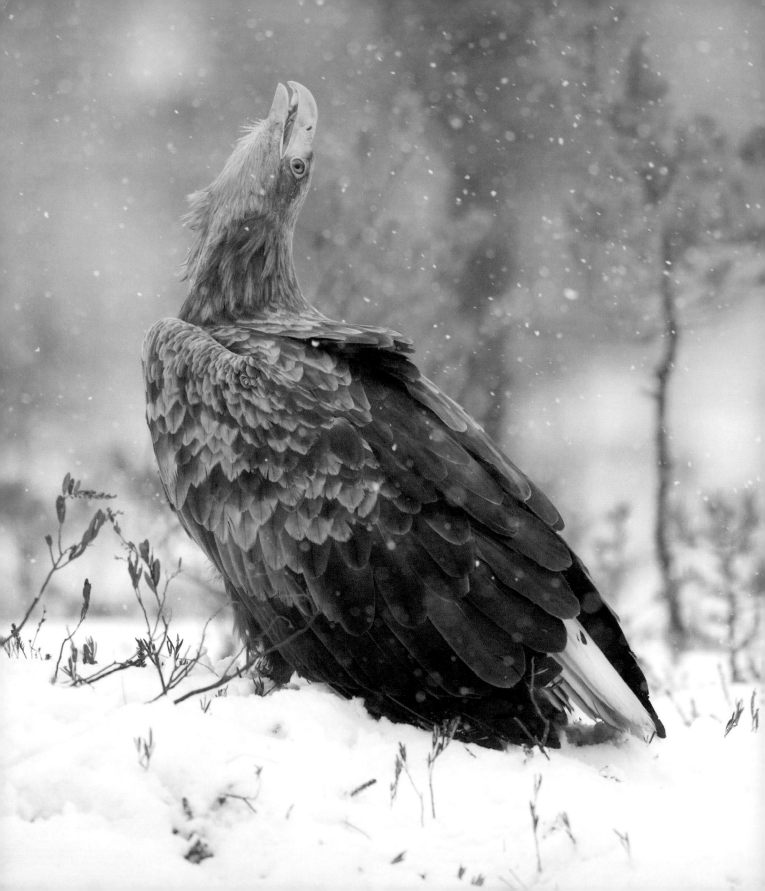

FINDING AND **SHARING**

When I started my career as a photographer and writer 20 years ago, there were relatively few good pictures in print of golden eagles, otters, red squirrels and black grouse, and virtually none of sea eagles or crested tits. Information about sites was the professional photographer's most valuable and closely guarded asset. Yet in this golden age for nature photographers, not only is there fabulous equipment for creating and distributing photographs, but access to a whole range of species has been opened up to anyone with the money to join a photo tour.

I, for one, am glad that many more people (albeit as part of a group and at some expense) can get close to the species that I've photographed over the years and experience the same thrill of proximity; this offers the best possibility of building respect for the animals.

ECOTOURISM

I don't want to construct a case against this sort of photography. If you only have a few weeks' holiday a year and limited spare time, you simply won't have the chance to establish contacts and do the ground work yourself, so it's tempting to buy the package. Also, in several parts of the world eco-tourism has been shown to be beneficial for local economies and for the animals that attract the visitors. They acquire more value alive than dead, providing local people with a real incentive to maintain a population. That is all self-evident and positive.

Having said that, let's put on our stubborn, creative hats and recognize that this sort of spectacular experience can easily become a commodity, consumed by hundreds or thousands of other photographers. There's nothing necessarily wrong with that, yet, it is much harder to tease out your own narrative when it is tightly woven in with those of so many others. It is dishonest to claim ownership of the story when the hard work of establishing the site and building the subject's trust has been done by someone else. On a personal level, great pictures resulting from a relationship which you, rather than someone else, built with the natural world are often more satisfying.

While I don't mean to dismiss the pleasure that many people get from visiting these locations, I also recognize that for many more photographers they are unaffordable. If you're in this majority group, let me reassure you that great work *can* be produced from scratch, possibly even close to where you live. There will be an investment, of course, but in time and imagination rather than hard cash.

PUTTING YOUR FAITH IN LUCK

We have to accept that in most parts of Europe, away from the honey pots, the chances of making good 'stumble-overs' are pretty slim. Most great wildlife pictures don't just appear in front of us; they are the result of much thought, planning and luck. The luck increases in direct relation to the time that we spend in the field; or so it was in the past. More and more photographers are leaving their cameras to put in the field time, waiting for the subject to walk or fly into a camera trap.

Sea eagle, Alam Pedja, Estonia.
There is nothing to match the thrill of working sites and animals that few, if any others, have photographed before. That calls for good fieldwork, and often also good friends.
Nikon D3, 700mm, ISO 1250, 1/100 sec at f/5.6

If you think this is an easy option, think again. How many of us could confidently state that, on a particular day, an animal will pass through a particular spot, a particular way, so that it takes its own picture? If you can, you're probably already using a camera trap. If you're not, you might want to reflect on the possibility for making really unique pictures at that location.

Nesting burrows and dens, along regular trails, feeding stations, drinking and bathing pools, scratching posts and territorial markers are all smart places to try using a camera trap because the odds of the subject appearing are swung a little in your favour. This is where investing your time pays dividends. Knowledge is only acquired through fieldwork and observation, getting to know a subject's habits. Even after all that, you've still got to get the gear to work and keep it secure. This is not easy, yet on the plus side, disturbance by the photographer is minimized and the photographs are unpredictable (so long as you use a large-capacity memory card and don't leave your scent at the trap too often). Importantly, each picture has its own unique background story.

BACKGROUND NARRATIVE

The way that stories are being told is changing. At the time of writing, a few of the top European nature photographers are starting to dabble with the HD video function that more and more cameras now have. While the audience hasn't lost its appetite for the breathtaking still image, it also seems to be enchanted by the behind-the-scenes story that video can show. This is especially fascinating when the still possesses a quality of 'otherness' that the photographer has conjured from the 'real world' portrayed in the moving image.

Economically, I don't think that anyone is quite clear yet where this sort of footage fits in. What we do know is that if you want to encourage more people to a website, you'll have a better chance of doing so with video than with stills alone. Video, of course, has been around for a long time, but now we have the potential to shoot high-quality video and stills with the same camera at the touch of a button. Naturally, if you're a moviemaker this technology holds relatively little appeal, but for storytellers frustrated that things can't always be summarized in a single image, it is a boon.

HIDING OUT

If camera traps are not for you, the main alternative route into the animal's living space is from inside a hide. This also needs lots of preparation to ensure that you don't end up facing the wrong direction for days on end. Even then, most photographers narrow the odds in their favour by attracting their subjects to the hide. Bait provision is a contentious issue, but in reality there would be very few pictures of wild European bears, wolverine, sea eagles, or even blue tits were it not for this practice. While I think that a reasonable argument could be made against it in wilderness areas, in cultural landscapes, where we have already done so much to interrupt natural food chains, denying red squirrels some hazelnuts on ethical grounds seems a little precious.

You may well find that the subjects you want to photograph are more common and easier to access away from home. I'm an avid fan of photographers in different parts of the world co-operating on so-called 'exchange visits'. This is the low-cost alternative to joining a photo tour and offers the added advantage of local perspective and expertise, sometimes even access to little-known locations. I've also found that when friends come to visit Scotland, I start to see familiar places anew through their eyes — it's a two-way creative street.

CAMPAIGN WORK

A similar sort of co-operation can also develop locally if you take the time to build good relationships with conservation Non Governmental Organizations (NGOs). If you take on an official role on their behalf, gaining access, site assistance and permissions is usually much easier than usual. This is just as well as, in spite of the importance of imagery to their campaigns, several NGOs are surprisingly reluctant to pay for images. So here's a tip: rather than invoicing at a nominal fee for licensing rights, charge them a normal commercial fee with a heavy discount. That way, the organization realizes what pictures actually cost, but you're seen to acknowledge the assistance that they have given. A high-profile campaign gives considerable exposure to the photography that drives it and you may well expect to license the pictures independently of the NGO.

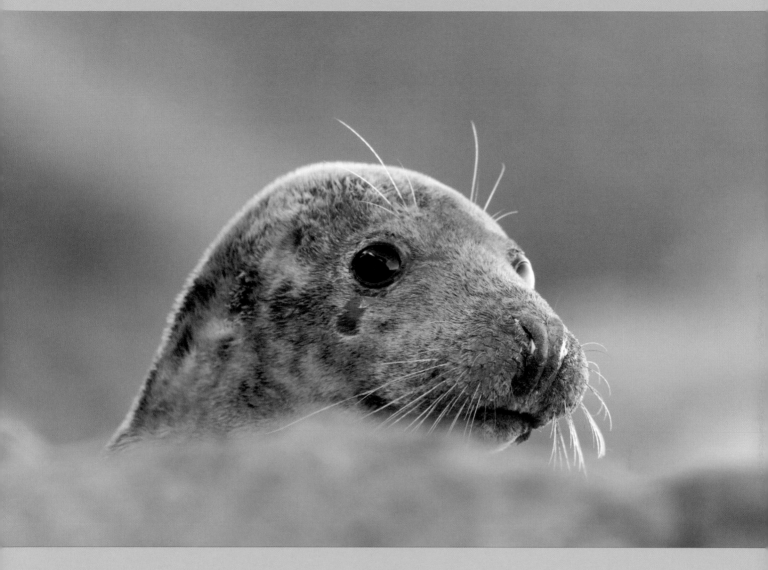

DAILY FIX

Even more than the photography, observation and connection need to be practised. If I haven't picked up a camera for few weeks, it takes a couple of days to really get into the swing of things again. So try to do something creative every day, even if it's just the way you make your morning pancakes. Don't let the spark go out and also try to get a nature fix each day. As I write, I've just seen a stoat with a vole in its mouth dash in front of where I'm parked. No pictures, but it was a view of the real world beyond the computer.

Grey seal, Scotland.
When you discover a new location, be very cautious about sharing it. This is an act of consideration to both the subject and the landowner, not selfishness.
Nikon D2x, 420mm, ISO 200, 1/125 sec at f/4.5

FRIGHTENED INVESTORS 'PILE INTO PROPERTY'.

MARKETS SOAR AS WORLD ACTS TO RESCUE BANK.

PERSONAL GROWTH INDEX

Whether we take photographs for professional or recreational reasons, we do so out of passion and for the satisfaction that we feel when we get it right. In short, photography can make us happy at quite a profound level. For many people, it is the ideal expressive tool. It also provides evidence of our interesting lives.

BENEFITS

Beyond the basic costs of running my household and business, my own 'Personal Growth Index' increasingly reflects the many external benefits of my job, such as the joy of being in wild places and the fascinating people I meet along the way. I have no difficulty in adding them to 'the bottom line' and acknowledging them as core contributors to my standard of living. Once you get into this way of thinking, the instinct to acquire diverts away from material possessions and more towards experiences, encounters and, in our case, images. The things we do buy serve the acquisition of experience rather than making a statement about ourselves.

In the process, we become less susceptible to advertising as we *know* what we actually need since we can't achieve our goal without it. Crucially, we boost our self-esteem, not through the possession of goods designed and made by others, but by things we have thought about and crafted for ourselves; be it prose, a photograph or even just a new idea. This is an altogether different model of consumption: non-destructive and with scope for unlimited growth.

REMAINING OBJECTIVE

At the time when the papers were full of the 2008 banking crisis, I was with a group of Estonian photographers in the north-west Highlands of Scotland. The mountain slopes were saturated, the birch and pine forests harried by westerly winds and the lochs restless and unreflective. Nevertheless, there were also sublime moments as rainbows were conjured from streaky black skies or a torn cloud momentarily allowed the sun to flood through.

I was struck, as I have often been before, by the huge disparity between 'the real world' I was experiencing and that presented by the metropolitan media. I made a series of pictures highlighting this incongruity by juxtaposing the photographs with news headlines used on the day the images were taken. My aim was to encourage the viewer to reflect on notions of 'the real world' by setting pictures of timeless and enduring natural processes alongside breathless statements of doom that will be long forgotten before even a tiny amount is eroded from the surface of the water-worked sandstone that appears in each of the pictures.

Torridon, Scotland.
Spectacular views of Torridon, Scotland, juxtaposed with actual news headlines from the 2008 banking crisis.
Nikon D3, 80–200mm, various exposures

STAND OUT FROM THE CROWD

Each of us probably reacted differently to the event. If I had lost a well-paid city job, I probably would not have viewed the crisis with such detachment. Yet as creatives, we each need to examine our reactions and find ways to demonstrate those feelings. Many photographers worry about originality, when, in fact, all they need to do is be themselves in their images, rather than trying to copy those they regard as 'successful' photographers. They also had to do the basic 10,000 hours to become as good as they are. Value your take, even if it isn't immediately popular, although be prepared to defend it. As you pick up on the ideas in this book and gain confidence in trying out new things, you may well go through a phase of feeling creatively isolated, especially as your work no longer looks like 'proper' nature photography. Press on; the web will allow you to find your community sooner or later.

If you're worried about originality, here's something else to ponder. Most of us work jolly hard to make as many great pictures as we can. Sometimes we're extra lucky and make an iconic image along the way. Most photographers work this way and if you visit the same locations as others, the chances of getting your work seen are often quite slim, even if there's a lot of it. So, instead of aiming to make 1,000 very good, yet replicable, new images a year, try concentrating on producing perhaps six unique, quite new images instead.

A good example is Michael 'Nick' Nichols's perfectly joined panorama of a giant redwood from top to foot composed of 84 images taken from a rig that travelled parallel to the length of the tree. The preparations were lengthy and the execution was extremely challenging, but the audience for this image is massive compared to normal pictures of redwoods.

ONE STEP FURTHER

Anyone who has been to a national park will know that the vast majority of visitor activity is concentrated within a couple of hundred yards of the car park. Therefore, the approach I'm suggesting is the equivalent of a hike deep into the back country. You'll meet very few others there and you'll be able to show the folks back at the visitor's centre something they couldn't shoot from where they have stayed. It's a lot of effort to get there in terms of imagination and perseverance and you may have only one picture to show for it, but what a picture.

AVOID MARKETING TRAPS

When you have that unique, long strived for image, put it to work. Don't get hung up on marketing your image: aim for exposure and the profit will follow, if that is what you want. International photography competitions provide a great platform for photographers, even for those with very few pictures, so long as they are the results of long hikes into the creative backwoods. In addition, while conservation charities and NGOs may not always have picture budgets, an image supporting a high-profile campaign could well provide broader exposure. You'll also have done a good thing along the way.

The surest way to fail as a photographer, spiritually if not commercially, is to put raising profit ahead of passion and to compromise on the standards expected of us as the ambassadors of the natural world. Some of the most respected professional nature photographers earn very little money compared to most other business people. Yet they are still hugely successful because they are comfortable living on the fringes of mainstream culture. In fact, for any of us humbled by the experience of wild nature, that seems like the natural place to be.

More awe-inspiring shots taken in Torridon, Scotland, and placed alongside real headlines. Nikon D3, 17–35mm, various exposures

SLUMP PUSHES JOBLESS TOWARD TWO MILLION.

MARKET CRASH SHAKES WORLD.

GLOSSARY

Aberration An imperfection in the image, caused by the optics of a lens.

AE (autoexposure) lock A camera control that locks in the exposure value, allowing an image to be recomposed.

Angle of view The area of a scene that a lens takes in, measured in degrees.

Aperture The opening in a camera lens through which light passes to expose the CMOS sensor. The relative size of the aperture is denoted by f/stops.

Autofocus (AF) A reliable through-the-lens focusing system allowing accurate focus without the user manually turning the lens.

Bracketing Taking a series of identical pictures, changing only the exposure, usually in half or one f/stop (+/−) differences.

Buffer The in-camera memory of a digital camera.

Burst size The maximum number of frames that a digital camera can shoot before its buffer becomes full.

Cable release A device used to trigger the shutter of a tripod-mounted camera at a distance to avoid camera shake.

Centre-weighted metering A way of determining the exposure of a photograph placing importance on the lightmeter reading at the centre of the frame.

Chromic aberration The inability of a lens to bring spectrum colours into focus at any one point.

CMOS (complementary oxide semi-conductor) A microchip consisting of a grid of millions of light sensitive cells — the more sensors, the greater the number of pixels and the higher the resolution of the final image.

Colour temperature The colour of a light source expressed in degrees Kelvin (K).

CompactFlash card A digital storage mechanism offering safe and reliable storage.

Compression The process by which digital files are reduced in size.

Contrast The range between the highlight and shadow areas of an image, or a marked difference in illumination between colours or adjacent areas.

Depth of field (DOF) The amount of an image that appears acceptably sharp. This is controlled by the aperture: the smaller the aperture, the greater the depth of field.

Dioptre Unit Expressing the power of a lens.

dpi (dots per inch) Measure of the resolution of a printer or a scanner. The more dots per inch, the higher the resolution.

Dynamic range The ability of the camera's sensor to capture a full range of shadows and highlights.

EF (extended focus) lenses Canon's range of fast, ultra-quiet autofocus lenses.

Evaluative metering A metering system whereby light reflected from several subject areas is calculated based on algorithms.

Exposure The amount of light allowed to hit the CMOS sensor, controlled by aperture, shutter speed and ISO-E. Also the act of taking a photograph, as in 'making an exposure'.

Exposure compensation A control that allows intentional over- or underexposure.

Extension tubes Hollow spacers that fit between the camera body and lens, typically used for close-up work. The tubes increase the focal length of the lens, as well as magnifying the subject.

Fill-in flash Flash combined with daylight in an exposure. Used with naturally backlit or harshly side-lit or top-lit subjects to prevent silhouettes forming, or to add extra light to the shadow areas of a well-lit scene.

Filter A piece of coloured, or coated, glass or plastic placed in front of the lens.

F-stop Number assigned to a particular lens aperture. Wide apertures are denoted by small numbers such as f/2; and small apertures by large numbers such as f/22.

Focal length The distance, usually in millimetres, from the optical centre point of a lens element to its focal point.

Focal length and multiplication factor The CMOS sensor of the EOS 350D / Digital Rebel XT measures 22.2 x 14.8mm — smaller than 35mm film. The effective focal length of the lens appears to be multiplied by 1.6.

fps (frames per second) The ability of a digital camera to process one image and be ready to shoot the next.

Histogram A graph used to represent the distribution of tones in an image.

Hotshoe An accessory shoe with electrical contacts that allows synchronization between the camera and a flashgun.

Hotspot A light area with a loss of detail in the highlights. This is a common problem in flash photography.

Incident-light reading Meter reading based on the light falling on the subject.

Interpolation A way of increasing the file size of a digital image by adding pixels, thereby increasing its resolution.

ISO-E (International Standards Organization) The sensitivity of the CMOS sensor measured in terms equivalent to the ISO rating of a film.

JPEG (Joint Photographic Experts Group) JPEG compression can reduce file sizes to about 5% of their original size.

LCD (liquid crystal display) The flat screen on a digital camera that allows the user to preview digital images.

Macro A term used to describe close focusing and the close-focusing ability of a lens.

Megapixel One million pixels equals one megapixel.

Memory card A removable storage device for digital cameras.

Microdrives Small hard disks that fit in a CompactFlash slot, resulting in larger storage capabilities.

Mirror lock-up Allows the reflex mirror of an SLR to be raised and held in the 'up' position, before the exposure is made.

Pixel Abbreviation of 'picture element'. Pixels are the smallest bits of information that combine to form a digital image.

Predictive autofocus An autofocus system that can continuously track a moving subject.

Noise Coloured image interference caused by stray electrical signals.

PictBridge The industry standard for sending information for printing directly from a camera to a printer, without having to connect to a computer.

Red-eye reduction A system that causes the pupils of a subject to shrink by shining a light prior to taking the flash picture.

Resolution The number of pixels used to either capture an image or display it, usually expressed in ppi. The higher the resolution, the finer the detail.

RGB (red, green, blue) Computers and other digital devices understand colour information as shades of red, green and blue.

Rule-of-thirds A compositional device that places the key elements of a picture at points along imagined lines that divide the frame into thirds.

Shading The effect of light striking a photosensor at anything other than right angles is to lose resolution.

Shutter The mechanism that controls the amount of light reaching the sensor by opening and closing when the shutter release is activated.

SLR (single lens reflex) A type of camera (such as the EOS 350D / Digital Rebel XT) that allows the user to view the scene through the lens, using a reflex mirror.

Spot metering A metering system that places importance on the intensity of light reflected by a very small portion of the scene.

Teleconverter A lens that is inserted between the camera body and main lens, increasing the effective focal length.

Telephoto lens A lens with a large focal length and a narrow angle of view

TTL (through the lens) metering A metering system built into the camera that measures light passing through the lens at the time of shooting.

TIFF (Tagged-Image File Format) A universal file format supported by virtually all paint, image-editing and page-layout applications. TIFFS are uncompressed digital files.

USB (universal serial bus) A data transfer standard, used by the EOS 350D / Digital Rebel XT when connecting to a computer.

Viewfinder An optical system used for composing and sometimes focusing the subject.

White balance A function that allows the correct colour balance to be recorded for any given lighting situation.

Wideangle lens A lens with a short focal length.

BIBLIOGRAPHY

Watson, P., *Capturing the light,* Photographers' Institute Press, 2008

Zuckerman, J, and Stulberg, S., *Digital Photographer's New Guide to Photoshop Plug-Ins,* Lark Books, 2009

Benvie, N., *Creative Landscape Photography,* David & Charles Publishing, 2003

Schaub, G., *Focus on Digital Landscape Photography,* Lark Books, 2010

Frost, L., *Lee Frost's Landscape Photography: How to take spectacular photographs* in all environments, David & Charles Publishing, 2009

Sheppard, R., *Magic of Digital Landscape Photography,* Lark Books, 2010

Scott, K., *Photographing changing light: A guide for Landscape Photographers,* Photographers' Institute Press, 2004

Cleghorn, M., *Photoshop in a weekend,* Photographers' Institute Press, 2008

Watson, P., *Reading the Landscape: An Inspirational and Instructional Guide to Landscape Photography,* Photographers' Institute Press, 2009

Till, T., *Success with Landscape Photography,* Photographers' Institute Press, 2008

Benvie, N., *The Art of Nature Photography: Perfect Your Pictures In-camera and In-computer,* David & Charles Publishing, 2004

Miotke, J., *The BetterPhoto Guide to Digital Nature Photography,* Amphoto books, 2005

Plant, I., *Ultimate Guide to the Nature Photography Digital Darkroom,* Mountain Trail Press LLC, 2010

INSPIRATION FOR THE AUTHOR

Littschwager, D, & Middleton, S., *Archipelago: Portraits of Life in the World's Most Remote Island Sanctuary,* National Geographic Books, 2005

Widstrand, S., *Wild Sweeden,* Stockholm: Norstedts

Borges, P., *Tibetan Portraits: The power of compassion,* Rizzoli International Publications, 1996

Munier, V & M., and Joffrion, L., *Clair de brume: Regards sur les Vosges,* Hesse, 2007

Hermansen, P., *Svalbard/Spitzbergen Guide,* Travel Media Gmbh, 2008

For more information on Niall Benvie's workshops: www.imagesfromtheedge.com

ACKNOWLEDGEMENTS

In Scotland: my children, Eliot and Iona; my three ever-supportive sisters, Aileen, Viv and Dawn; Giles Laverack and Fiona Guest; Liz and Tom Forrest; NTS; SWT; RSPB; Sid Clarke; André Goulancourt and Lin Middleton; Lorne Gill.

In Israel: Yossi and Shuli Eshbol.

In France: Michel Blanchet; Robert Lemaitre; Joel Lejeune; Thierry and Nicole Guibert.

In Estonia: Jaanus and Kerttu Jarva; Mr and Mrs Rahe; Mr and Mrs Jarva; Sydney Jarva.

In Latvia: Janis Ozolins; Maris Strazds; Janis Kuze; Janis Macanis.

In Finland: Haanu Hautala.

In Norway: Ole Martin Dahle; Duncan and Sachiko Halley; Torgeir Nygard.

In Czech Republic: Dr Ales Toman.

In England: Colin Hawes; Jonathan Piers Tyler.

In United States: David Ward (Light and Land).

In The Netherlands: Dr Addy de Jongh; Mirelle de Ronde.

In Austria: Benjamin Bachmair and Anna Hofbauer; Kurt Lechner; Lisi Falkeis; Dr Ernst Partl; Wolfgang and Elke Ertl; Philipp Kirschner.

In Spain: José Benito Ruiz and Joaquina; Diego Lopez; Jesus Morales and Maria.

My companions on trips: Pål Hermansen; Jaanus Jarva; Erwin Christis.

Staffan Wldstrand, Florian Moellers and Pete Cairns of Wild Wonders of Europe for allowing the use of a number of pictures shot on commission for that project. www.wild-wonders.com

Special thanks to my readers, Erwin and Charlie, for their hard work on the text.

INDEX

*To request a full catalogue of
Photographers' Institute Press titles,
please contact:*

GMC Publications Ltd
Castle Place, 166 High Street, Lewes,
East Sussex, BN7 1XU, United Kingdom
Tel: +44 (0) 1273 488005 Fax: +44 (0) 1273 402866
Website: www.pipress.com